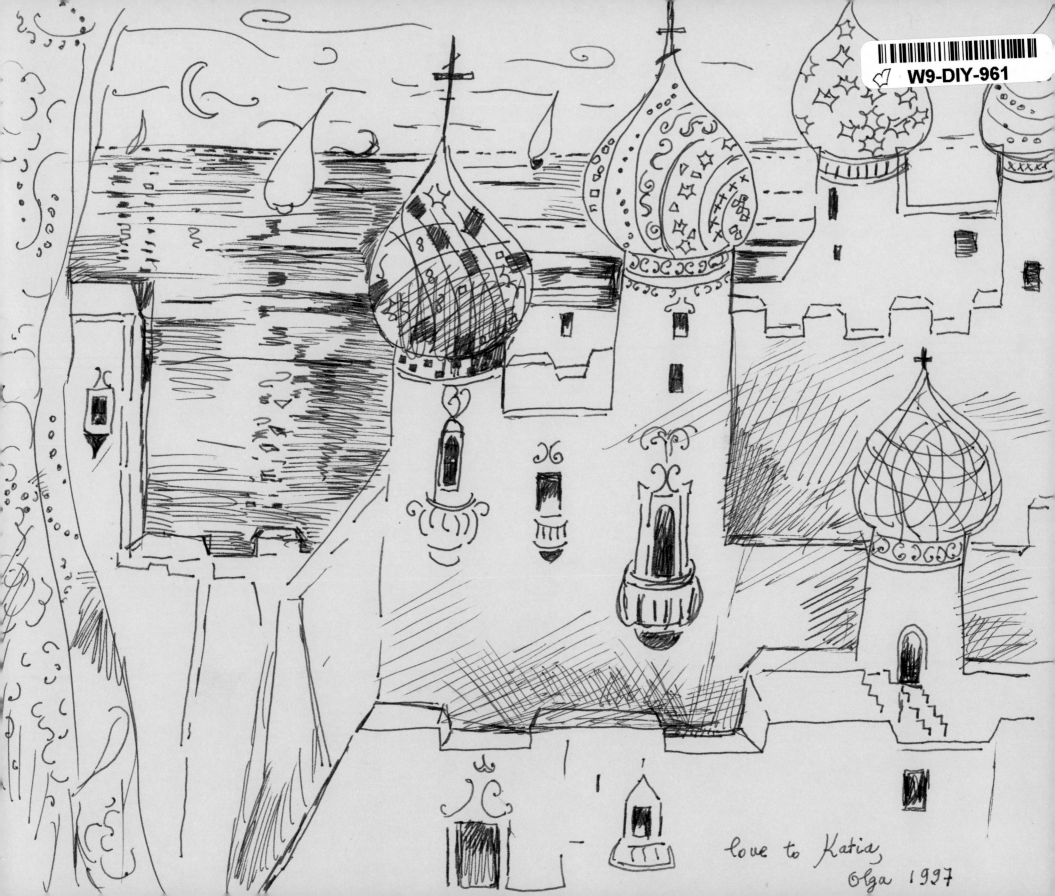

love to Katia,
Olga 1997

W9-DIY-961

# RUSSIAN JOURNAL

## 1965-1990

TO ARTHUR AND REBECCA, WITH LOVE

# RUSSIAN JOURNAL

## 1965-1990

BY INGE MORATH

With an Introduction
by Yevgeny Yevtushenko

AN APERTURE BOOK

Aperture gratefully acknowledges PepsiCo, Inc. for its generous
support of this project.

Copyright © 1991 by Aperture Foundation, Inc. Photographs
copyright © 1991 by Inge Morath. Introduction copyright ©
1991 by Yevgeny Yevtushenko. Journal excerpts copyright ©
Inge Morath. "Letters to Inge" Copyright © 1991 by Andrei
Voznesensky. "Instantaneous Forever" copyright © Olga
Andreyev Carlisle. "Thunderstorm, Instantaneous Forever"
copyright © Estate of Boris Pasternak.

From *In Russia* by Arthur Miller and Inge Morath, 29 illustrations,
copyright © 1969 in all countries of the International Copyright
Union by Inge Morath. Used by permission of Viking Penguin,
a division of Penguin Books USA, Inc.

All rights reserved under International and Pan-American
Copyright Conventions. Distributed in the United States by
Farrar, Straus and Giroux. Distributed in Europe by Nilsson
& Lamm, B.V., Netherlands. Distributed in the UK by
Sinclair-Stevenson, Ltd., London.

Composition by Pub-set, Inc., Union, New Jersey. Printed by
South China Printing Company (1988) Ltd. in Hong Kong.

Library of Congress Catalog Number: 91-70195
Hardcover ISBN: 0-89381-473-3

Aperture publishes a periodical, books, and portfolios of
fine photography to communicate with creative people
everywhere. A complete catalog is available upon request.
Address: 20 East 23rd Street, New York, New York 10010.

The staff at Aperture for *Russian Journal* is Michael E. Hoffman,
Executive Director; Andrew Wilkes, Editor; Jane Marsching,
Assistant Editor; Susannah Levy, Joseph Miller, Editorial Work-
Scholar; Stevan A. Baron, Production Director; Linda Tarack,
Production Associate, Junie Lee, Production Work-Scholar

Project Editor: Peggy Roalf
Design concept: Veronique Vienne

# CONTENTS

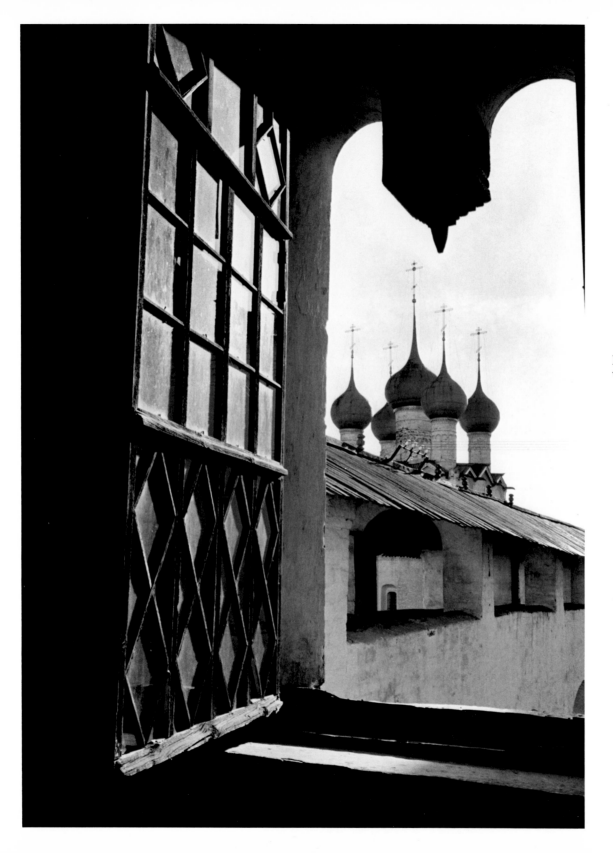

ROSTOV-VELIKI, 1967
View inside the kremlin.

6

# PREFACE

SINCE I CAN REMEMBER PLANNING VOYAGES—as a child, I had traveled extensively with my parents until the Second World War interrupted our normal stream of life—I wanted to go to Russia. Not the Soviet Union; the place I longed to know had no political name.

I was born in southern Austria near the borders of Czechoslovakia, Hungary, and Yugoslavia, and behind those small countries Russia loomed large. Books of Russian fairy tales with splendid illustrations created a child's dreams of a whole new world of spirits, of bears, mushrooms, and snowflake fairies. Old people spoke of taking the waters in Karlsbad and meeting Russians, whose characters always seemed immense, moody, much more ample and unpredictable than those I knew, impetuously bursting out with feelings that were too powerful to be filtered by Western skepticism. An impoverished Prince Gagarin gave Russian lessons to my father and told about his countryside, speaking with such eloquent nostalgia that birch trees, wooden dachas, and rivers also entered my dreams.

During World War II, part of which I spent in Berlin when everything was censored, I could still openly read Tolstoy and Dostoyevski in the underground air-raid shelters. In Paris after the war, I found not only among the Russian émigrés, but mainly among my French friends, a fervor for the Revolution. At that time I started to read Mayakovsky, Blok, Tsvetayeva, and they touched me deeply with their vulnerability and swift changes of mood, which reflected my own searching. But it was also their disappointment in the Revolution's having turned into a dictatorship that gave their work immediacy for me.

There were Russian churches in Vienna and Paris, which I loved to visit on Easter and Christmas, whose Byzantine ritual washed like a healing wave of joy over their differences. Neighbors kissed on both cheeks, and this extravagance spilled into their way of crossing themselves —not just once but over and over in high arcs from forehead to heart to shoulder.

In the early sixties, the time to go to Russia finally arrived. Stalin was dead, and as Khrushchev's rule began, it seemed to promise a thaw in the cold war. Two of the new voices carrying a reborn spirit in Russian poetry, Andrei Voznesensky and Yevgeny Yevtushenko, came to New York and read their work to packed halls. In ringing voices, so different from the restraint of most Western poets, they called out their credos, their feelings, doubts, and prayers, and my childhood Russia of larger-than-life people and passions came alive. These writers soon became my friends.

IN THE WINTER OF 1965, Arthur Miller and I took a train from Düsseldorf to Moscow. I had wanted to feel the vastness that separates East from West, and here were two and a half days of staring out at the snow-blanketed earth stretching to the horizons. The fulfillment of a long on-and-off love affair with the real Russia began. Arthur Miller's and my book, *In Russia*, was banned in the Soviet Union for almost twenty years but was secretly read and loved by many Russians. In 1985, with the arrival of glasnost, we went back together several times, and sometimes I went alone with my camera. This book is a journal in photographs with excerpts from my diaries spanning some twenty-five years; but in fact, it really goes further back to nearly a lifetime of thoughts and feelings about a people and my desire to come closer to them with the means that I have been given.

I.M., ROXBURY, CONNECTICUT,
December 30, 1990

MIKHAILOVSKOYE, 1967
Peasant hut with birdhouses
in the provinces.

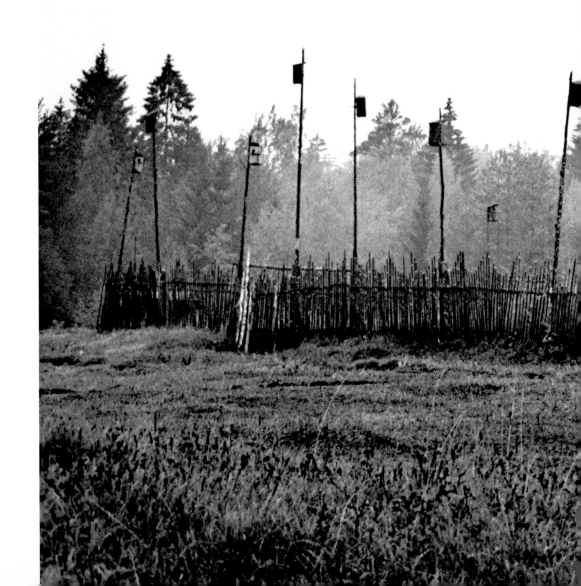

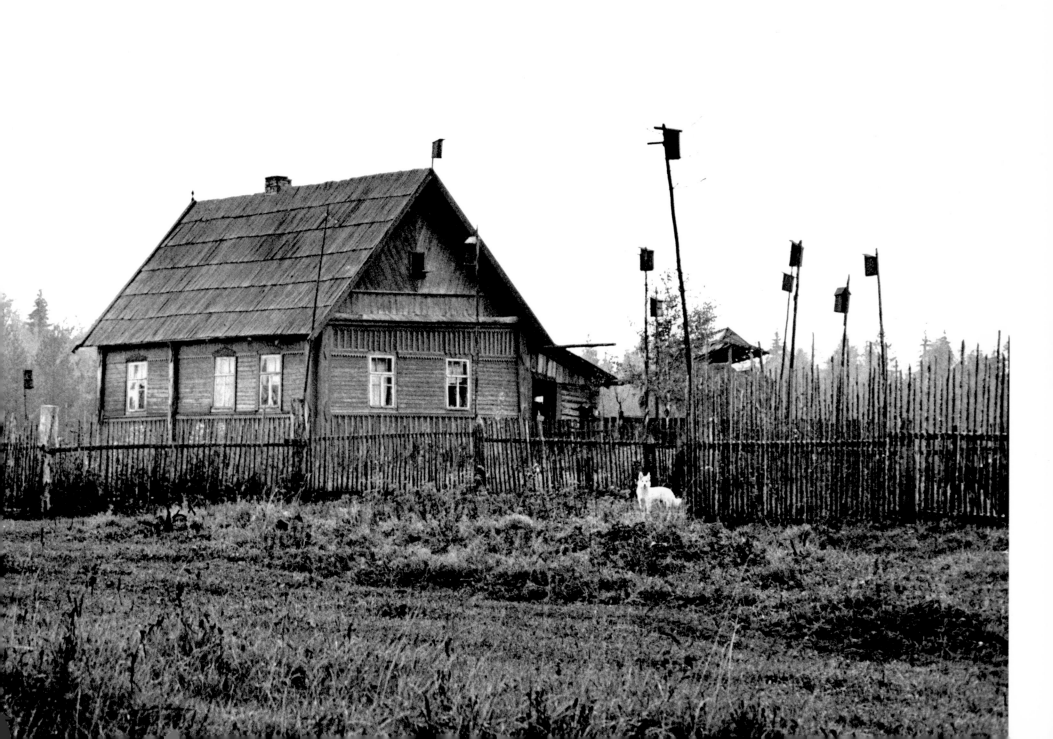

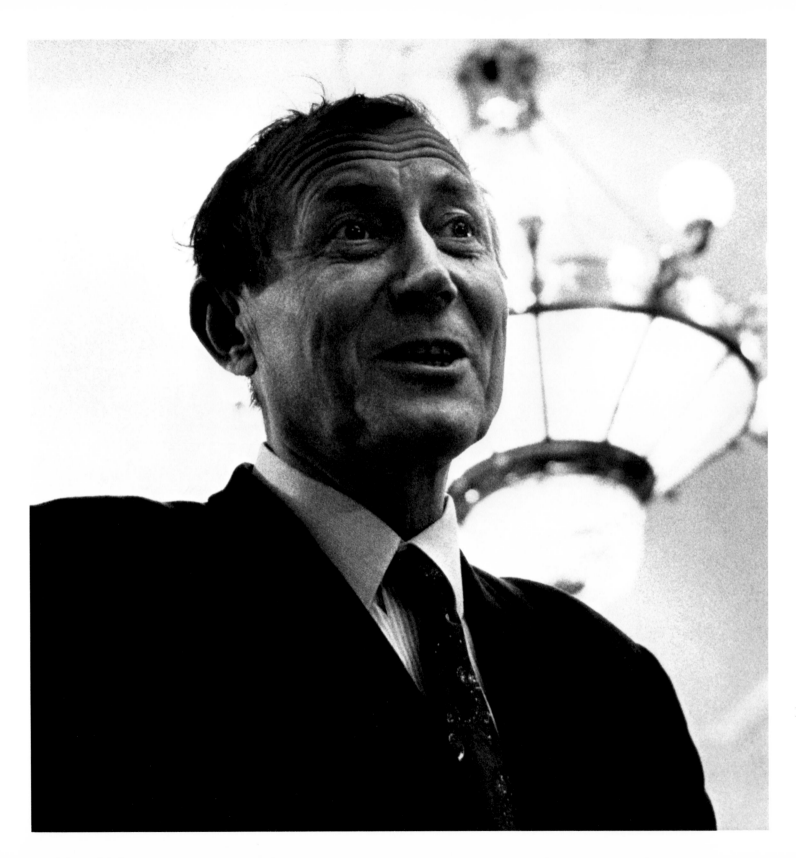

MOSCOW, 1985

# A GOSSAMER THREAD

by Yevgeny Yevtushenko

I THINK IT WAS MIRABEAU WHO SAID, "The only revolution that we can win is one that women support." And revolution is as ominous as an echo in the mountains.

In our country, the revolution was won when Russian widows aroused it with their inconsolable plaint for soldier husbands killed meaninglessly in World War I, and it began rolling like an avalanche, taking them with it, they who had awakened it. And the revolution, once hailed and welcomed by Russian women, gradually turned from what looked like salvation into damnation, pulling them into years of waiting in lines at stores and, more horribly, at prison gates, trying to learn something about their fathers, their husbands, their sons. Losing the trust of the exhausted women, our revolution ceased being a revolution and turned into the daily tyranny of shortages.

Inge Morath understood our country and our people. She understood us and did not humiliate us with insulting sentimentality. She understood and did not fall for the trite fairy tale about the "mysterious Slavic soul." Instead, she understood that soul, entered it like a forest that naturally has its dangerous swamps covered with emerald-green scum but is also the place where the she-bear gets up after lying on her side and walks off with red berries in her black fur that glint like the wise eyes of Mother Nature.

She understood and did not get lost, holding on to the barely shimmering gossamer thread that lighted her way— the thread that kept her from losing herself in the forest of the Russian soul.

That thread is a talent for loving the unfamiliar, for making the alien one's own. The planet has too many professional internationalists whose declared love for foreign peoples is a political gesture, a means of existence. A love that's too logical is always suspicious, whether it's for your wife, or for another nation, or for all of mankind. Professing love too easily for all of mankind is a form of prostitution.

INGE MORATH'S CAMERA CAN BE MOCKING and even sharply ironic, especially when she observes official functions. A true artist, she is one with the poor and hungry and not with those who are hungry because they are dieting. Her camera becomes sorrowful when it touches people who are, in Pasternak's words, "stifling in the myriad petty humiliations" of everyday life. I love one of Inge's best-known Russian photographs, that of Minister of Culture Ekaterina Furtseva. Inge's camera must have seen her as a caricature at first; it was Furtseva, they say, who once told the great pianist Sviatoslav Richter, when he refused to go abroad because the Ministry of Culture was exploiting him shamelessly: "Listen, dear comrade Richter, just pack up your violin and go where you're told when it's the Minister of Culture speaking." But observing that self-important illiteracy in Mme. Furtseva, Inge took pity, and her finger didn't press the button cruelly but waited until the viewfinder showed the suffering confusion of a woman facing the incompatibility of talent and fate, the constant fear that tormented Furtseva's soul.

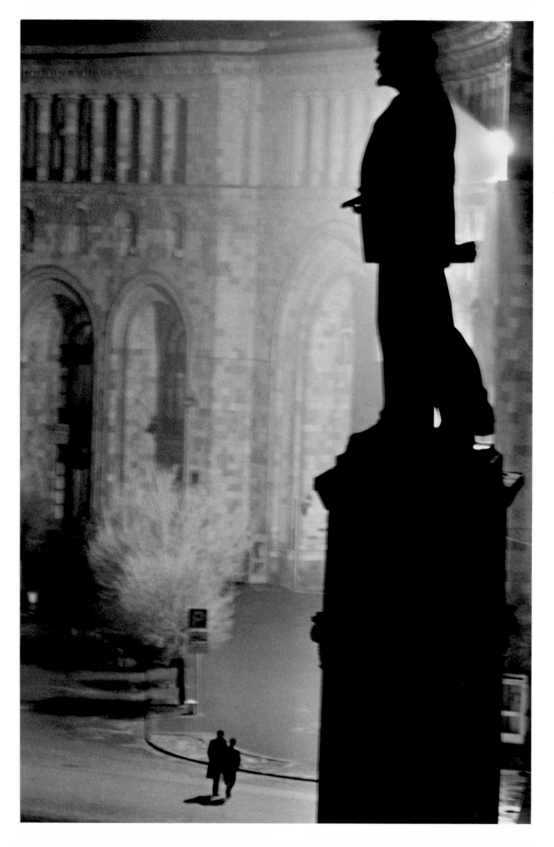

YEREVAN, 1987
This colossal statue of Lenin
still dominates the main
square of the capital of
Armenia.

The camera is so tender in its panorama of old women's faces in Zagorsk, as if the European-American Inge had lived the life of each one of them. The study *Lomonosov–Leningrad Train* is imbued with the inexpressible sadness of life on the wane inside the coach while life is blossoming outside the window. Inge's ballet suite is filled with barely perceptible quotations from Degas, and her acrobats seem to step out of Picasso's blue period. We must not forget that Russia is a part of Europe. A touch of French influence is natural in a portrait of Russia. Pushkin is about to sit down on the white bench waiting for him. The landscapes of prerevolutionary Russia are infused with such nostalgia that one would think Inge Morath might almost have lived in St. Petersburg, an aristocratic ghost returning to Russia with a Leica in her hands.

There have been many photographic books about Russia published in the West. The best among them are by Cartier-Bresson and William Klein. Their main theme is the absurd incongruence between official posters and sculptures and the people's faces. The books done by recent émigrés are usually harsh and negative. Inge Morath has avoided these clichés. Lovers of garbage dumps may find some of her landscapes too pretty, but must we, even in a long-suffering country like Russia, reject the beauty of our countryside and our architectural heritage? We can't let political depression affect our attitude toward trees, mushrooms, sunsets, and sunrises!

Inge Morath has one more quality that is characteristic of a true artist—respect for death. There is a marvelous photograph in this book taken in the Novodevichy Cemetery. Two people, now stone. In life they may have known each other but never had a chance to speak heart to heart. Now in death they stand side by side caught in stone, but they can't move, they can't embrace.

Inge Morath's book is valuable because she helps Russians and foreigners break out of the stone and step forth.

–Peredelkino, November 10, 1990

Translated by Antonina W. Bouis

---

YEVGENY YEVTUSHENKO, born in 1933 in Siberia, became the voice of the post-Stalin generation in the mid-fifties. There was a new sound in his poetry, a freshness throwing caution to the wind. He read his poetry to large audiences in the USSR and abroad and acquired international fame in 1961 with *Babi Yar*, a poem against anti-Semitism in the Soviet Union. He never stopped fighting his generation's battle for freedom of expression on the poetic front, for which he was frequently condemned by the authorities. In 1986 he was elected honorary member of the American Academy of Arts and Letters. His *Collected Poems* was published in New York in 1991.

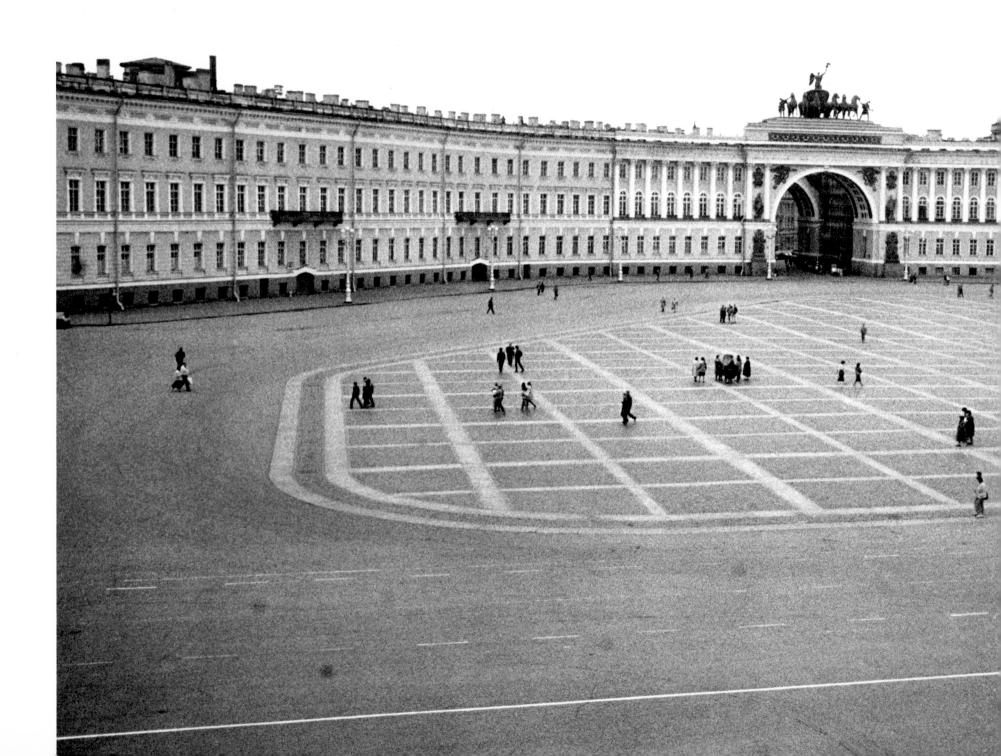

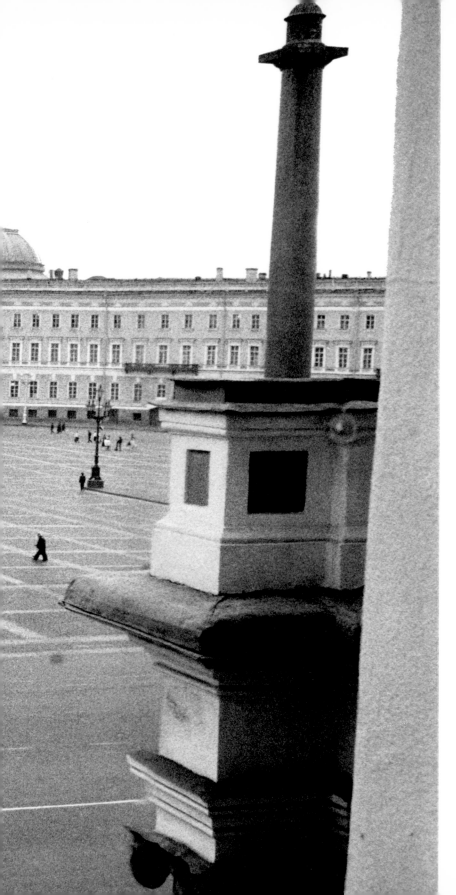

# TSARIST SPACE

LENINGRAD, 1989

The tsars recognized that the power of nature's space demanded that man-made space be of equally impressive proportions. Palace Square has played an important part in the history of Leningrad; it was in the Winter Palace that the revolutionaries ousted the provisional government. I climbed to a top window to get a tsar's view of his subjects, tiny people moving like ants on a chessboard.

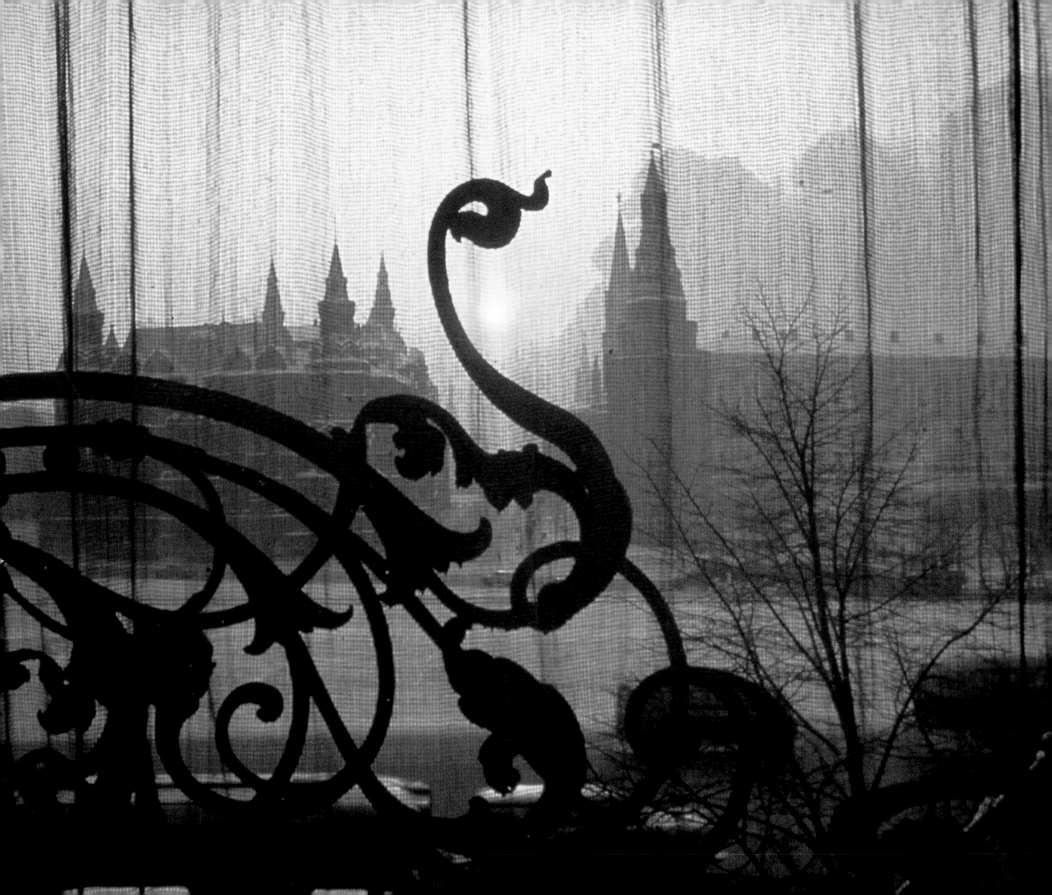

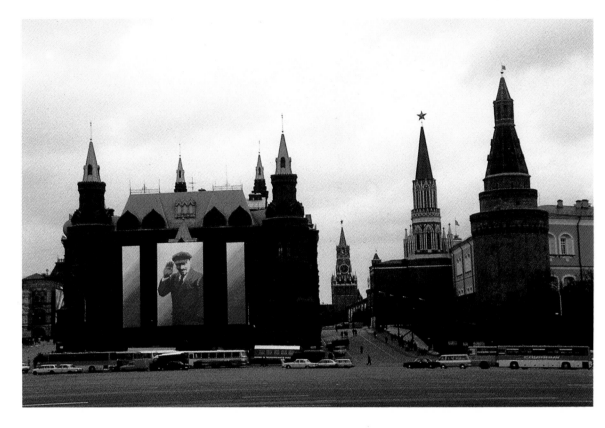

LEFT: MOSCOW, 1965

Moscow in the early morning, looking toward Red Square through the Art Nouveau grille of the National Hotel dining room. To the right is a corner of the Kremlin's fortified wall.

ABOVE: MOSCOW, 1989

As part of the decorations for the May Day parade, Lenin salutes his comrades from gigantic banners at the entrance to Red Square.

RIGHT: LENINGRAD, 1989

Sailors on the cruiser *Aurora* fired a blank round to signal the storming of the Winter Palace during the October Revolution. Compared to its historic importance, the ship looks toylike in the rosy morning light on the Neva River.

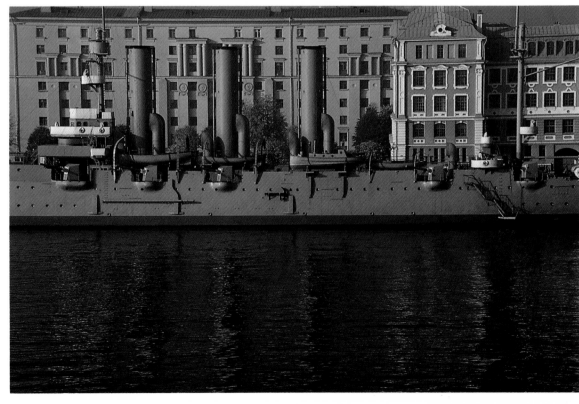

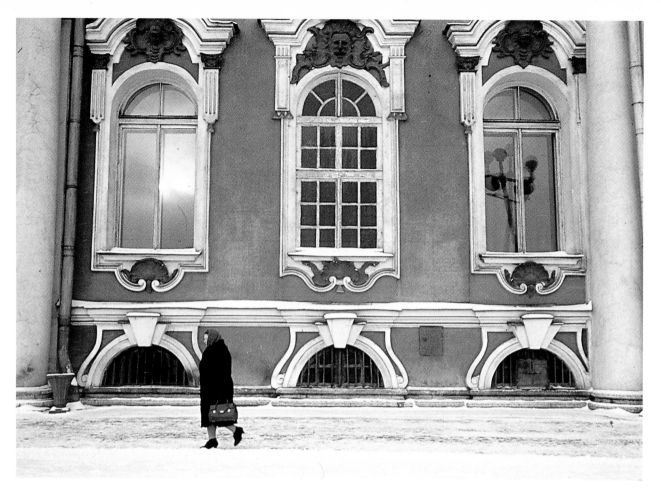

LEFT: LENINGRAD, 1965
The colors of Leningrad, a
certain blue, a dark red,
a green, and sometimes a
yellow, are astonishing.
Occasionally, decorations like
frozen foam playfully sur-
round the windows.

RIGHT: PETRODVORETS,
1989
The Versailles of Peter the
Great was built on the Baltic
Sea by the architects Jean
Baptiste Le Blond and Bar-
tolomeo Francesco Rastrelli
between 1717 and 1750. In
the Great Cascade, golden life-
size allegorical figures stream
down from the palace to the
great park beyond. Fountains
spring up all around them
from dolphins, cornucopias,
and amphoras. Rivers of
water collect in a pool only to
be picked up again and
spewed from a golden triton;
the rising and falling veil of
water finally settles in a canal
that flows to the Gulf of
Finland.

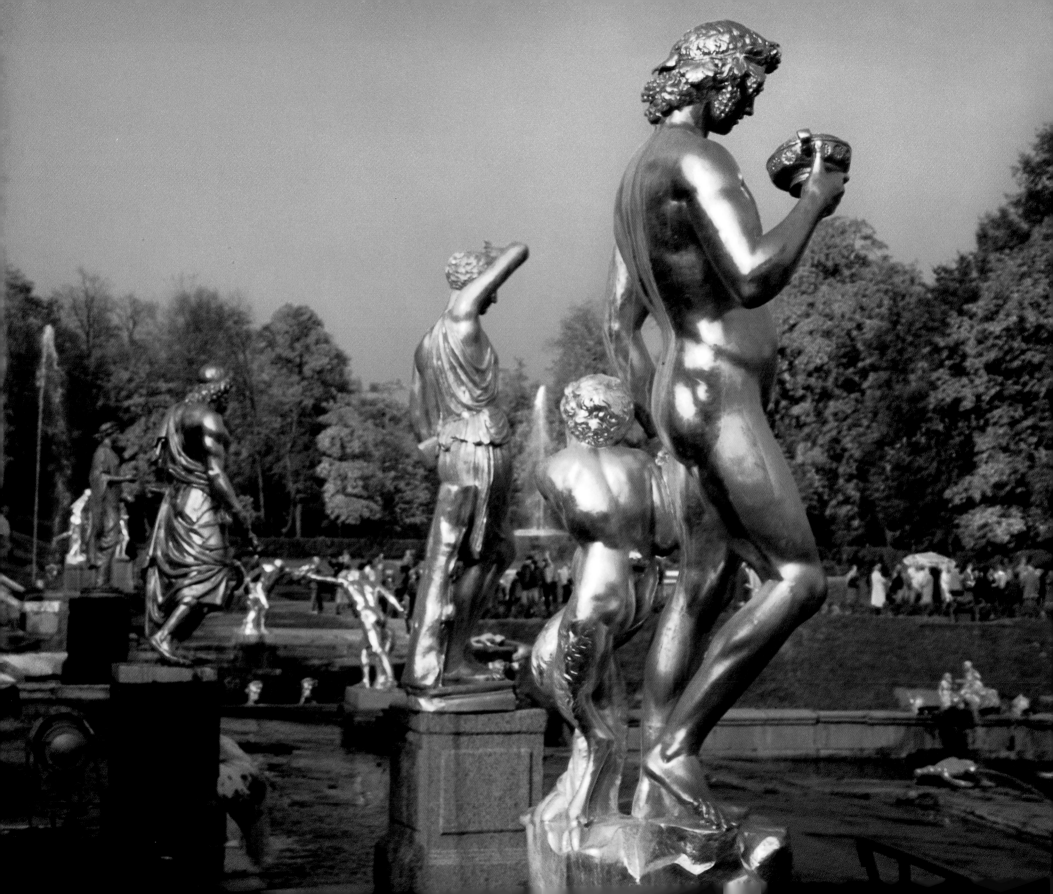

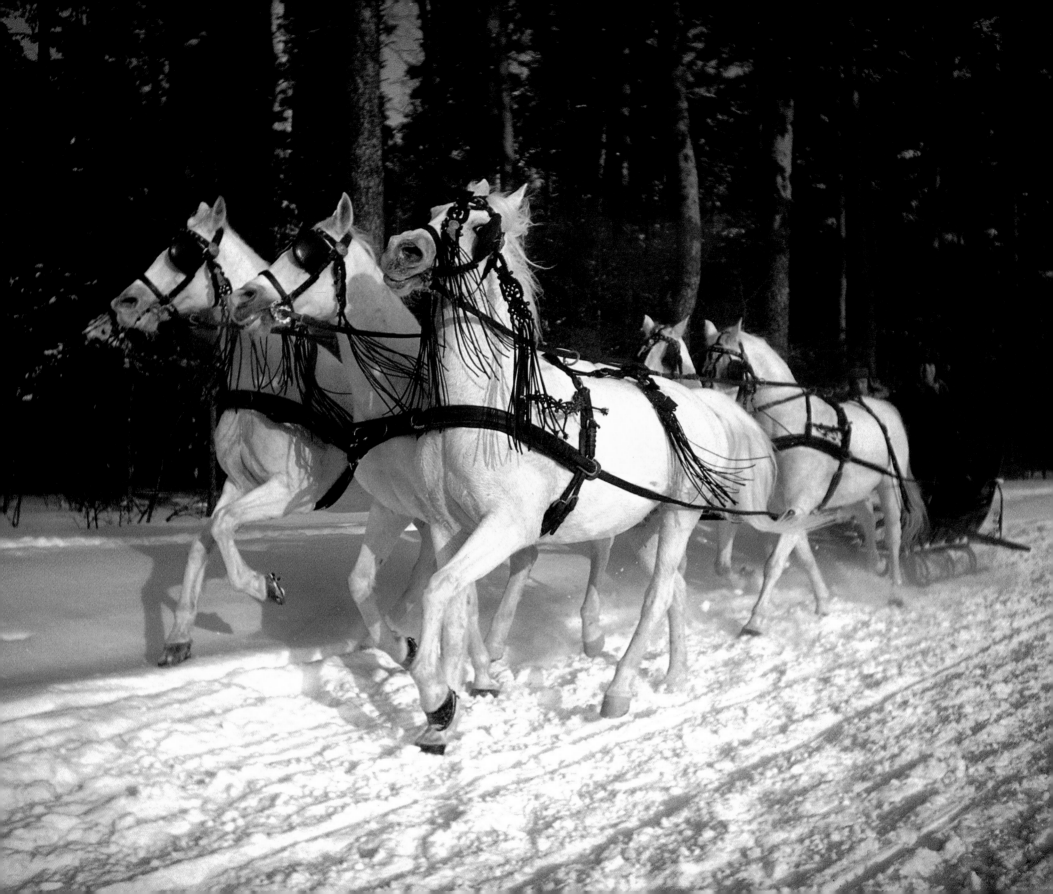

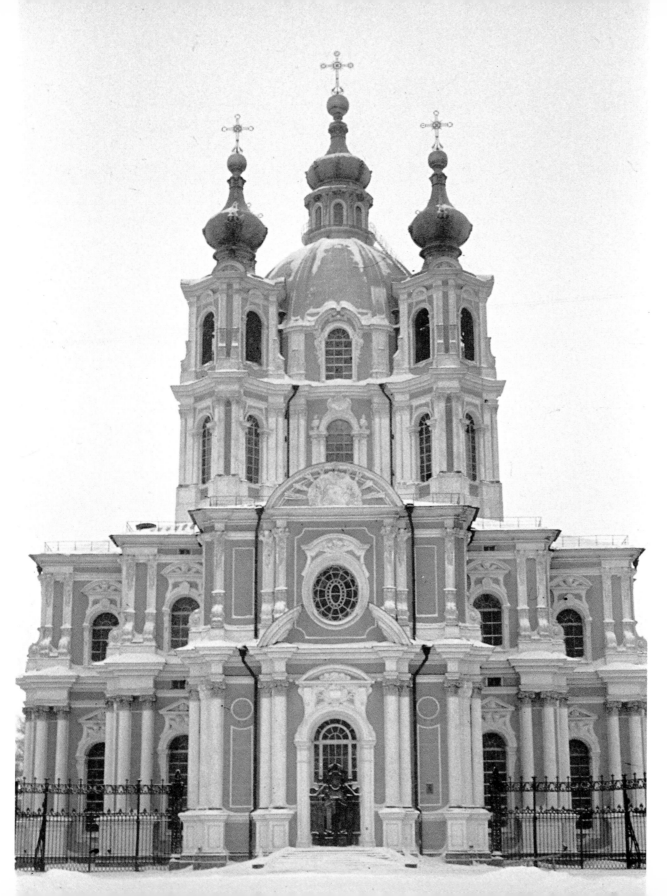

OPPOSITE: PIATNITSA,
1965

One of the most spectacular
things here is to rush over the
snow. The *piatnitsa*, a sleigh
drawn by five horses, flies,
borne aloft as much by the
horses' joy as by their speed.
The driver has ten reins
flowing through his fingers;
he leans back almost flat to
pull those reins with all his
weight. Steam rises from the
horses' rumps, the pine trees
flash by, the pounding of
hooves on the snow soothes
the mind.

LEFT: LENINGRAD, 1965

The Cathedral of the Resur-
rection on the grounds of the
Smolny Convent was designed
by Rastrelli in the eighteenth
century. The nearby Smolny
Institute was founded by
Catherine the Great for the
education of young ladies of
the nobility. In 1917, Lenin
established headquarters here
and organized the October
Revolution.

21

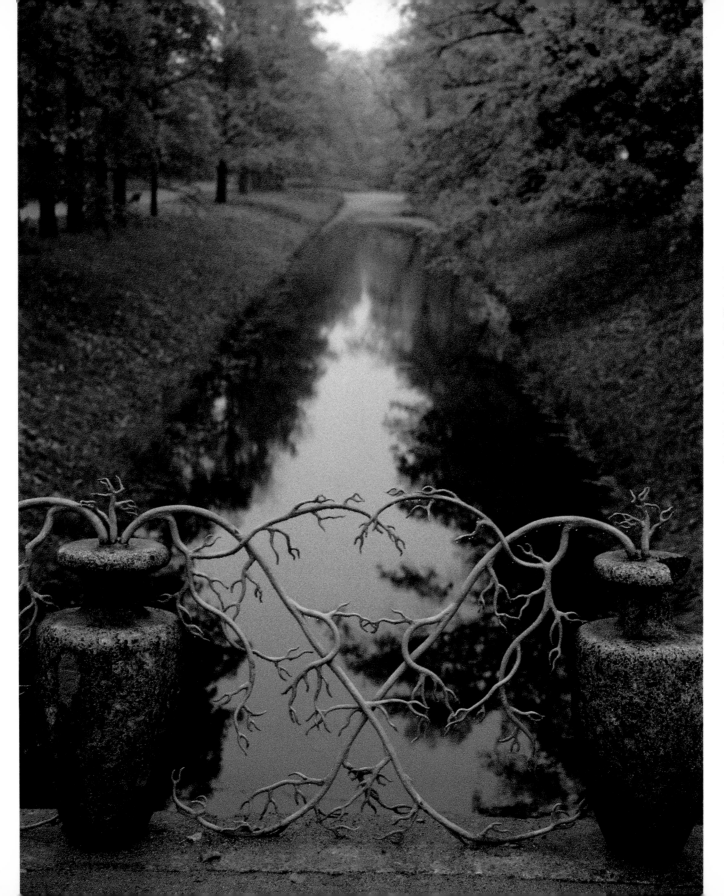

LEFT: PUSHKIN, 1989
In Alexander Park, carved
granite vases on a tiny bridge
are connected by a delicate
ornamental fence wrought in
the form of coral branches.

RIGHT: LENINGRAD, 1967
Inside Catherine Palace, a
painting of the nude Tsarina
Elisabeth hangs in the Chi-
nese Salon.

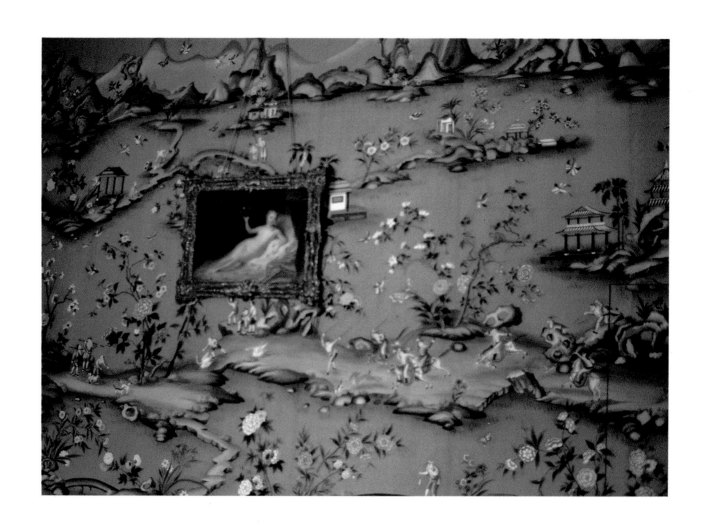

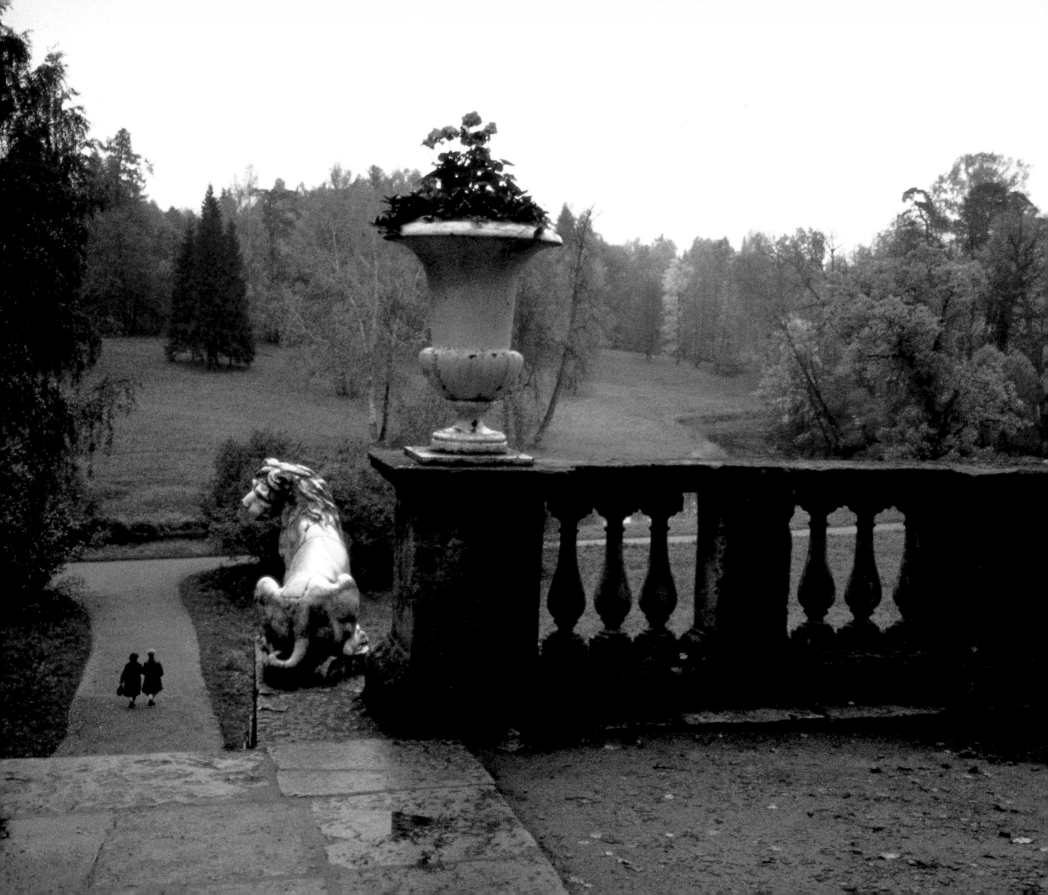

LEFT: PAVLOVSK, 1989
Catherine the Great had her
favorite architect, Charles
Cameron, build a palace for
her son Pavel between 1782
and 1786. The slight neglect
of the splendid English gar-
dens adds to their nostalgic
charm.

RIGHT: MOSCOW, 1967
St. Basil's Cathedral, with its
jumble of differently shaped
domes in a multitude of
colors, which dominates the
ceremonial space of Red
Square next to the Kremlin,
was built under Tsar Ivan the
Terrible to glorify his victory
in Kazan. He named it the
Church of the Intercession of
the Holy Virgin, but it was
later renamed after St. Basil,
a holy fool who supposedly
spoke out against the tsar.

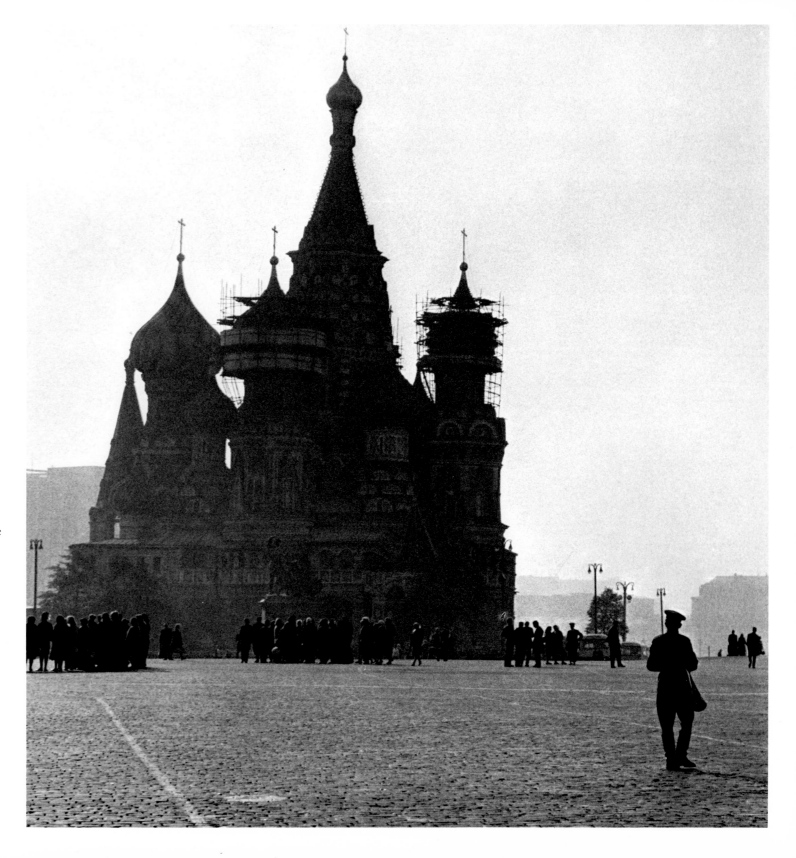

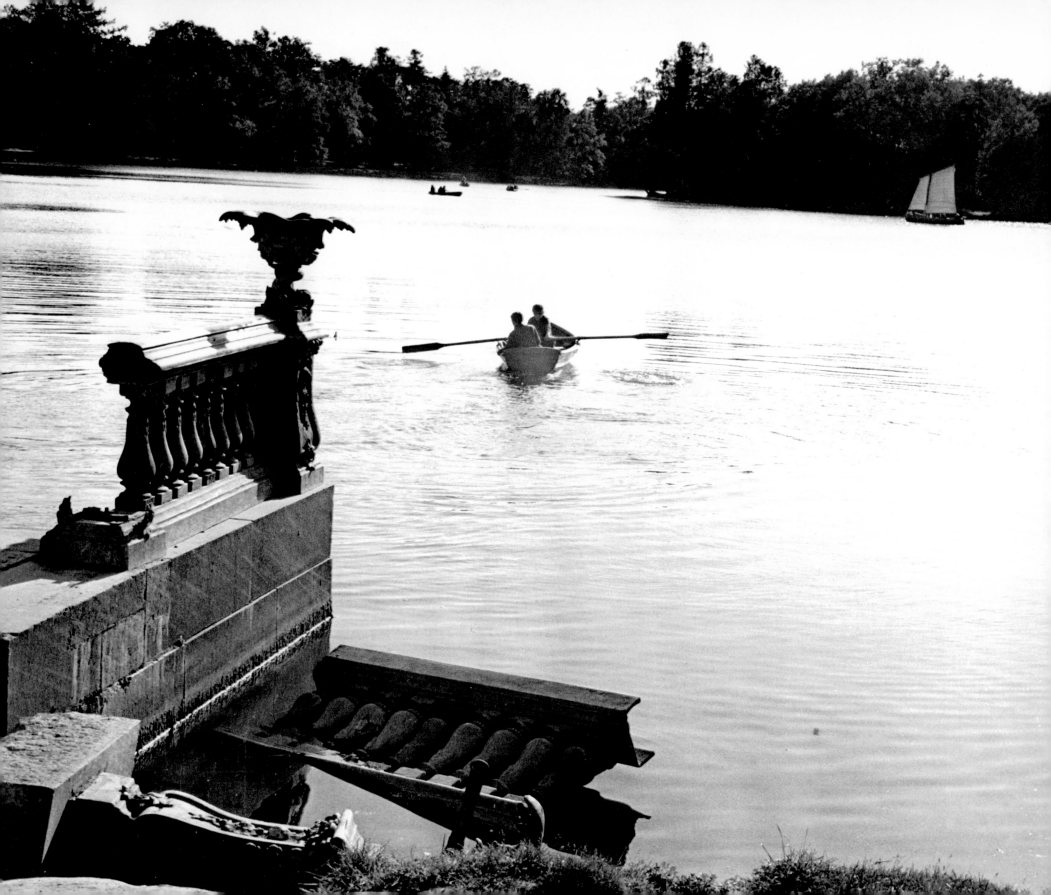

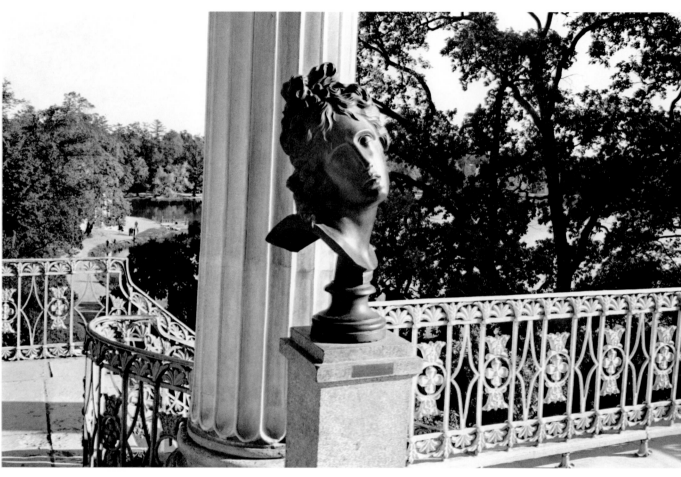

PUSHKIN, 1967
The park around Catherine
the Great's summer palace in
Pushkin, formerly Tsarskoye
Selo, was laid out by Charles
Cameron; the sculpture
gallery bears his name. Badly
damaged by German forces in
World War II, the palace and
gardens are still being re-
stored, but their regal charm
remains undiminished.

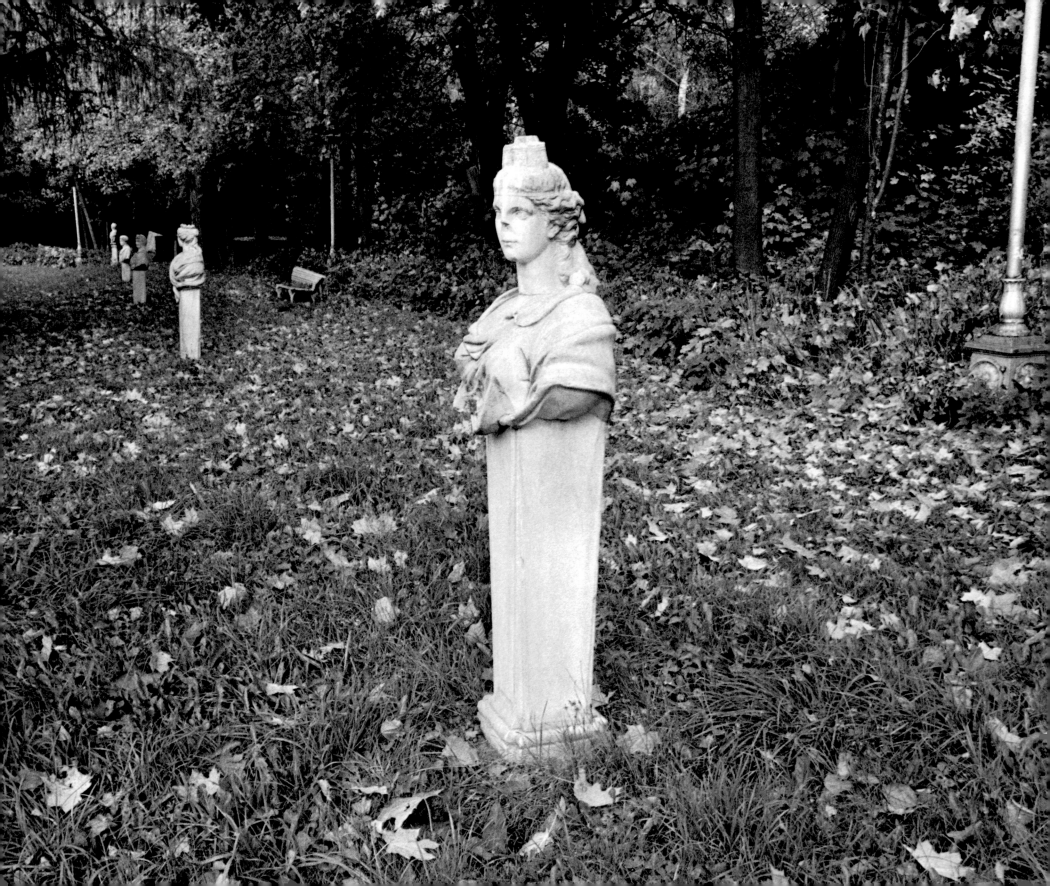

LEFT: MOSCOW, 1989
Abandoned Muses in the
garden at Ostankino Palace,
once owned by the counts
Sheremetyev, wait to be
admired again.

RIGHT: LENINGRAD, 1965
The towering wax effigy of
Peter the Great in the Herm-
itage Museum is true to scale.
He had the vision to build his
new capital on an outlet to
the Baltic Sea in proximity to
Western Europe, but so many
laborers perished executing
his great plan that Leningrad
is said to be built on bones.

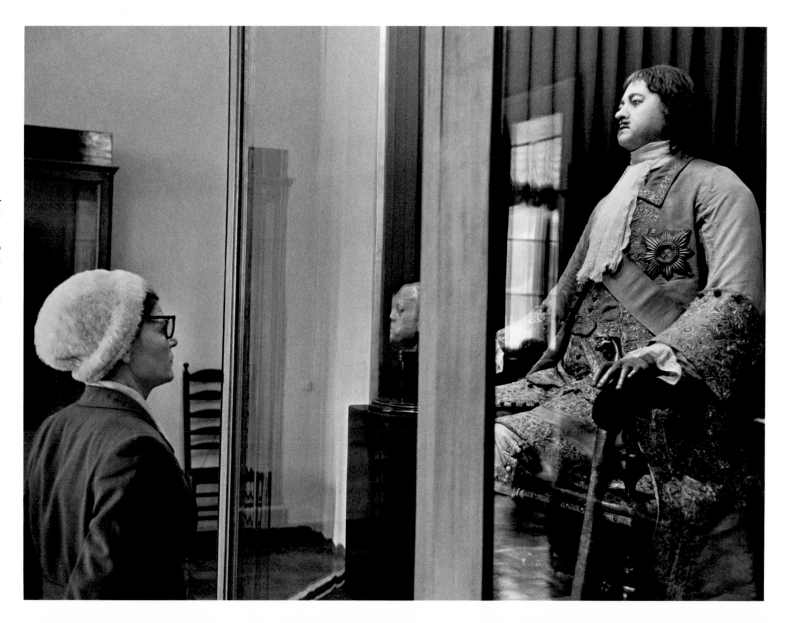

LENINGRAD, 1967

The phones in the hotel are tapped. The authorities frown on citizens receiving foreigners in their homes. Joseph Brodsky has just been released from jail and should not be put to more risk. But when Olga Andreyev Carlisle and I finally reach him from a phone booth, he invites us to come to his house that evening.

"You mustn't wear perfume, they might smell it in the staircase," warns Olga. "And don't speak French, don't speak at all." We get past the concierge, hurry up the stairs to the communal apartment, go through a kitchen, past his father's darkroom, and finally enter Brodsky's lodgings. With intense blue eyes and a hypersensitive face, he welcomes us warmly. A few fellow writers and friends are scattered about the room; he begins at once to recite from his latest work with great intensity, until his voice resounds through the open windows into the street. We discuss translations of poetry, and someone reads Akhmatova. It is an ardent evocation of the art of poetry, a midnight celebration in the face of the authorities.

At one in the morning we go on a two-hour walk back to the hotel, accompanied by everyone. Brodsky shows us the secret-police station where he was taken after his arrest, places where Dostoyevski lived. It is a dance through nocturnal Leningrad, a dance courting danger.

Two days later we meet again; Brodsky insists we see more of his beloved city. We climb a grassy slope to the roof of the Fortress of Peter and Paul. A big sign forbids entry. "Come on," says Brodsky, "the best views of the city are from up here." We step up onto the roof, and at our feet the panorama of Leningrad opens: the Winter Palace, the Summer Garden, the huge expanse of the Neva River. Here and there we peek into the spy holes of the stone guard towers. Then we go to the waterfront, where his father used to take him to play; we discuss poetry, translations, other writers, and life elsewhere. Joseph Brodsky is restless. He is persecuted. To leave means to abandon all the loved ones. To stay means to be stifled.

JOSEPH BRODSKY was exiled in 1972. He won the Nobel Prize for Literature in 1987. He now lives and writes in the U.S.

30

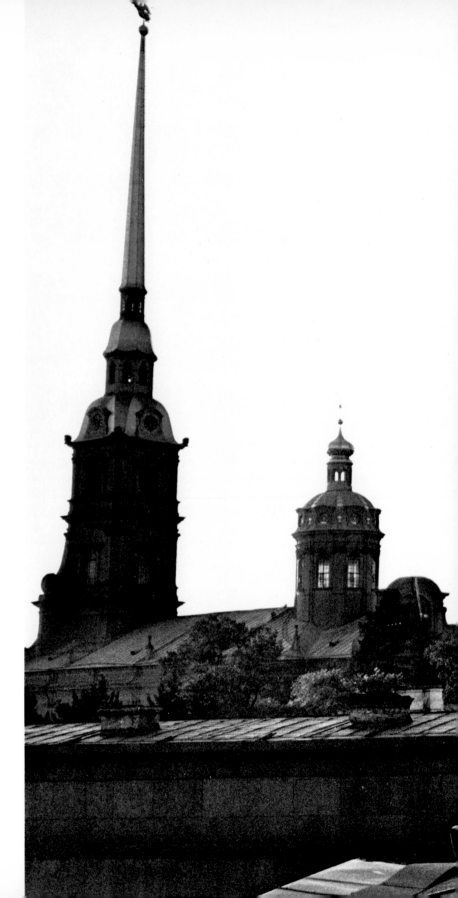

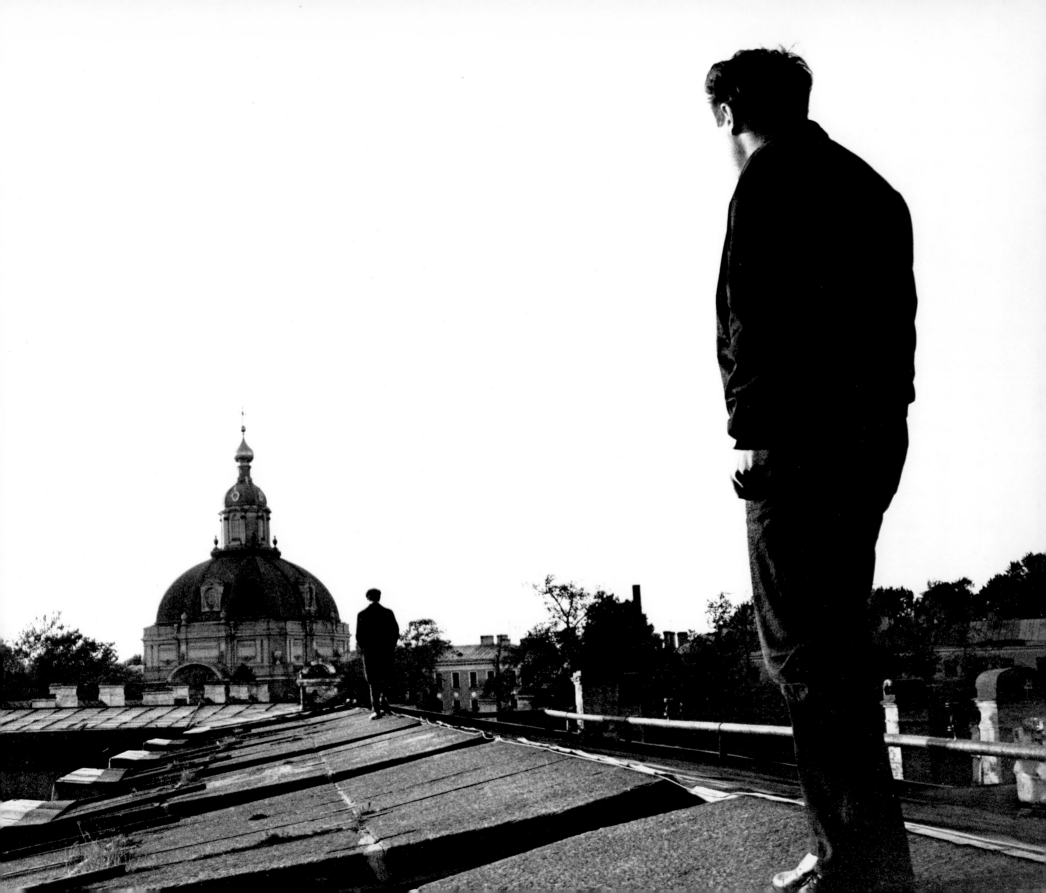

# LETTERS FROM
# NADEZHDA MANDELSTAM

WHEN OLGA ANDREYEV CARLISLE AND I find her apartment in a remote block of flats, Nadezhda Yakovlevna Mandelstam eagerly greets us, proud of her two small rooms. She is living in Moscow again after long years of exile. She sits next to the kitchen stove on an elegant black settee with a finely carved frame. Here she drinks her excellent tea, rolls her cigarettes, and receives friends and admirers. In the thirties she had followed her husband, the poet Osip Mandelstam, into exile, but was not with him on the last journey, which led to his death en route to a labor camp. Nadezhda was faithful to her name, which in Russian means hope: she committed all her husband's verses to memory, defying the destruction of his manuscripts, and lived to see his entire oeuvre put into print in the West. In 1970 she published her autobiography, *Hope Against Hope*, followed by *Hope Abandoned* in 1974. Her proud voice can be heard in letters she wrote to us in English between 1968 and 1973:

Dear Mr. Miller:

I thank you very much for the book of stories you have sent me. I liked the stories very much—the one about the nervy little Jewish child with keen and promising feelings. His mother is much like other Jewish mothers all over the world, making a fuss about nothing. . . . I see that you feel your origins and ancestors more strongly than I do. I think it is because all my misfortunes came from my husband's

being a Russian poet. Once Marina Tsvetayeva said that in our thoroughly Christian world, all poets are Jews (which means pursued as Jews). So being a poet means to be a Jew raised to the second power . . . that is why I am at a loss what to feel stronger about. Truly yours,

NM

Dear Inge:

I was charmed to see the photo of your Rebecca. What a happy and beautiful child! Has she got her first admirers? I think she must be eleven or twelve. It is high time to have admirers. I hope she is healthy and knows she is charming. A girl ought to know it. She must know that she is of great value, or she will be grateful to her admirers, which doesn't pay. . . . But do spoil her, do pet and pamper her. I think that I was able to live out my life and didn't fall down at the first difficulty only because I was so spoiled in childhood. It really helps in life. Give my love to your husband and don't forget me. Thank you for the photograph. Yours,

NM

Dear Inge:

You really think I am not shaky. I am. My age is seventy and people at seventy are always shaky. I do not feel like traveling, for instance, and I hope to live my last days here in my flat where you came to see me. I hope I don't hope against hope. With love,

Nadezhda

MOSCOW, 1967

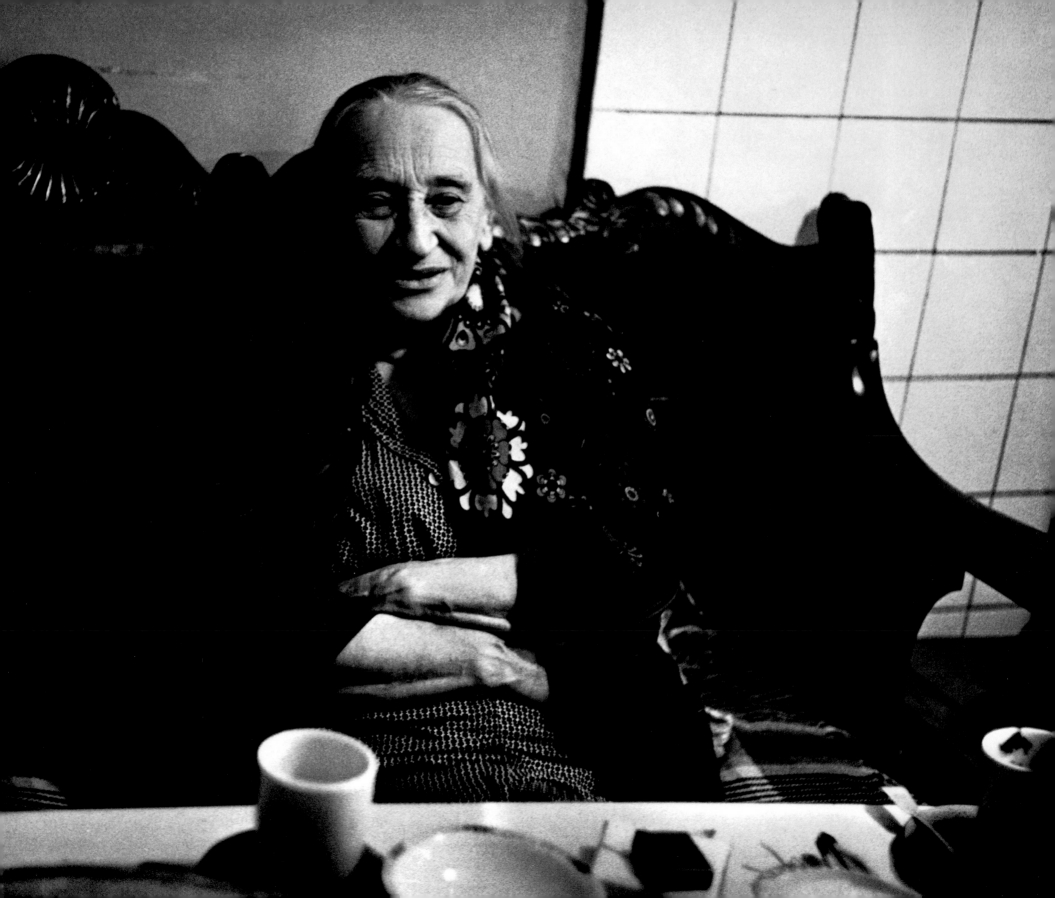

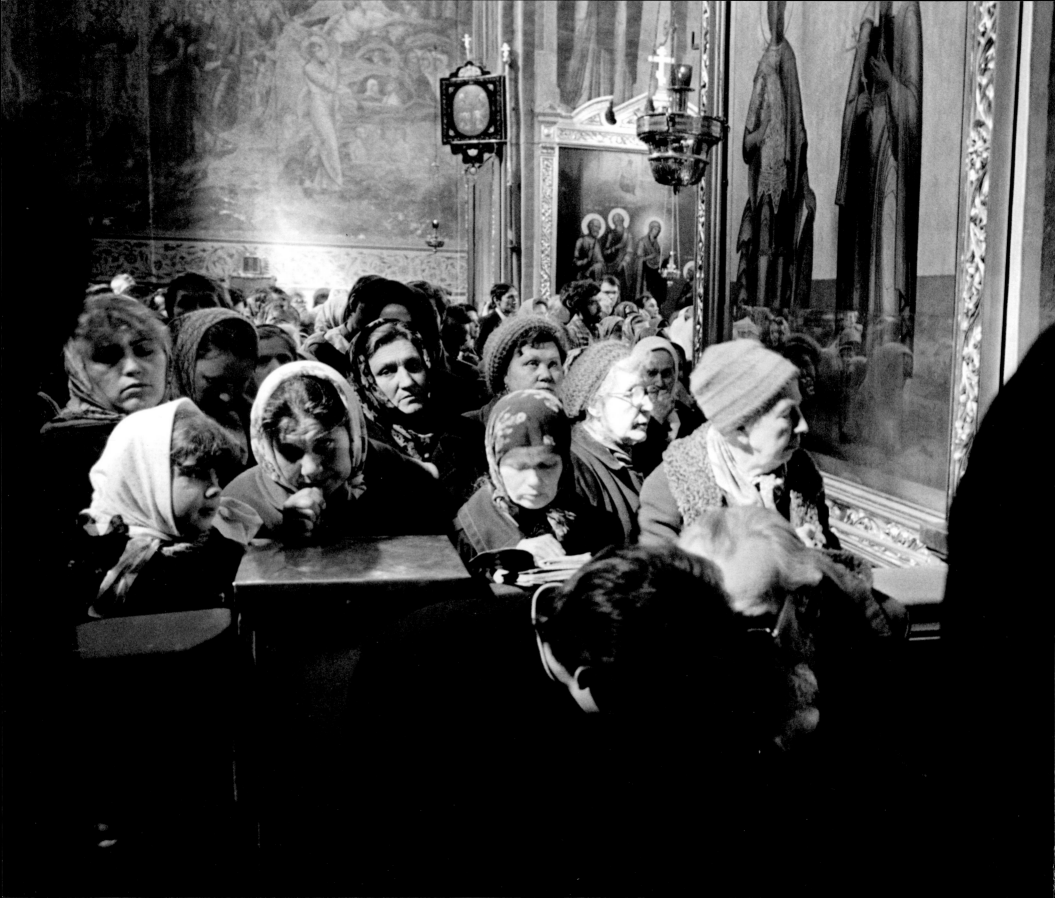

# LIVING WITH ICONS

ICONS AND FRESCOES
cover the walls of Orthodox
churches from floor to ceiling.
In a glow of colors, of silver
and gold, the bent figures of
saints, the Madonnas with
piercing eyes, envelop the
worshipers. Perhaps the love
of a certain clutter stems from
this: paintings hung row upon
row in living rooms, objects
clustered on shelves and in
vitrines, big photographs of
the parents prominently
displayed.

LEFT: ZAGORSK, 1988
Sunday-morning mass in the
Cathedral of the Assumption
at the Zagorsk Monastery. An
important religious center
from the fourteenth century,
its celebrated icons, its blue-
and-golden-domed churches,
its miracle-working well, and
the splendor of its services
continue to attract thousands
of sightseers and worshipers,
many of whom have their
children baptized here.

RIGHT: ALAVERDI, 1967
In contrast, the eleventh-
century church in Alaverdi is
falling down. Still, the faithful
came to light candles in front
of a stamped-out Christ in the
center of the huge nave held
up by scaffolding.

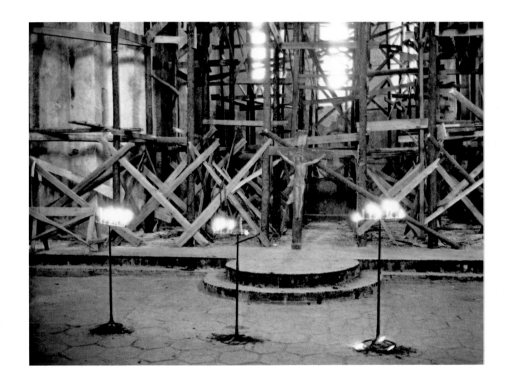

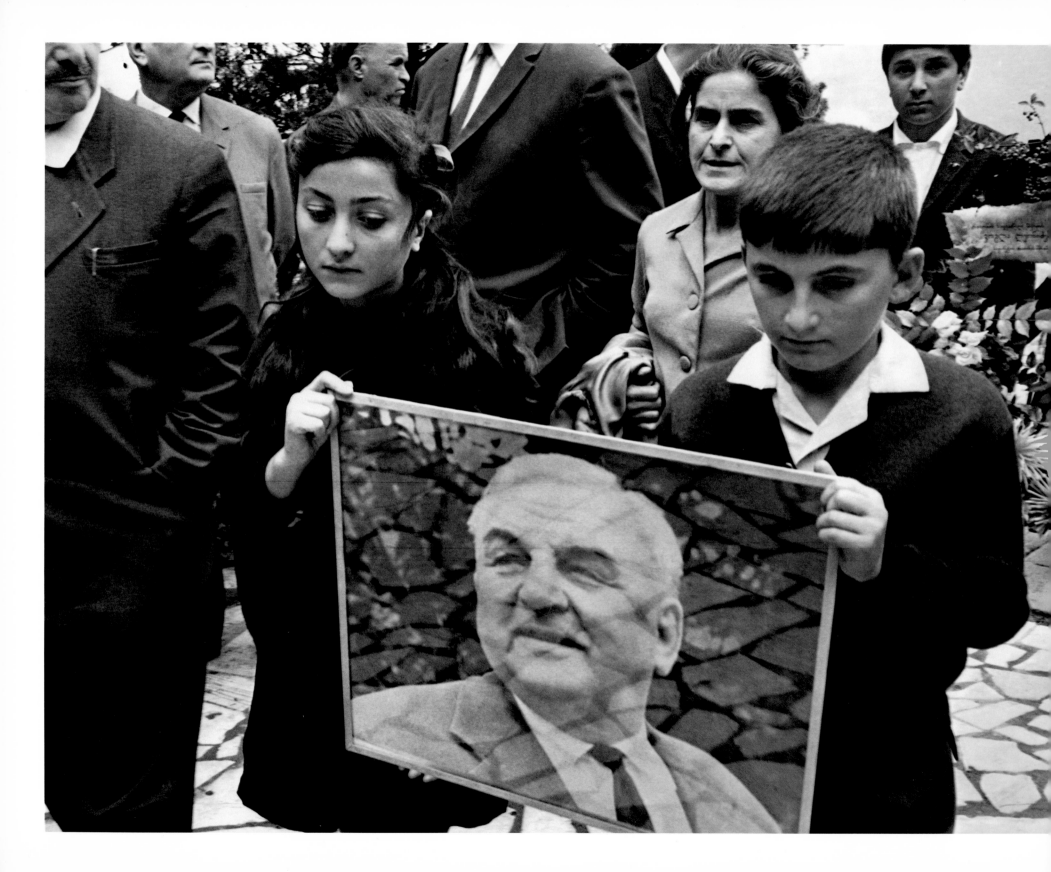

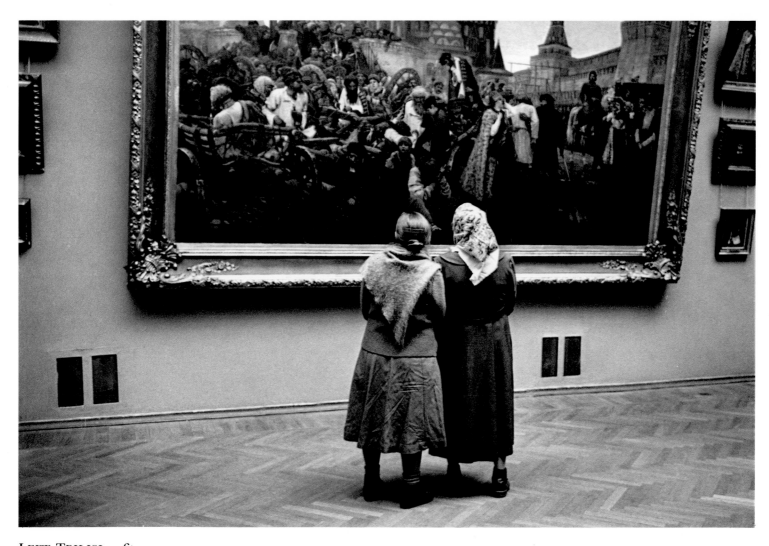

LEFT: TBILISI, 1967
At a memorial service for
the Georgian poet Georgi
Leonidze, solemn teenagers
display a portrait while his
poetry is read over the
loudspeaker.

ABOVE: MOSCOW, 1965
The large nineteenth-century
historical paintings in the
Tretyakov Gallery are espe-
cially popular with Russian
visitors.

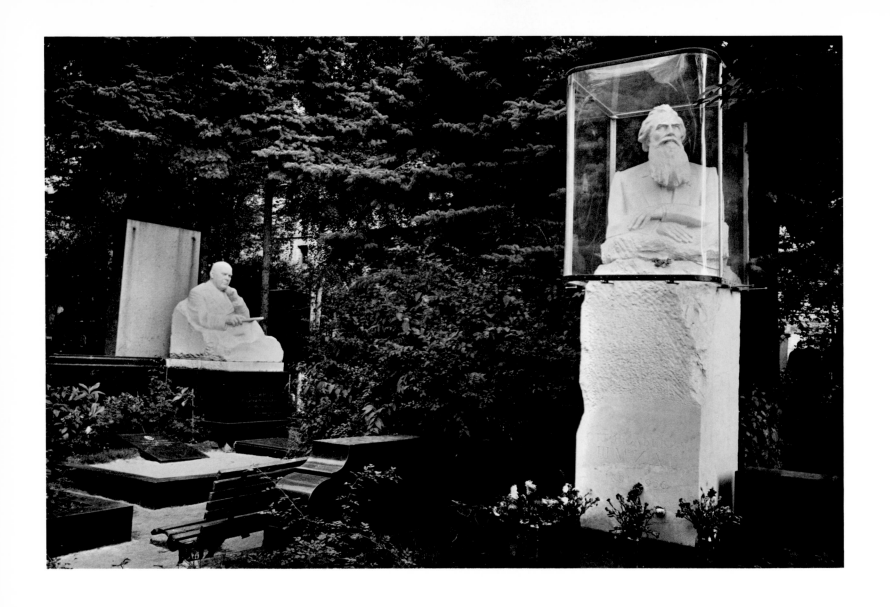

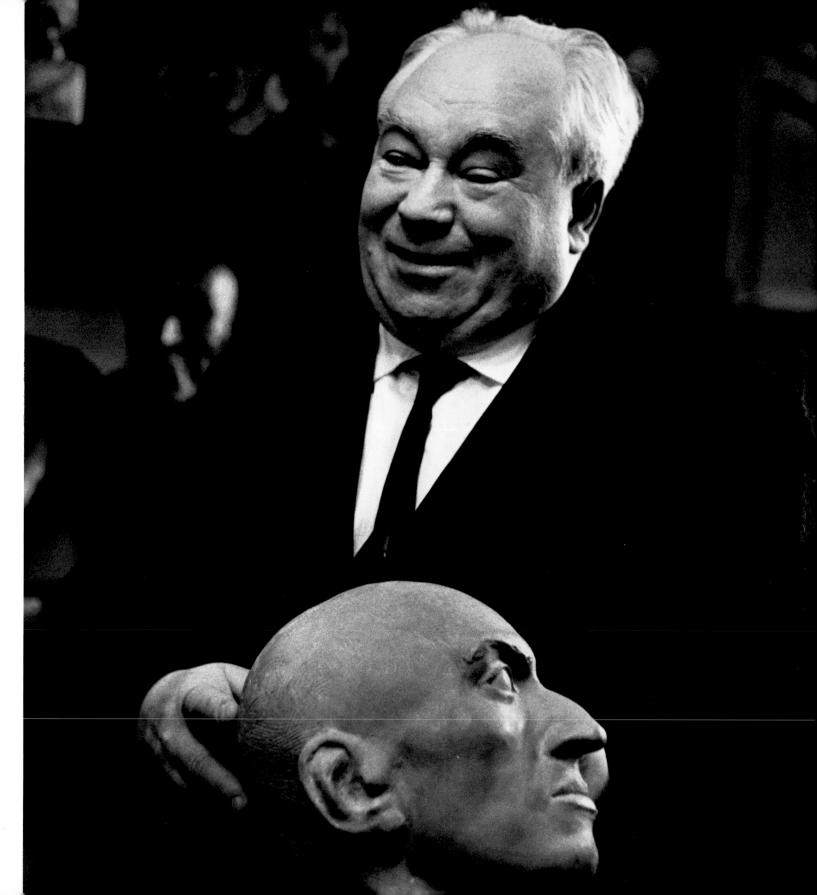

LEFT: MOSCOW, 1967
Tombs in Novodevichy Cemetery marked by life-size busts of Arctic explorer Lieutenant Schmidt and army general Zakharov. Many of Moscow's famous citizens are buried here, including Chekhov, Scriabin, Prokofiev, and Ehrenburg.

RIGHT: MOSCOW, 1965
Anthropologist and sculptor Professor Mikhail Gerasimov excavated old tombs for the bones of historical figures. Here, he holds one of his most prized creations, the reconstructed head of the German poet and dramatist Friedrich von Schiller.

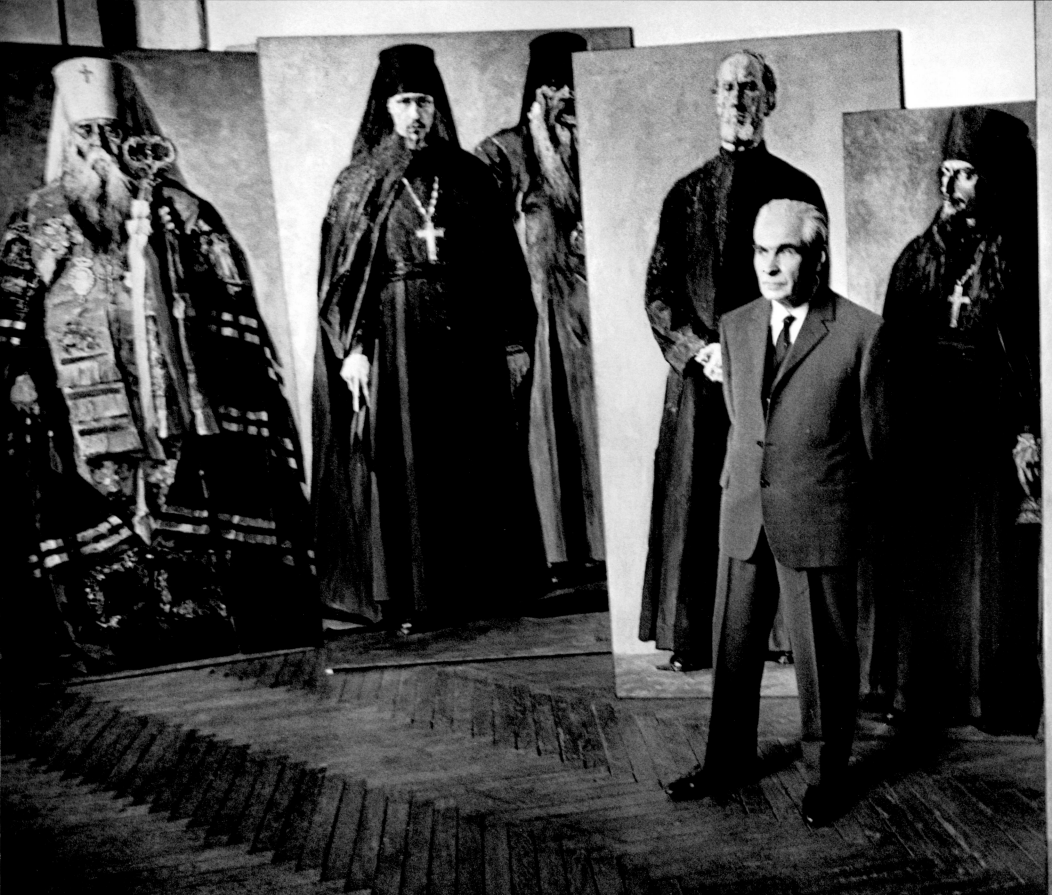

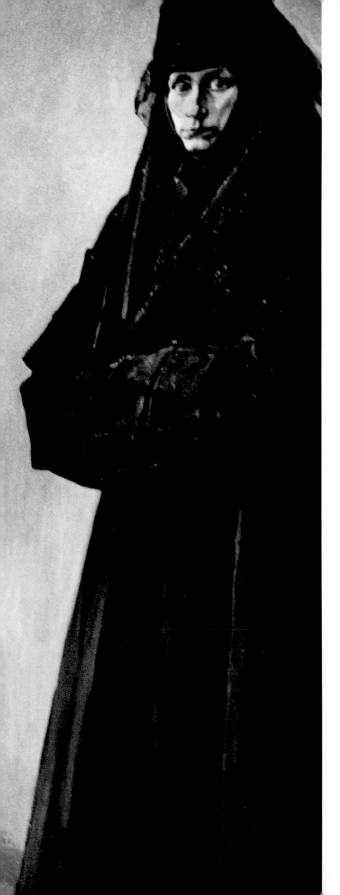

LEFT: MOSCOW, 1965
Pavel Korin painted heroic
portrait studies of eminent
religious figures for his monu-
mental ensemble commemo-
rating the past. He stands
among them, awaiting the
government commission's
final approval before sending
them off to the first show of
contemporary Soviet art in
the United States.

RIGHT: MOSCOW, 1989
Mikhail Bulgakov wrote *The
Master and Margarita* in the
thirties, but it remained
unpublished in Russia until
1967. Bulgakov is now a cult
figure; his young followers
painted this graffito to his
memory at the entrance of his
former residence, where they
often congregate on the
staircase, smoking almost
anything.

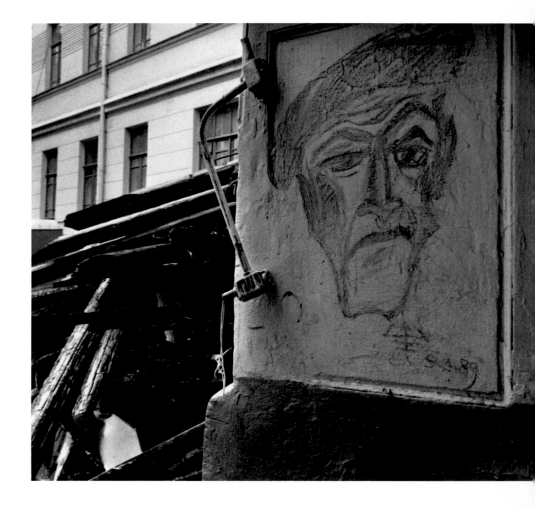

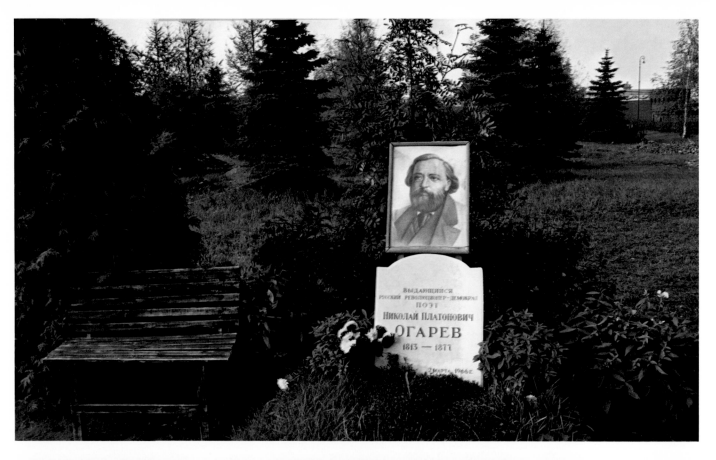

**LEFT: MOSCOW, 1967**
A bench next to the tomb of writer Nikolai Platonovich Ogarev provides a place for quiet contemplation in Novo-devichy Cemetery. Even Stalin is said to have sat here on a marble bench at the tomb of his wife, Nadezhda Alliluyeva.

**BELOW: SAMARKAND, 1967**
Faded portraits of political leaders guard a path in Samarkand's Park of Rest and Culture.

**RIGHT: LENINGRAD, 1989**
The daily routine of Lenin-graders continues under the penetrating gaze of Dosto-yevski. Here on Kuznechni Street, he wrote *The Brothers Karamazov* in his last house, which is now the Dostoyevski Museum.

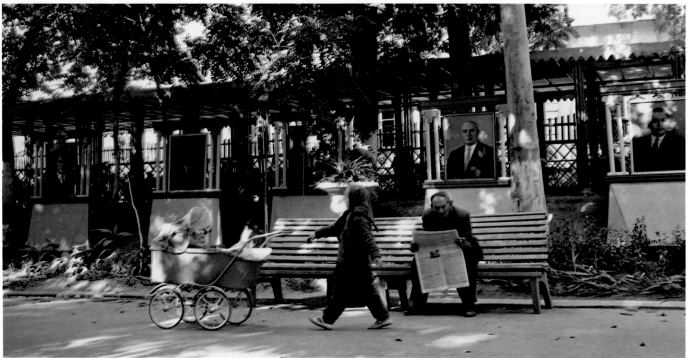

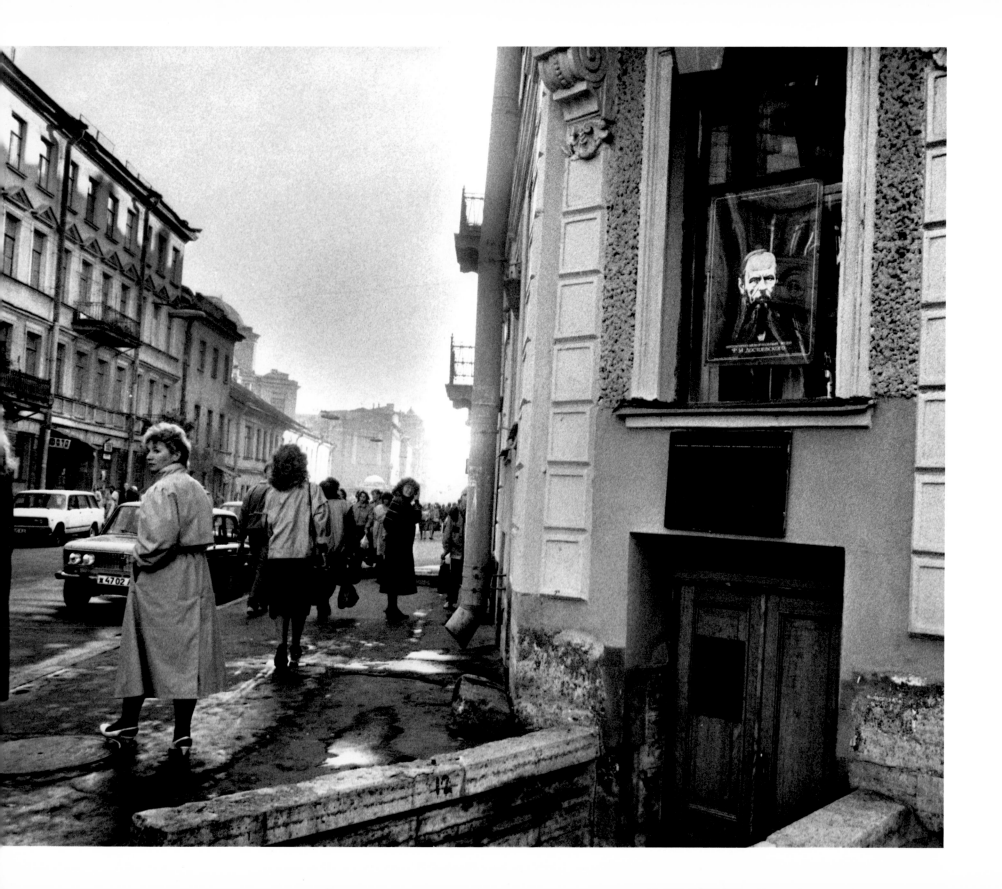

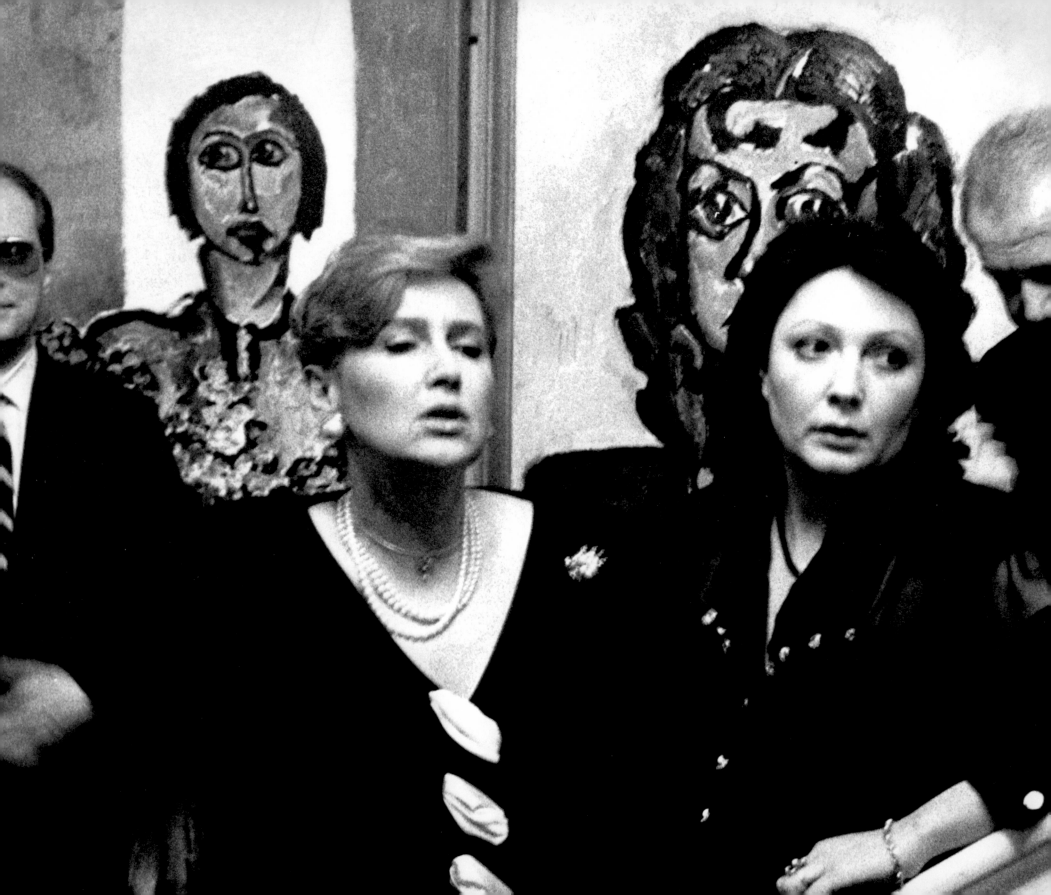

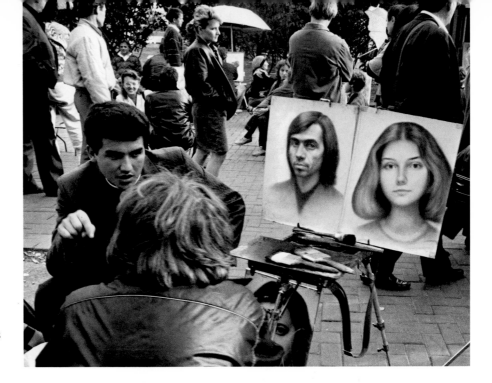

**LEFT: MOSCOW, 1990**
An elegant party at the home of Georgian painter Zorab Tseretelli, where his paintings line the walls from floor to ceiling.

**ABOVE: MOSCOW, 1989**
The Old Arbat, once favored by artists and intellectuals for its mix of bohemia and squalor, has been refurbished with pedestrian zones and art galleries. Fifty or sixty painters have set up shop; it's the rage to go and have your portrait done in an idealized way.

**RIGHT: MOSCOW, 1989**
In the New Tretyakov Gallery, an exhibit of art collected by influential Moscow women, along with their portraits by favorite artists, baffles some of the visitors who have just recently been exposed to contemporary painting.

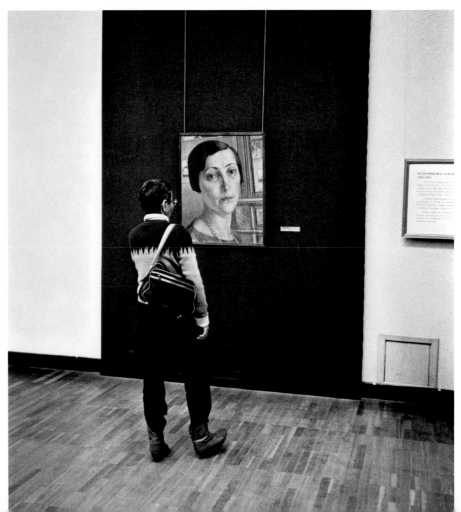

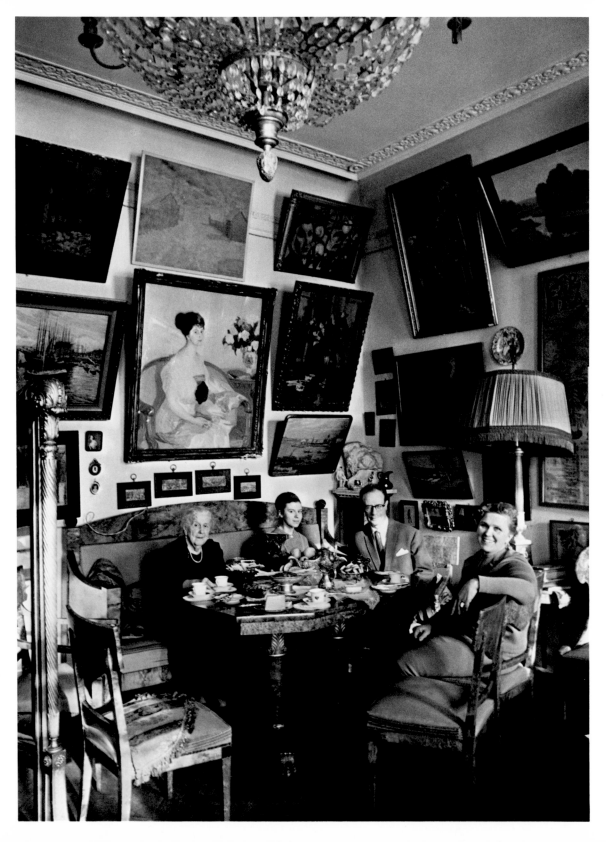

**LEFT: MOSCOW, 1965**

Mme. Sobinov, widow of a famed tenor, sits below her portrait as a young woman; her granddaughter at her side resembles the girl in the painting almost perfectly. In this interior from a prerevolutionary world, nothing has changed.

**RIGHT: MOSCOW, 1989**

Arcadi Wainer, a former police official, became a successful detective-story writer working with his brother Georgi. Personal icons include the large portrait of his father over the door and the equally large portrait of himself to the left. He is very popular; one of his novels, *The Black Cat*, was made into a movie starring Vladimir Visotsky.

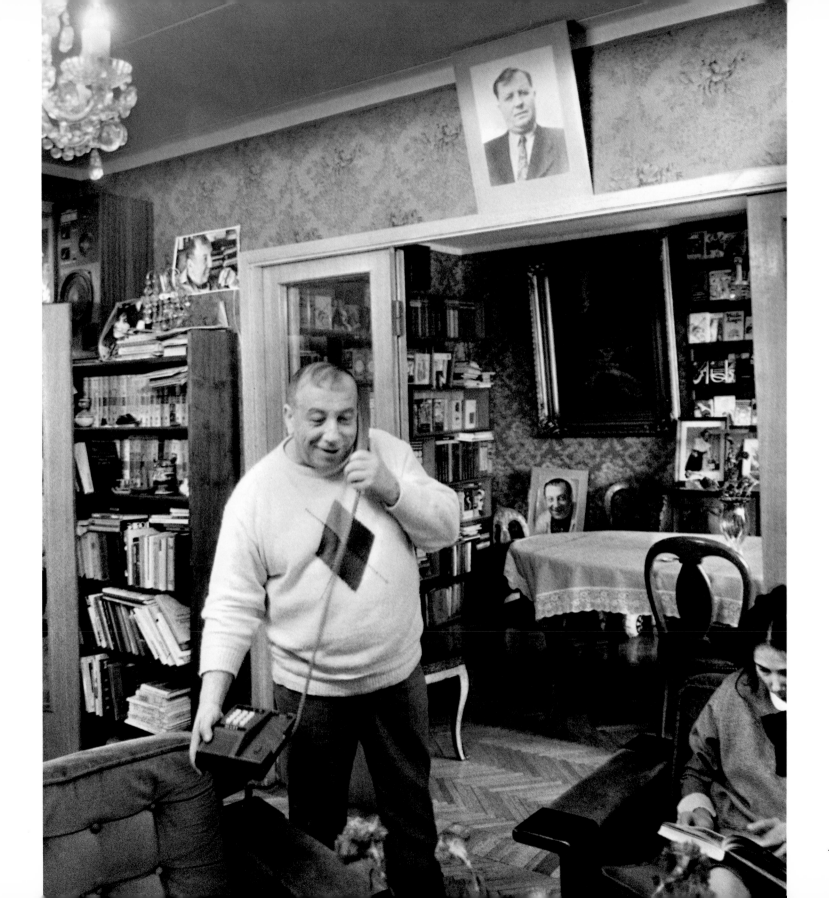

47

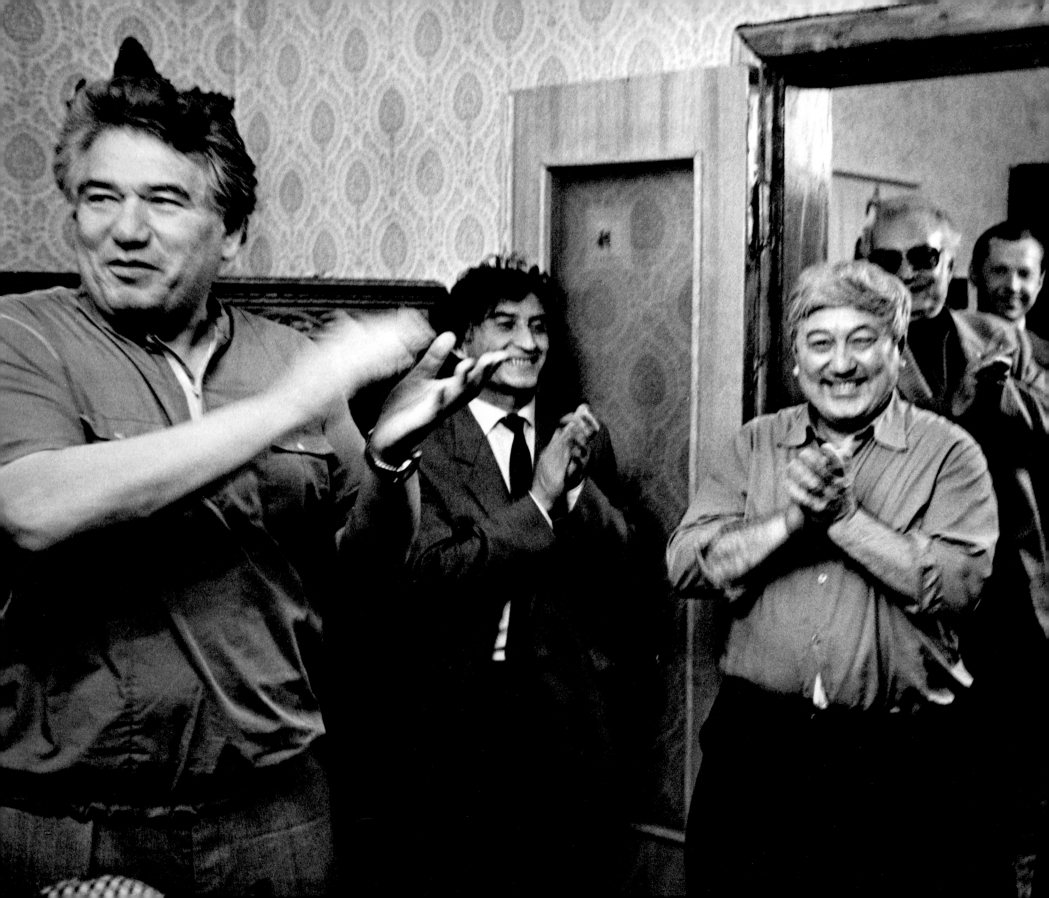

# THE FESTIVE SPIRIT

RUSSIAN HOSPITALITY is vast and genuine. There is no house in which you can sit down without being offered food or drink, even in the hardest of times. Something has always been put away for a special occasion, and there is joy in sharing it. There is a generosity that gives boiled potatoes served in a special bowl the same festive importance as a dish of caviar.

LEFT: FRUNZE, 1986
Chingiz Aitmatov, author of *The Day Lasts Longer Than a Hundred Years*, and his guests applaud the chef after a splendid Kirghizian dinner of spicy vegetables, richly sauced meats, platters of rice, and mountains of sweets. In the old tradition, the chef returns the applause.

RIGHT: MOSCOW, 1990
The table is set for a party. Should yet another guest arrive, another plate will somehow be squeezed onto the groaning table.

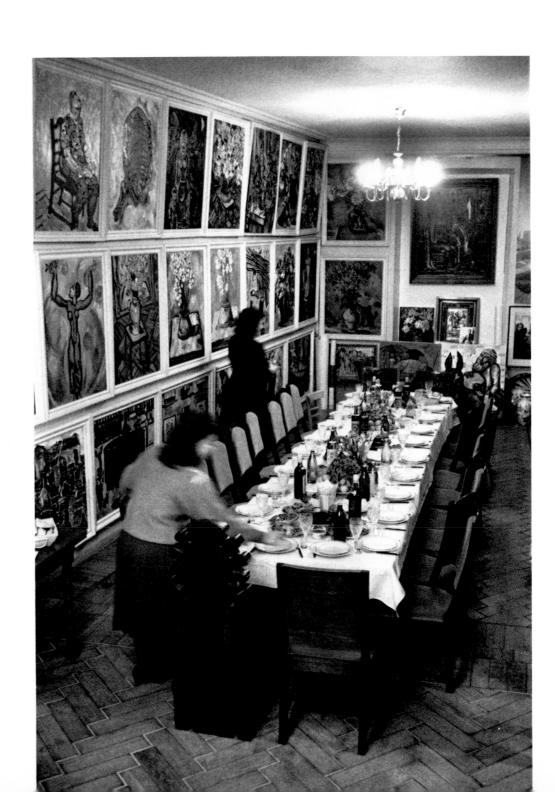

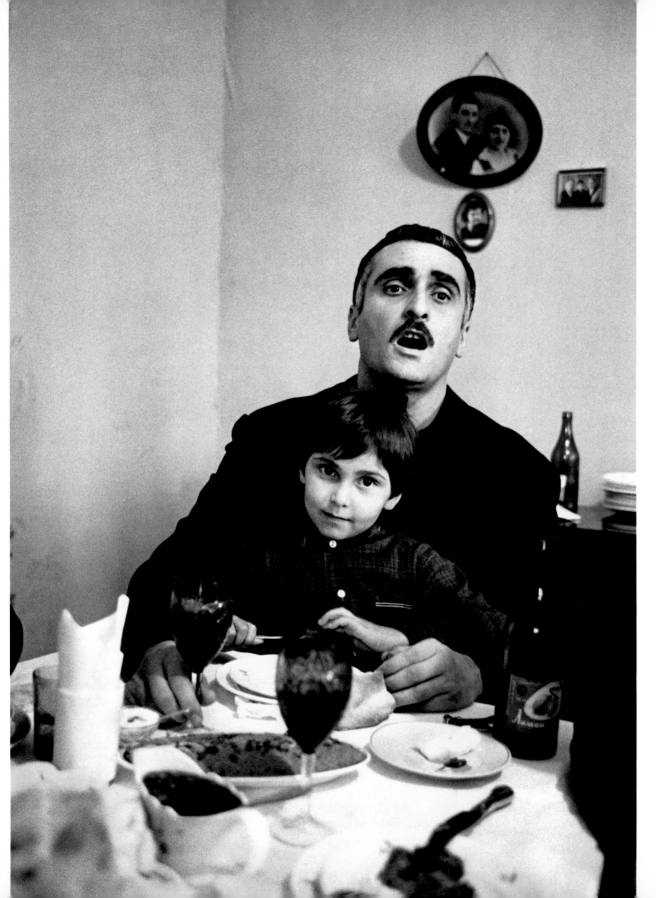

LEFT: MTSKHET, 1967
At a feast of what seemed like hundreds of dishes, with lemonade and local wine served in drinking horns, when at last nobody can eat any more, a member of the family breaks into a long ballad to honor the guests and to celebrate Georgia.

RIGHT: MOSCOW, 1986
Tea and an abundant selection of desserts are served for an afternoon reception at the Writers' Union in Moscow, in a wood-paneled room described by Leo Tolstoy in his novel *War and Peace* as the place where Count Pierre Bezukov was inducted into the Masonic Order.

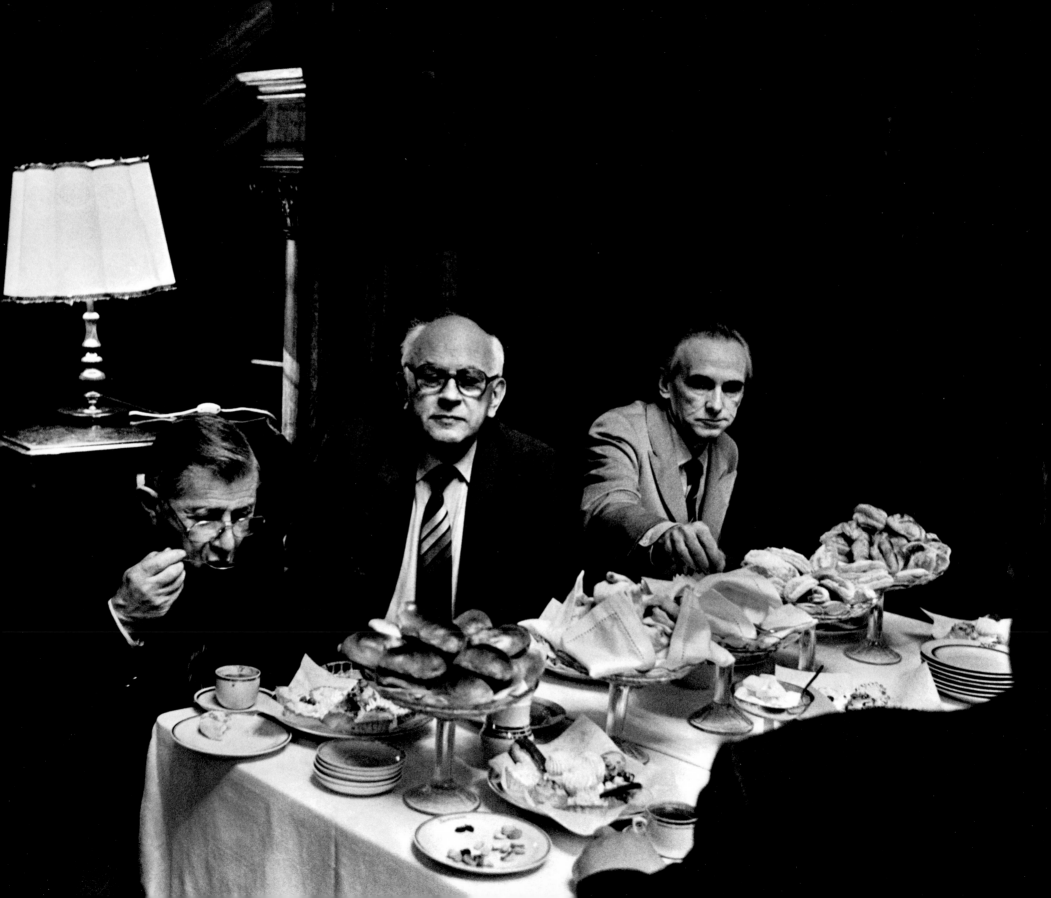

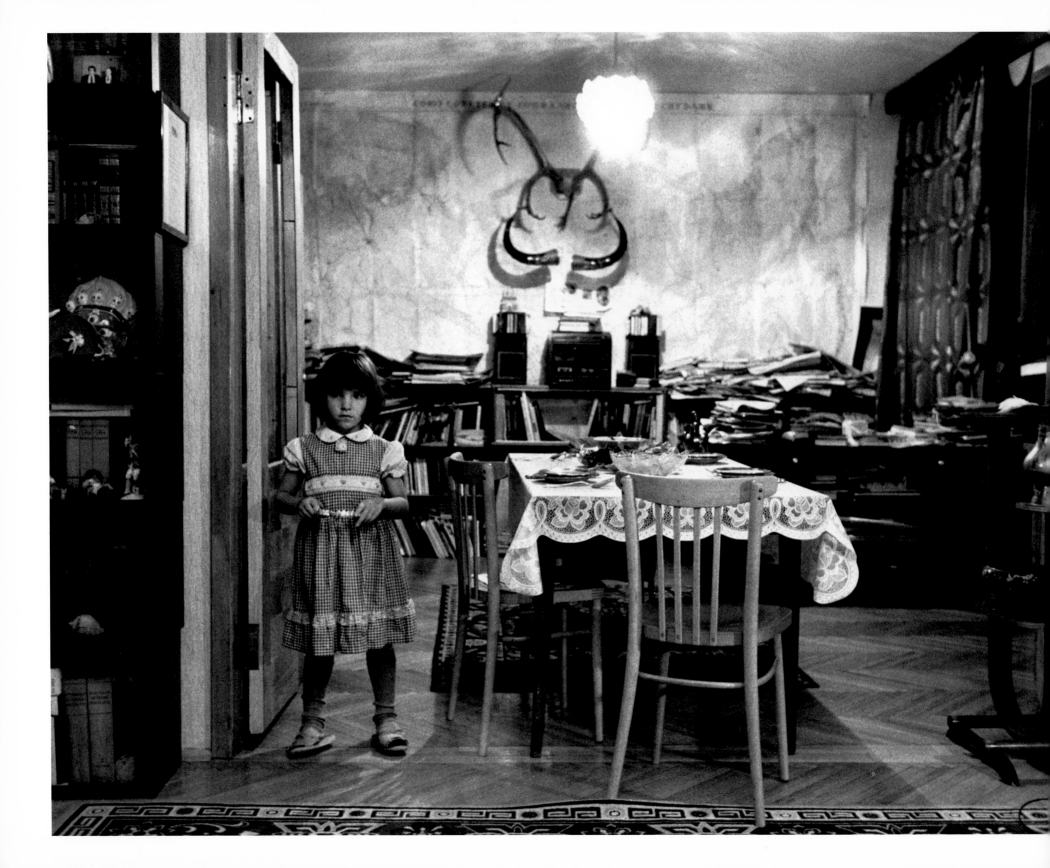

LEFT: MOSCOW, 1989
In the crowded studio of economist Vladimir Kvint, the table is set with lace and the best china; the young daughter eagerly awaits the guests, for whom she and her sister will later perform as gymnast and pianist.

RIGHT: MOSCOW, 1967
Midmorning in the one-room Moscow studio of Lydia Brodskaya, comfortably jammed with books, paintings, and souvenirs. A Russian who recently saw this picture said, "When was this taken? It must have been a long time ago; you can't catch delicacies like that anymore."

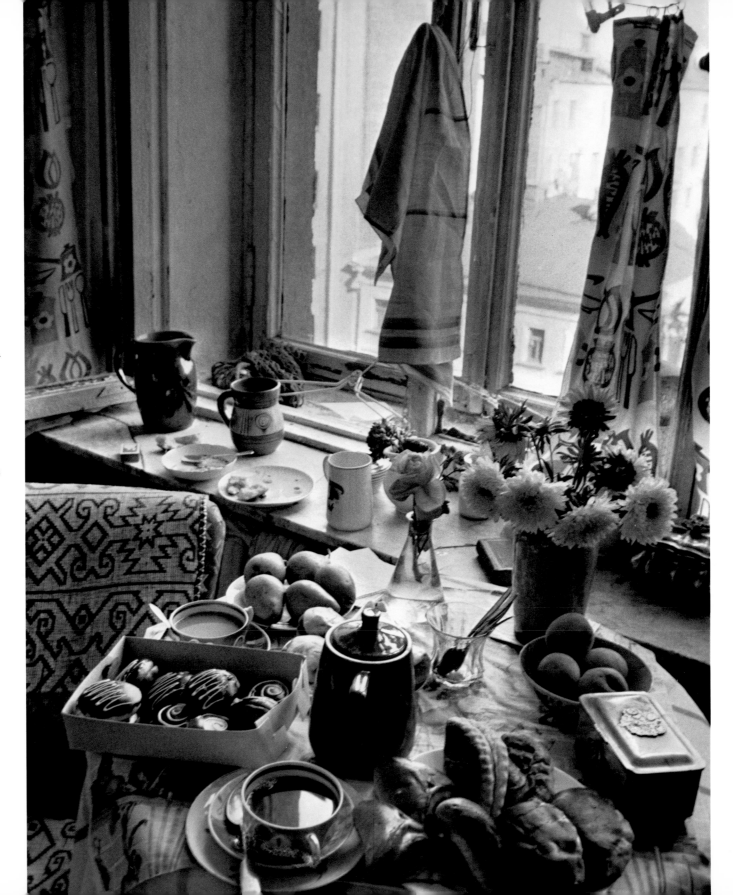

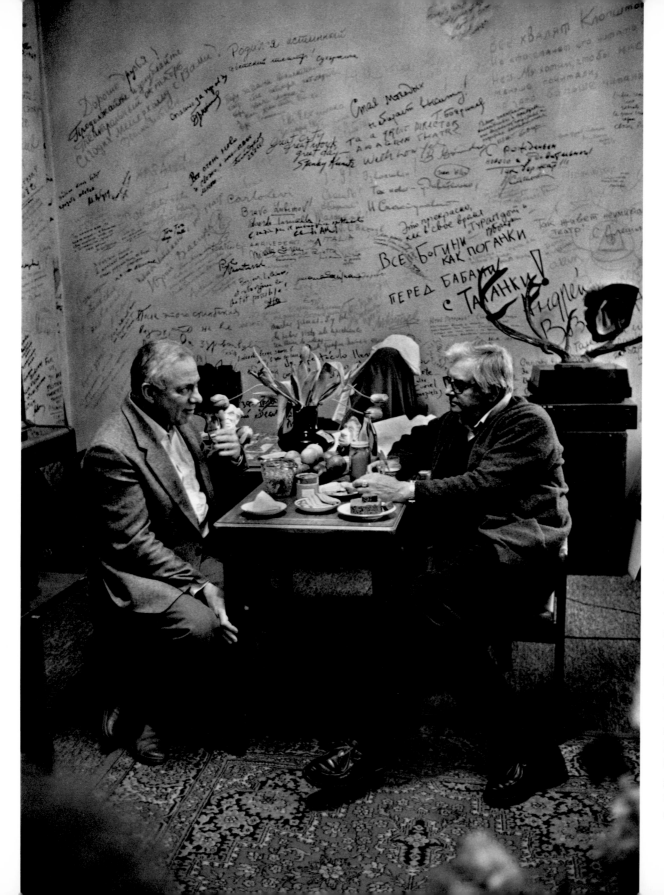

LEFT: MOSCOW, 1989
Yuri Lyubimov directed politically daring plays at the Taganka Theater; for this, he was banished during the Brezhnev regime. He led a successful professional life in the West and was invited by Gorbachev to return. Back in his old office, nothing has changed: the antler hat rack, the walls tattooed with hundreds of signatures of famous visitors. He is having a working sandwich with Nicolai Karetnikov, composer of the music for John Reed's play, *Ten Days that Shook the World.*

RIGHT: PEREDELKINO, 1990
It had been a festive day, the long-fought-for official celebration of Boris Pasternak's centennial and the dedication of his house as a museum. But the cold dampness went straight to our bones. "Come to my house and eat something," suggested Yevgeny Yevtushenko on the spur of the moment. We had hardly settled around the big table, under walls hung with modern paintings and souvenirs from trips abroad, when his wife, Masha, about to give birth to their second child, appeared with platters of homemade dishes. Wine from Georgia was poured into goblets of Siberian jade for toasts to Pasternak, to poetry, and to friendship.

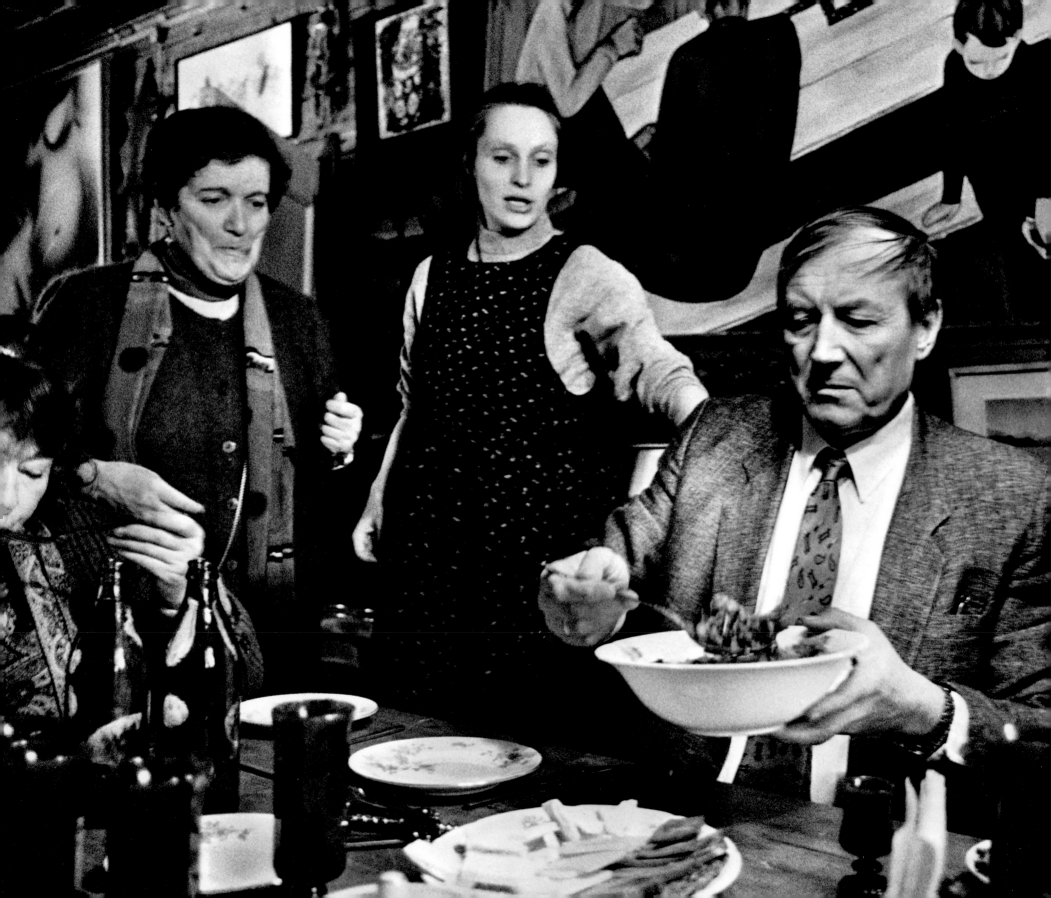

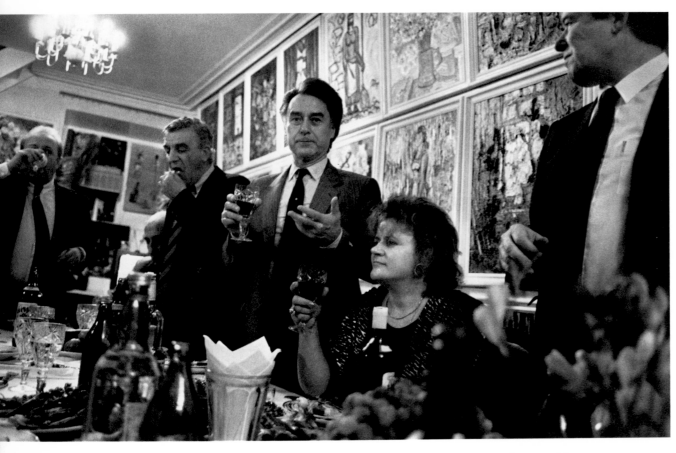

ABOVE: MOSCOW, 1990
A toast to the ladies.

RIGHT: MOSCOW, 1988
At the opening of my photography exhibit at Moscow's Union of Photojournalists, a troupe of young actors burst into the room, set up a few simple props, and performed *The Dog's Heart*, by Mikhail Bulgakov. The spirit of the new Russia is in the faces of these young Moscow actors looking for a theater but performing when and where they can.

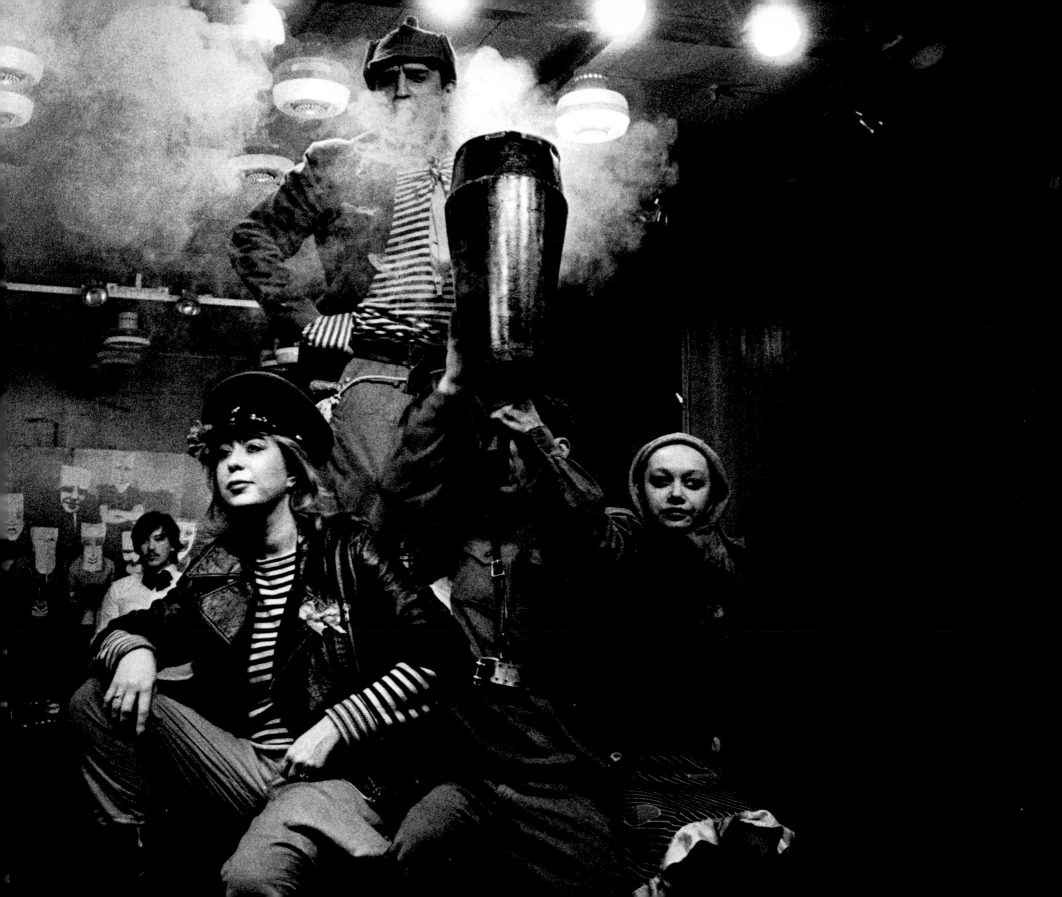

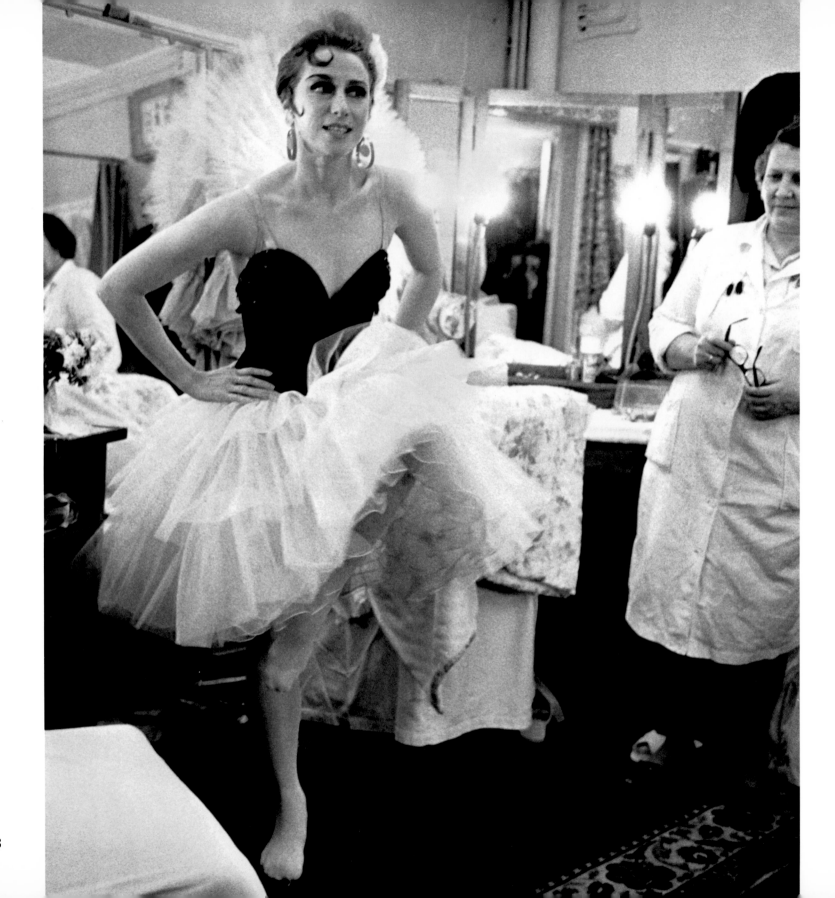

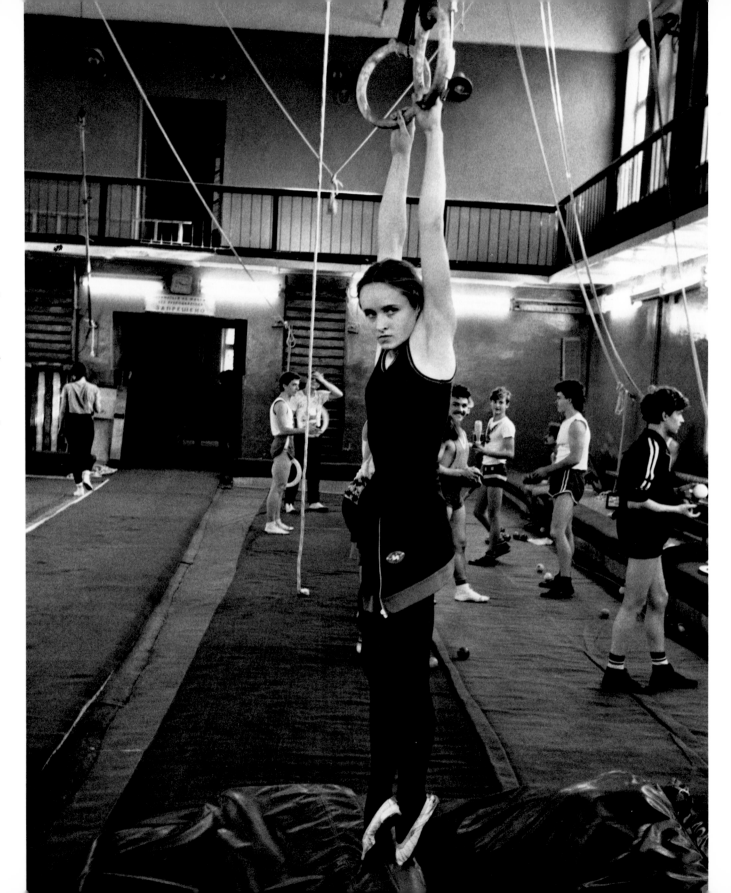

LEFT: MOSCOW, 1967

Like a thoroughbred, phenom-
enally beautiful and strong,
always in motion, subtly
turning her shoulders and
neck, pointing her toes, the
*prima ballerina assoluta* Maya
Plisetskaya receives us in her
loge just before going onstage.

RIGHT: MOSCOW, 1989

To become a circus performer
is regarded as a great achieve-
ment in Russia. At the
Moscow Circus School, a
serious young acrobat works
out on the rings as part of her
eight-hour training day.

59

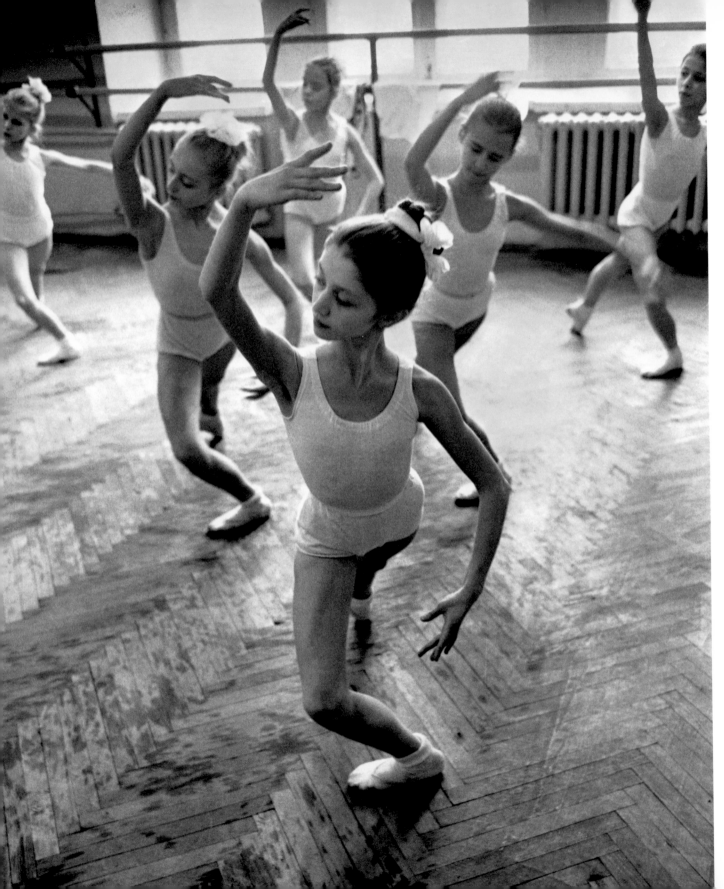

LENINGRAD, 1965
At the Leningrad State Ballet
School, dancers begin train-
ing as children: lean, with
long arms and legs, large
serious eyes. The older girls
wear wispy tunics reminiscent
of Isadora Duncan. They are
graceful, with curving arms,
hands, and legs in that diffi-
cult but effortless-looking
balance that makes them
seem weightless.

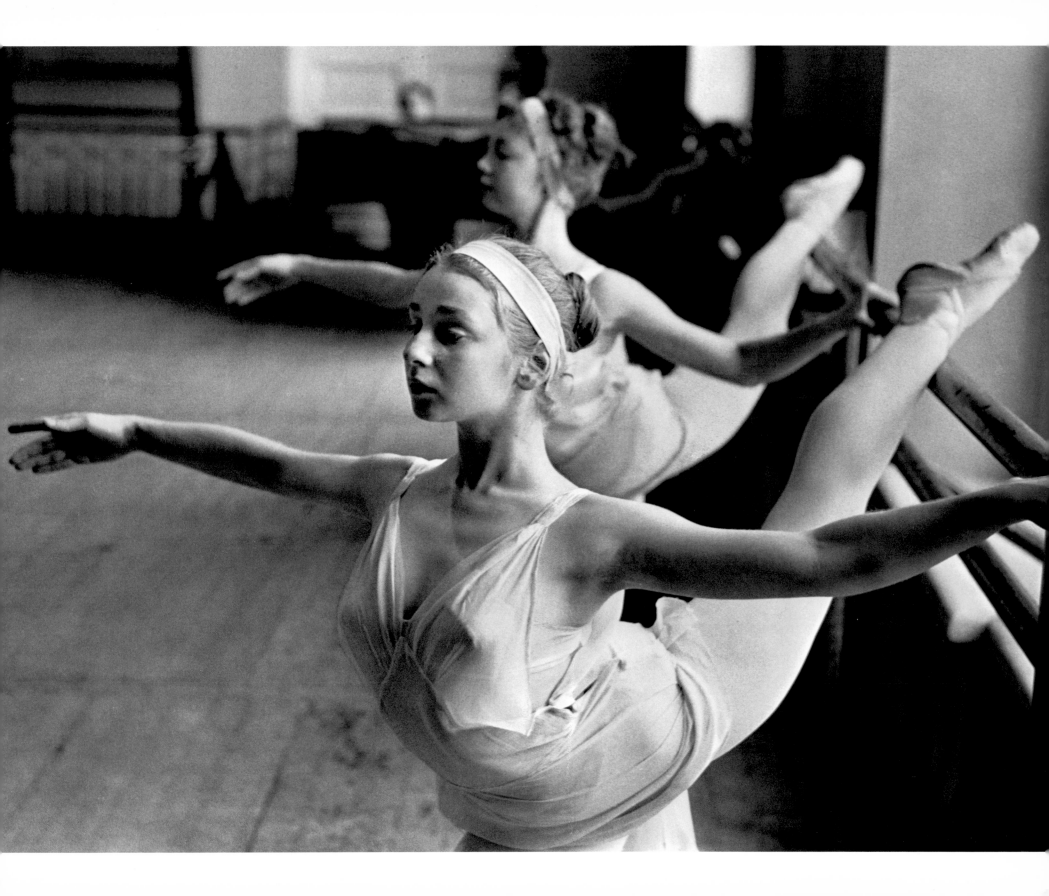

# IN THE PROVINCES

THE GOLDEN RING is a cluster of ancient capitals and trade centers in the northeastern part of central Russia. The roads are lined with painted wooden houses, with pine trees and birch groves. It is a region of lakes and fields crisscrossed by small streams. People from Moscow and Leningrad come to spend their summer holidays here, fishing, camping, picking berries and mushrooms, and visiting the relics of the past.

It is hard to get a seat on the crowded trains and planes to reach the more remote areas, such as the Black Sea, the Crimea and the republics of Georgia and Armenia; my dream of visiting Siberia has not yet materialized.

Life flows quietly in the provinces, its rhythm determined by the seasons. But the television antenna on top of any dacha that has electricity proves that they, too, are tuned into the world.

RIGHT: ROSTOV-VELIKI, 1989
On the shores of Lake Nero rise the towers of the Spaso Yakovlev Monastery, founded in the fourteenth century. Inside I find scaffolding everywhere. Seated at a rickety table behind a row of majestic columns, two bundled-up women shout that if I want to look around and photograph here, I must first buy tickets. They tear off the tickets they insist I need from yellowed rolls of perforated paper. It must be their only sale on this rainy day, so I pay and head for the first building that intrigues me. The door seems to be locked. Looking back, I see the two women doubled up with laughter. "Everything is closed for repair," they scream. "No way of getting in."

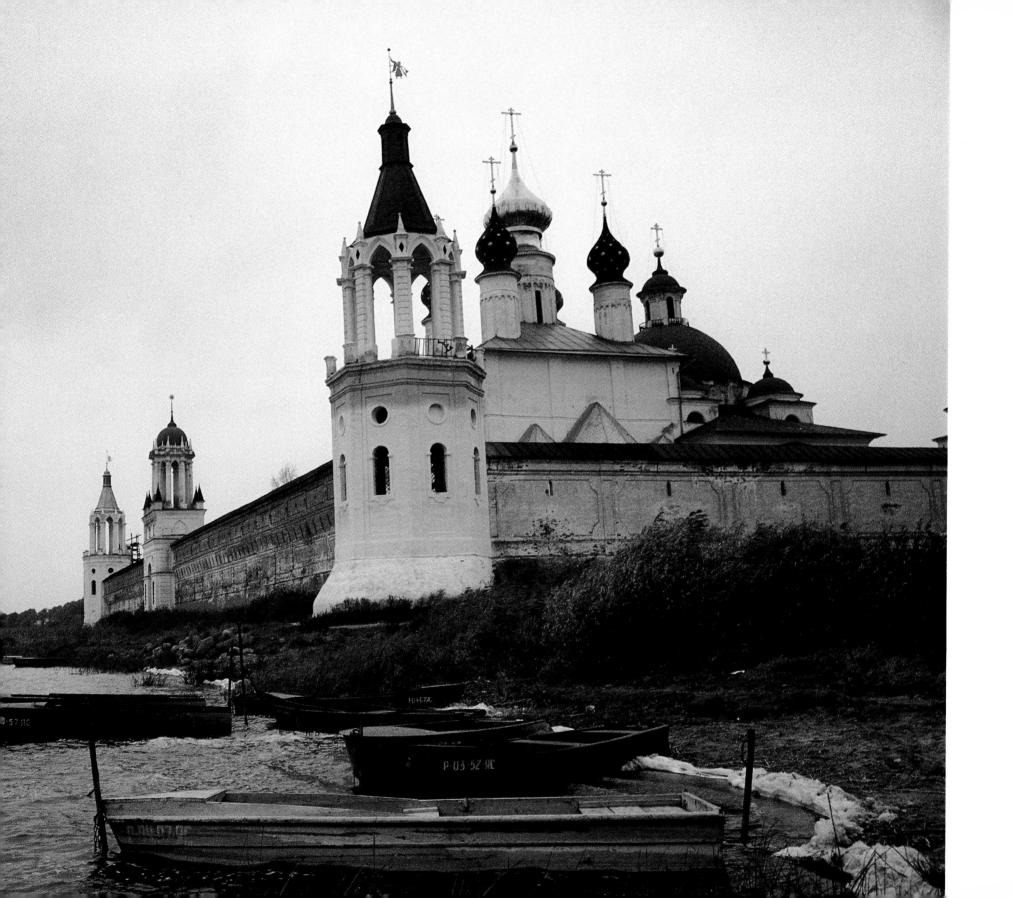

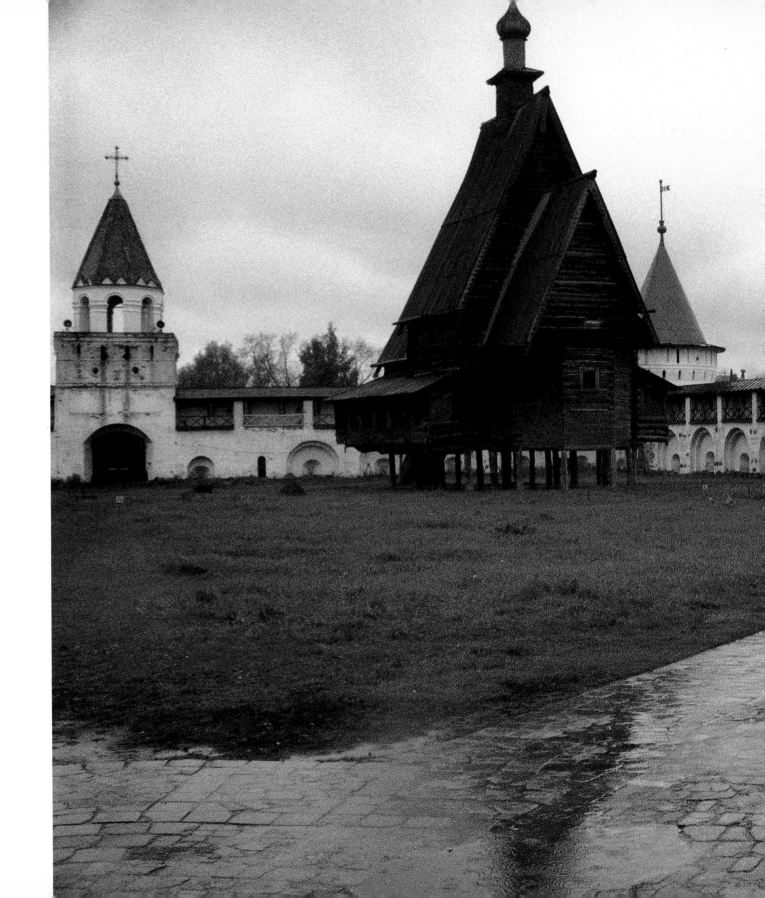

KOSTROMA, 1989

In this ancient town situated on terraces above the Volga lies the Ipatiyev Monastery. One of the great examples of old Russian architecture, it was established in 1330 by the Tartar Prince Zacharias Tchet, founder of the Godunov family, who had fled the "Golden Horde" to Moscow.

The buildings within the kremlin speak of its history: the house of the Romanov Boyars, the throne of Mikhail Fedorovich Romanov in the Cathedral of the Trinity, and a tenth-century wooden church that antedates the monastery.

LEFT: NEAR KLIN, 1967

Statues of sportive maidens, or sometimes cosmonauts, are placed along the Moscow-Leningrad Road for the enjoyment of motorists.

RIGHT: KOSTROMA, 1989

The tsars often stopped at the Ipatiyev Monastery when they traveled from Moscow to St. Petersburg.

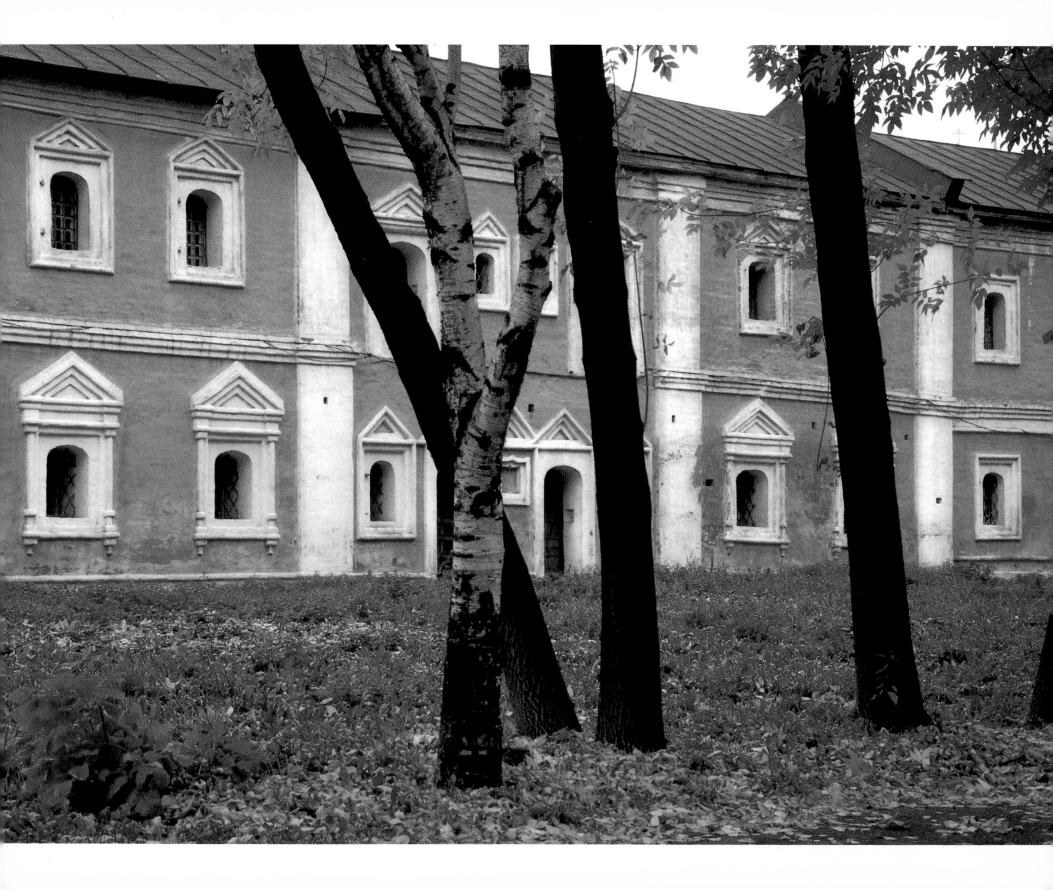

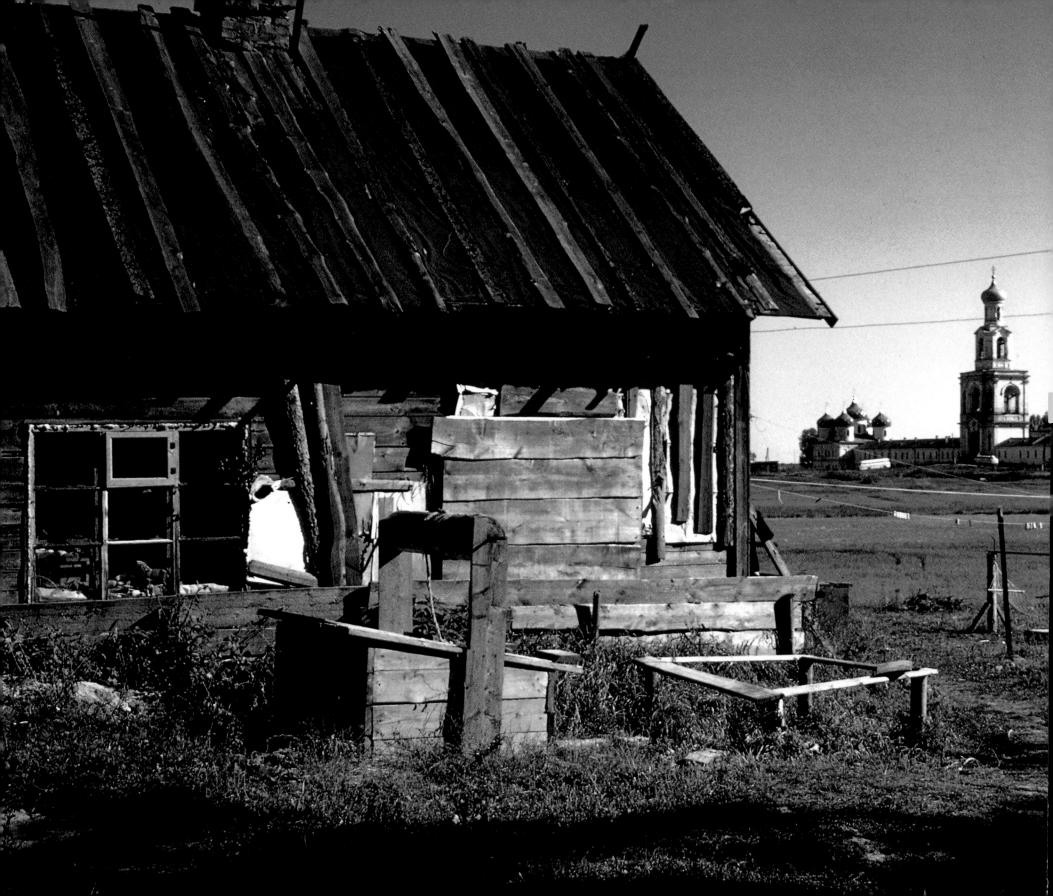

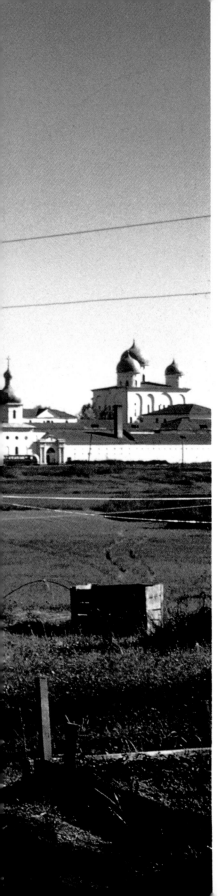

LEFT: NOVGOROD, 1967
A peasant hut faces the St. George Monastery on the west bank of the Volkhov River outside Novgorod. The first capital of Russia, founded in the ninth century, the city whose slogan once was "who can resist God and Novgorod the Great?" is now a provincial town.

RIGHT: PERESLAVL-ZALESKY, 1989
Wooden chapel inside the kremlin.

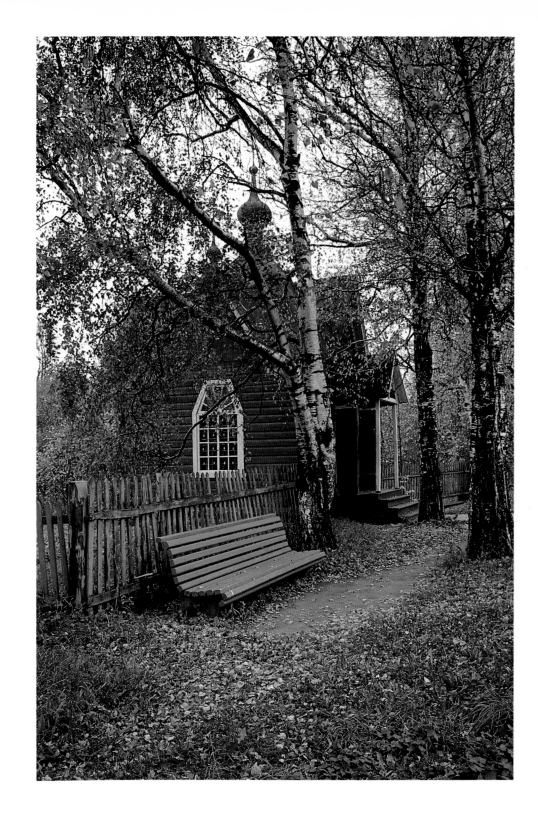

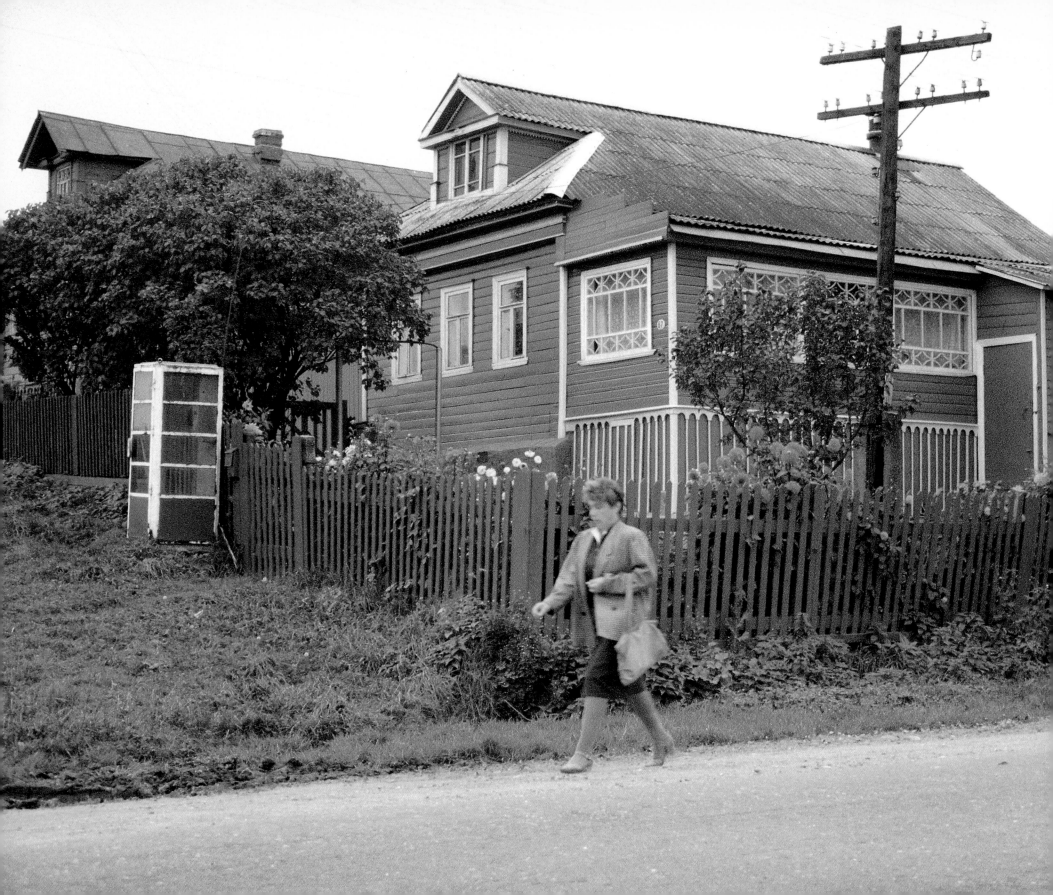

LEFT: PERESLAVL-
ZALESKY, 1989
The tradition of painting
wooden houses in lively colors
continues in the provinces.
The artistry of the fretwork
framing windows and doors
varies with the skill of the
owners.

RIGHT: LOMONOSOV, 1989
Decorative gatehouse in a
delightful park that is a favor-
ite excursion spot for Lenin-
graders.

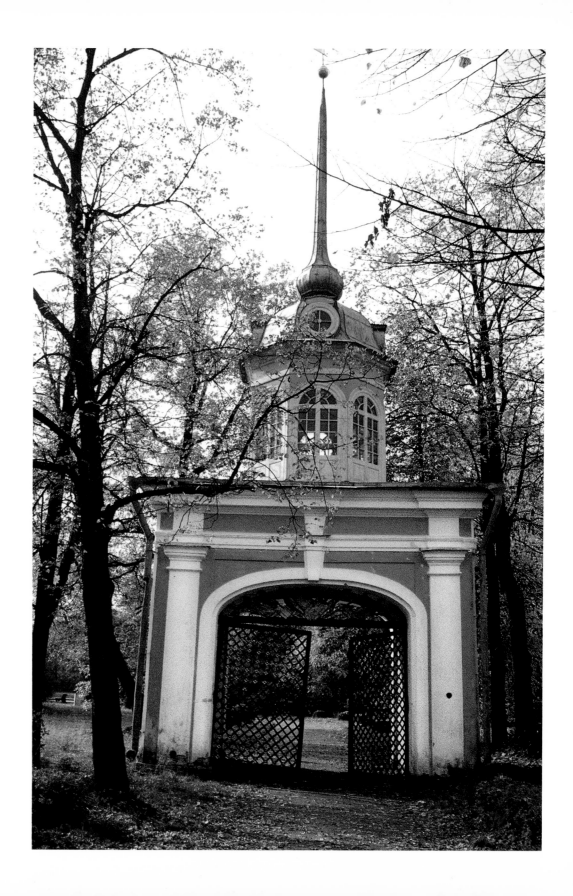

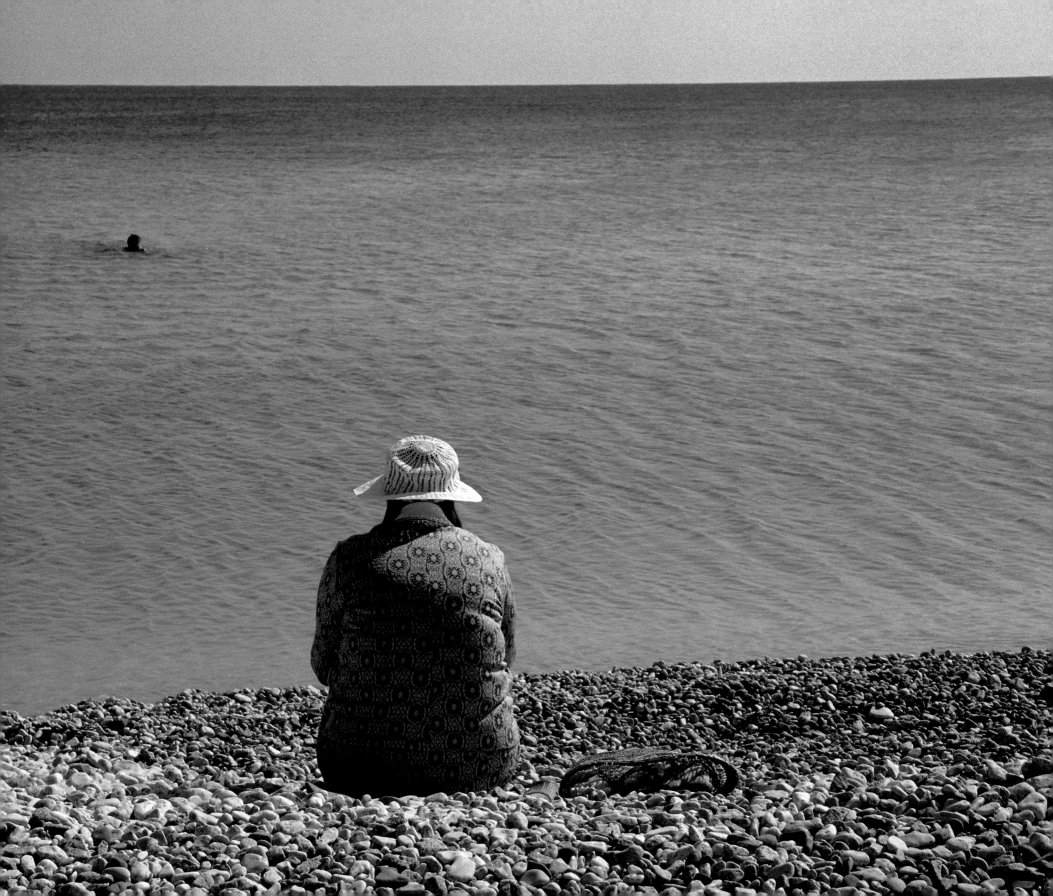

LEFT: KOKTEBEL, 1989
On the shore of the Black Sea, a resident of a writers' rest home enjoys the beauty.

RIGHT: NEAR KOSTROMA, 1989
Gennady Anchiforov, my traveling companion from Progress Publishers, drives off the road and parks in a grove so we can have a picnic. He eats a sandwich and says, "Excuse me for a moment." He disappears into the woods, plastic bucket in hand.

I finish my bread, walk around in the nearby woods, and find a huge mushroom, which I carefully cut up and place on the hood of the car.

Time passes. Where exactly are we? Once in a while a car rushes by. Mr. Anchiforov has the car keys and my passport. My feet are wet. It is freezing. Shall I hail a car and ask to be taken back to Moscow? But without a passport, I don't exist. I call into the woods. Nothing.

Two hours later, he shows up, pleased with his bucketful of mushrooms. He later confesses that he doesn't enjoy eating mushrooms, he only likes to pick them.

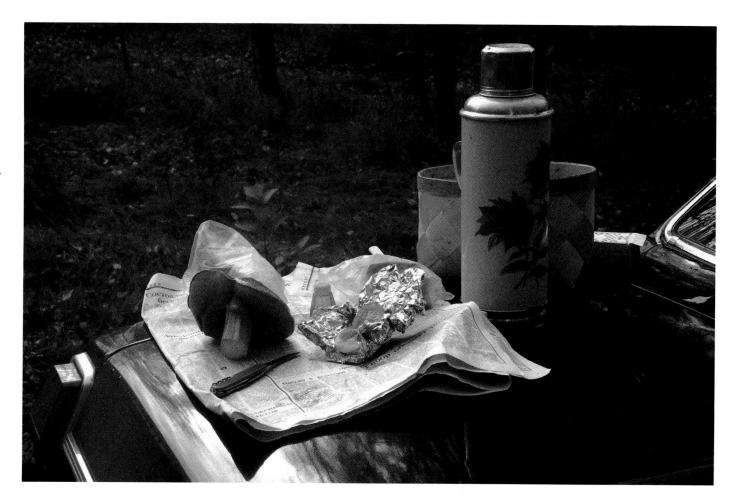

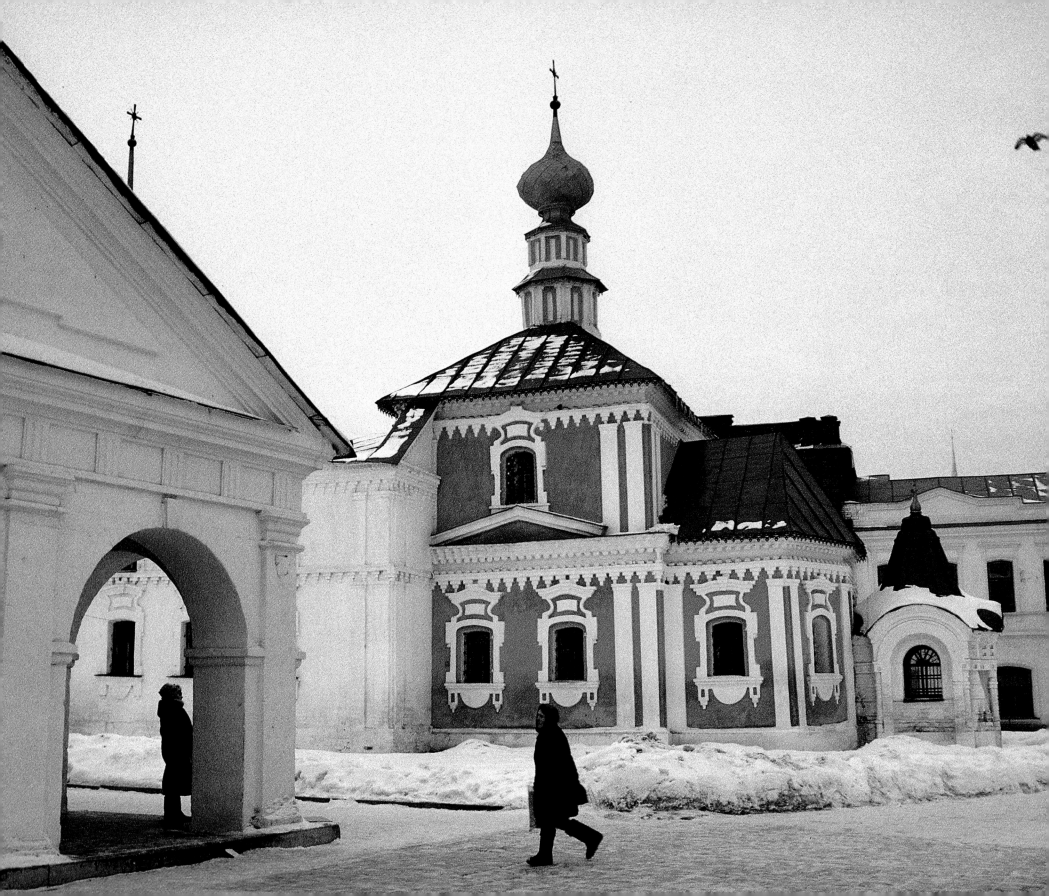

LEFT: SUZDAL, 1988

Suzdal is like a jewel box studded with exquisite treasures. The large churches are used in summer, the small ones in winter. Noble ladies, sent to the monasteries by husbands or fathers, brought their maids, who sewed earrings all over their gowns so that the jangling would frighten away ghosts in the lonely halls.

RIGHT: ZAGORSK, 1988

Inside the ornate chapel is a well with miracle-working water spouting from a black cross. These two women have waited in line and now pack their plastic bottles, talking about illnesses and new hopes attached to the treasured holy water.

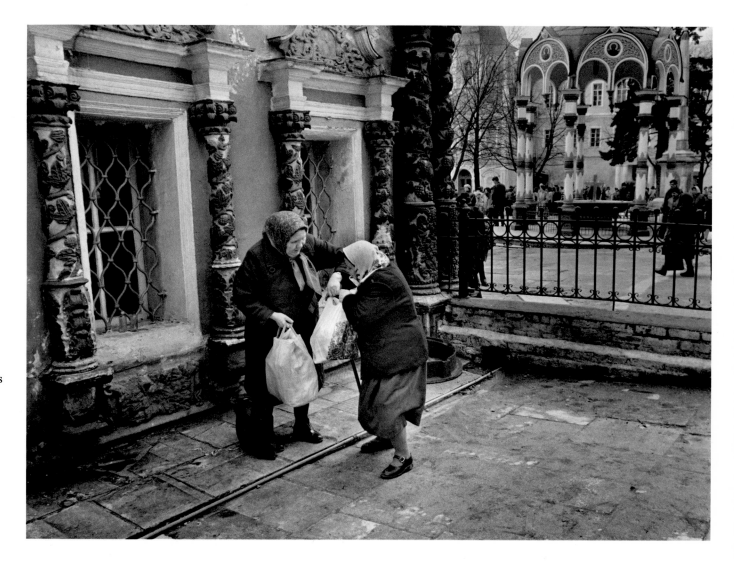

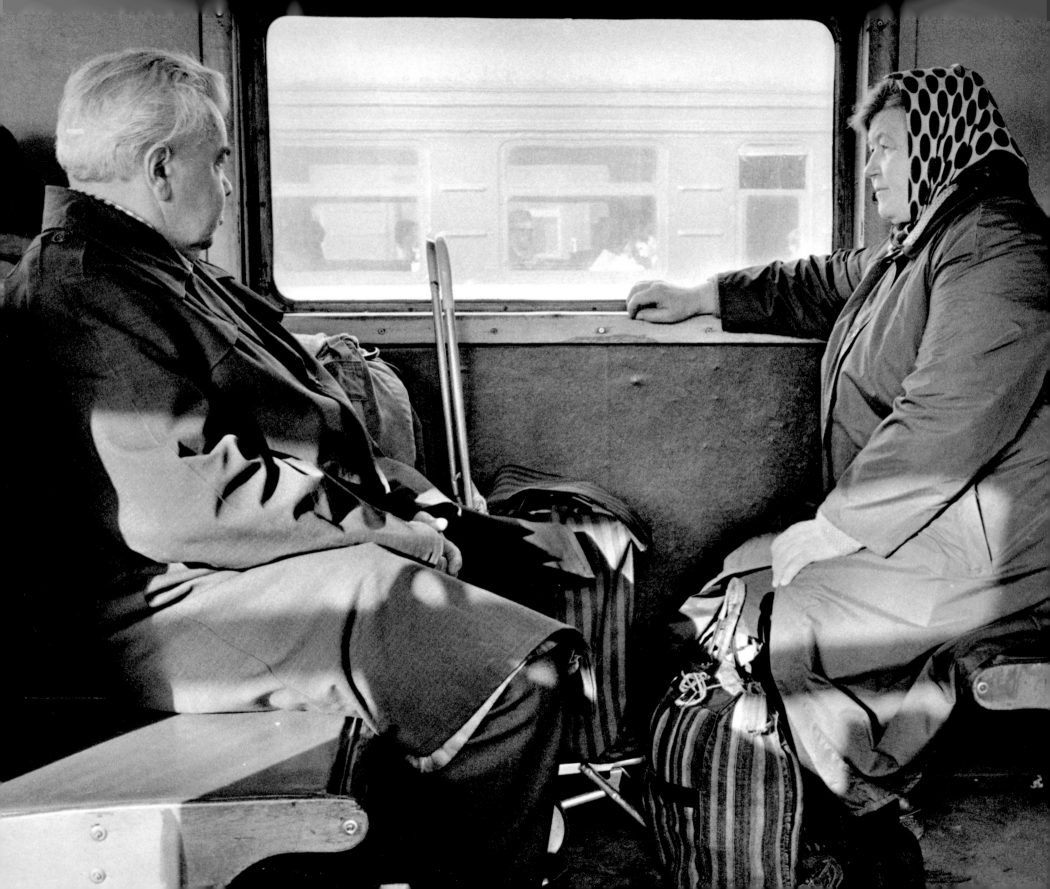

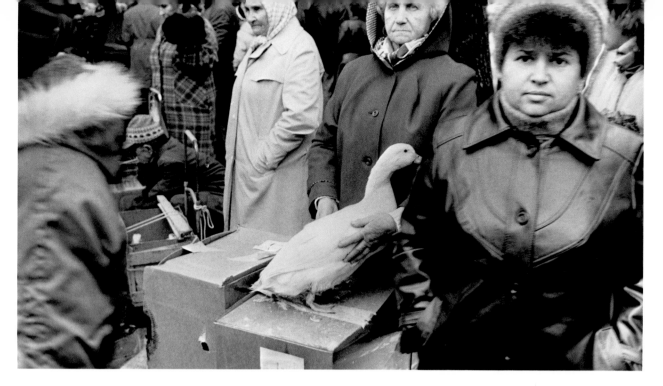

FAR LEFT: LOMONOSOV-
LENINGRAD TRAIN, 1989
This could be anywhere in
the provinces. A couple return
from the country, bags loaded
with whatever they have
managed to grow on their
small plots. Some of it may
find its way to the private
market, but the pride of the
housewife is the gleaming row
of pickled stuff awaiting a
festive occasion to be brought
out of the larder.

ABOVE: MOSCOW, 1989
People come to Moscow's bird
market every Sunday to sell
their animals, holding on to
cats, dogs, hamsters, and
birds as though a moment's
separation would break their
hearts. This woman has only
a duck. "Her name is Pasha,"
she says. "Come here, dear,
stroke her, you will see how
nice she is. You will want to
buy her."

LEFT: MOSCOW, 1967
At the Central Market, the
choice of just the right mush-
room can be agonizing.

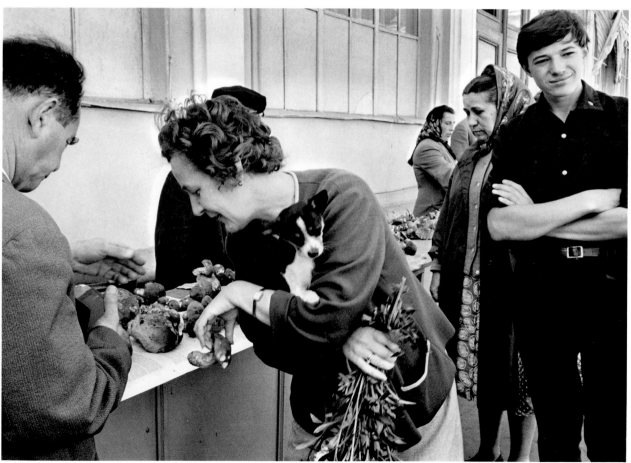

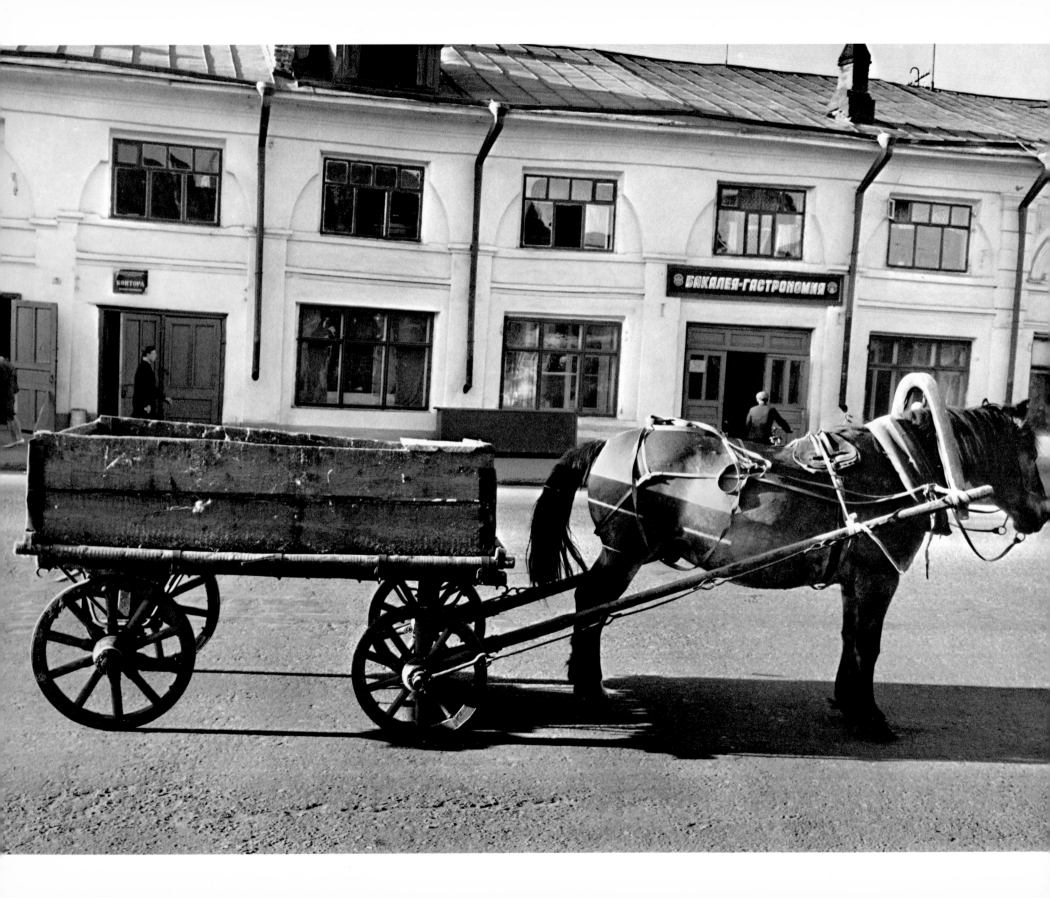

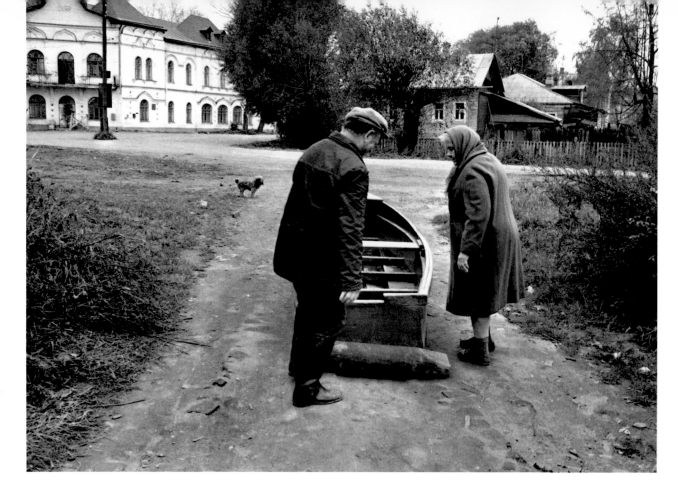

LEFT: ROSTOV-VELIKI, 1967
A main square in the provinces, with its old hostel and contemporary transportation, has not changed since the time of Gogol.

ABOVE: LAKE NERO, 1989
Nor have methods of moving heavy objects; this couple has just rolled their boat on a log all the way from the lake.

BELOW: CENTRAL ASIA, 1967
In the arid landscape near the Chupan Ata range, a large ceremonial gate in the middle of nowhere announces the border of a farming cooperative.

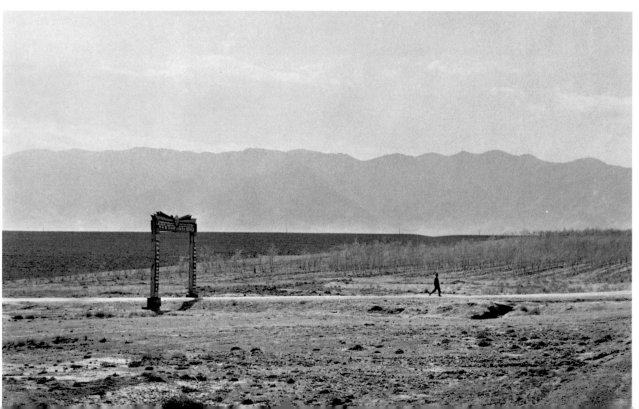

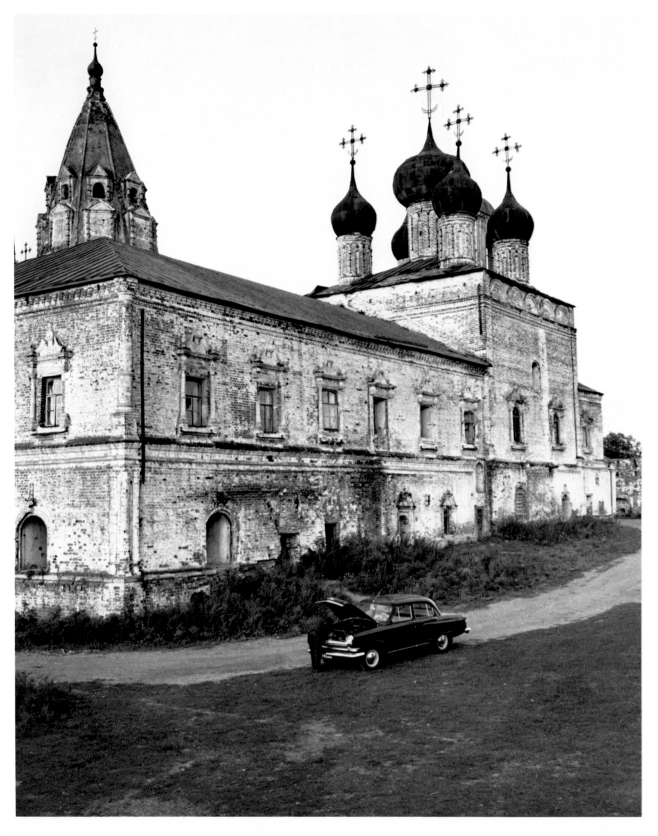

LEFT: PERESLAVL-
ZALESKY, 1989
A classic sight-seeing view: a
man repairs his broken car
next to a crumbling mon-
astery wall.

RIGHT: GEORGIAN
MILITARY HIGHWAY, 1967
At a bus stop on the Georgian
Military Highway there is
plenty of time for a chat, since
no one knows exactly when
the bus will arrive.

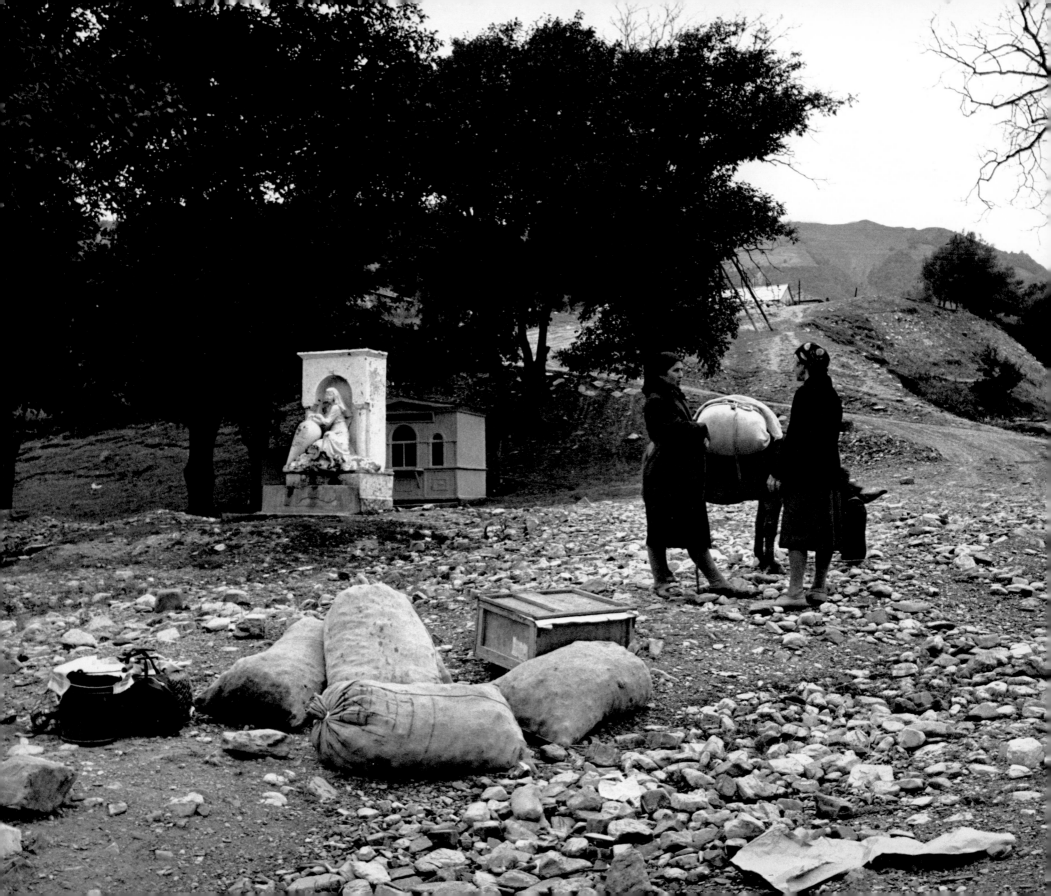

ROSTOV-VELIKI, 1989
Whatever your visions of the
old Russia, they endure in
the kremlin of Rostov-Veliki.
Peasant huts lean against
the walls of the seventeenth-
century monastic fortification,
which is crowned by the
splendid domes of its churches
and bell towers.

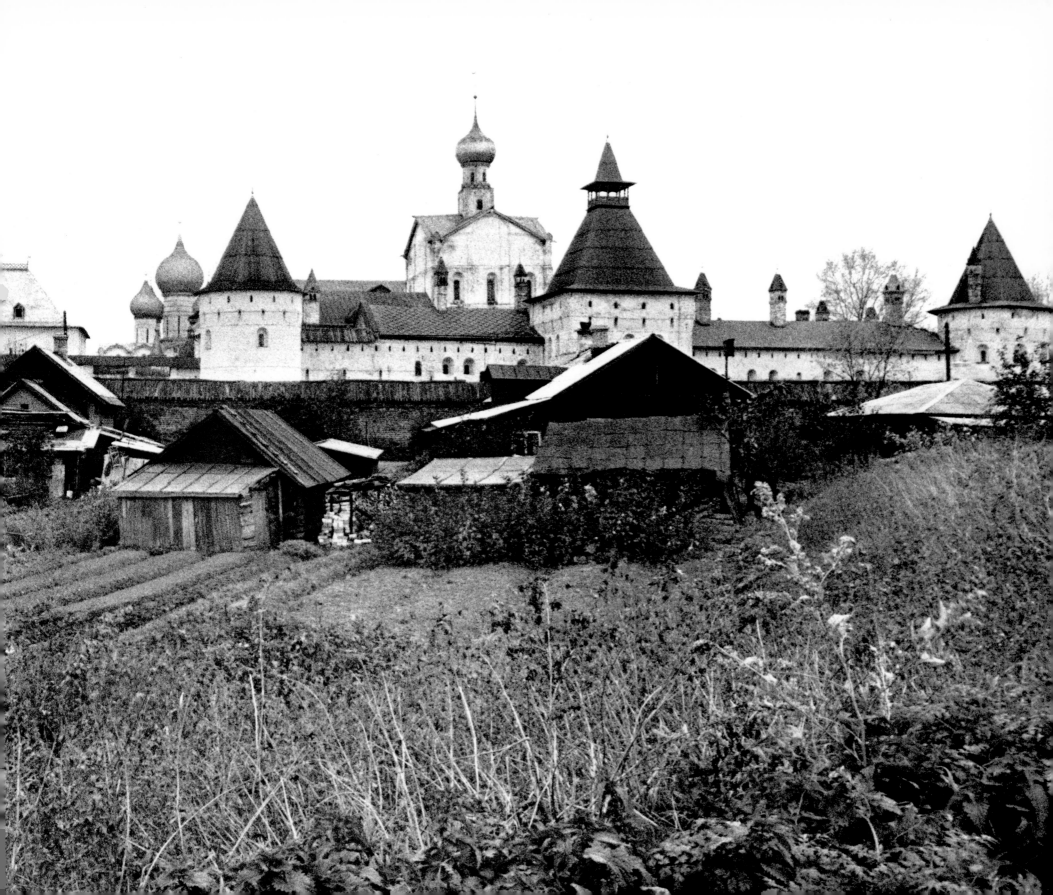

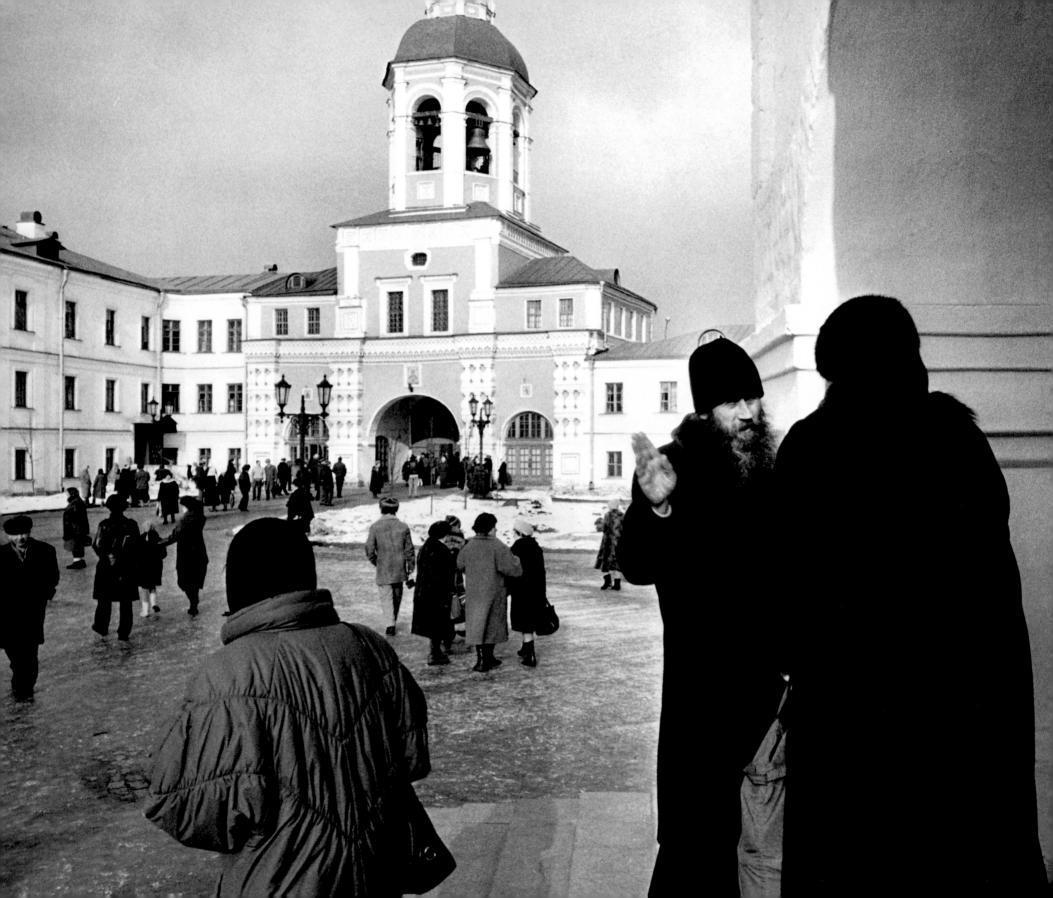

# PILGRIMAGES

RUSSIANS SHARE a passion for moving about, squeezing into uncomfortably crowded trains and buses with undiminished enthusiasm for what can turn a trip into a pilgrimage: a fervent prayer at one of the newly reopened monasteries, a search for roots in historic sites, and, most moving to me, a visit to the houses of great writers, which they treat with a reverence usually reserved for shrines.

LEFT: MOSCOW, 1989
In celebration of the thousandth anniversary of Russia's Orthodox Church, the Gorbachev government reopened the Danilov Monastery and allowed the church leaders to return from exile in Zagorsk.

RIGHT: SAMARKAND, 1967
The Tillakari Mosque, one of the great splendors of Samarkand, was built in 1618.

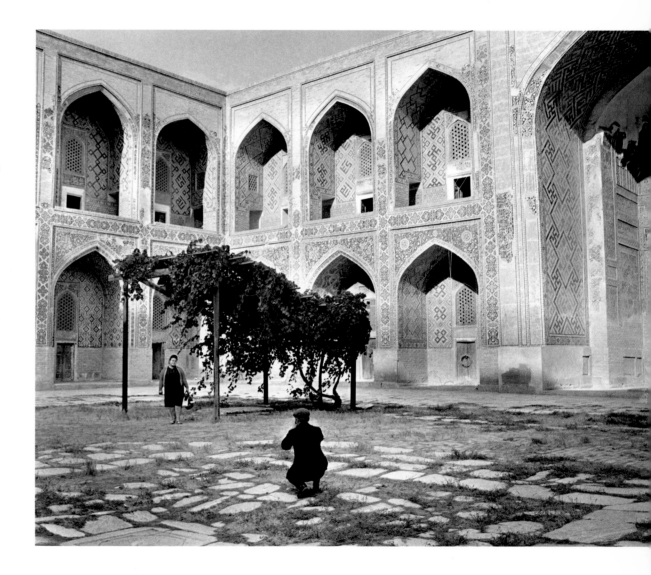

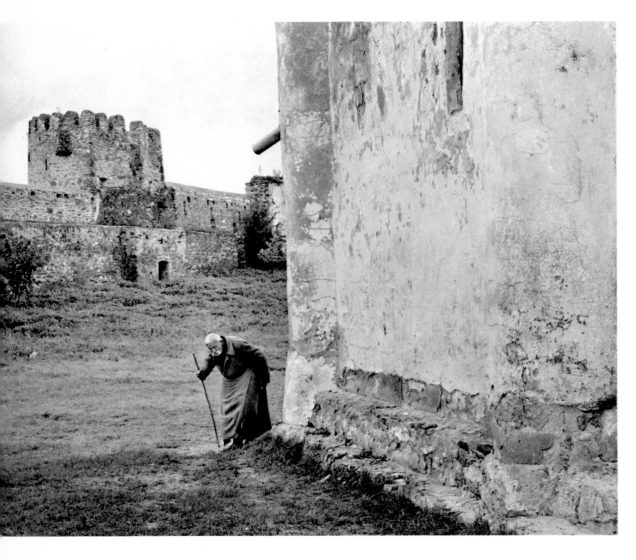

LEFT: KAHETI VALLEY, 1967
People go to the Church of Alaverdi to have candles and food blessed in celebration of the Georgian Festival of the Grapes. The old man has his own ritual: he goes around and around the church, kissing each corner, and finally joins the congregation inside.

RIGHT: GARNI, 1987
Mount Ararat is hidden by clouds. But even without this dramatic backdrop, the serene beauty of the temple at Garni, built by sun worshipers in the first century, is moving.

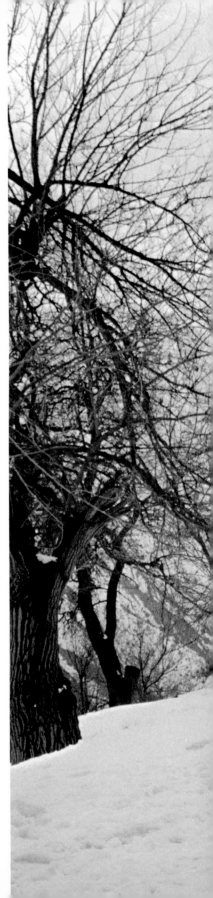

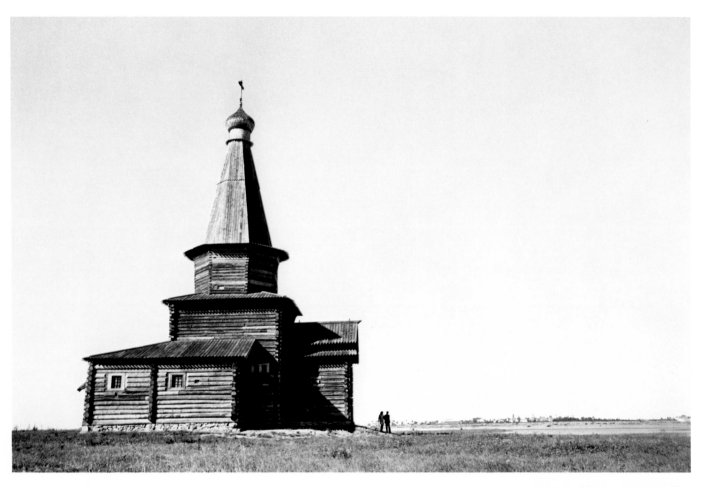

**ABOVE: NOVGOROD, 1967**
A wooden tent-roofed church
on the shores of Lake Ilmen
near Novgorod dates from the
eleventh century.

**RIGHT: MOSCOW, 1989**
After mass at a Danilov
Monastery church, worship-
ers turn around to cross
themselves once more in front
of the holy building.

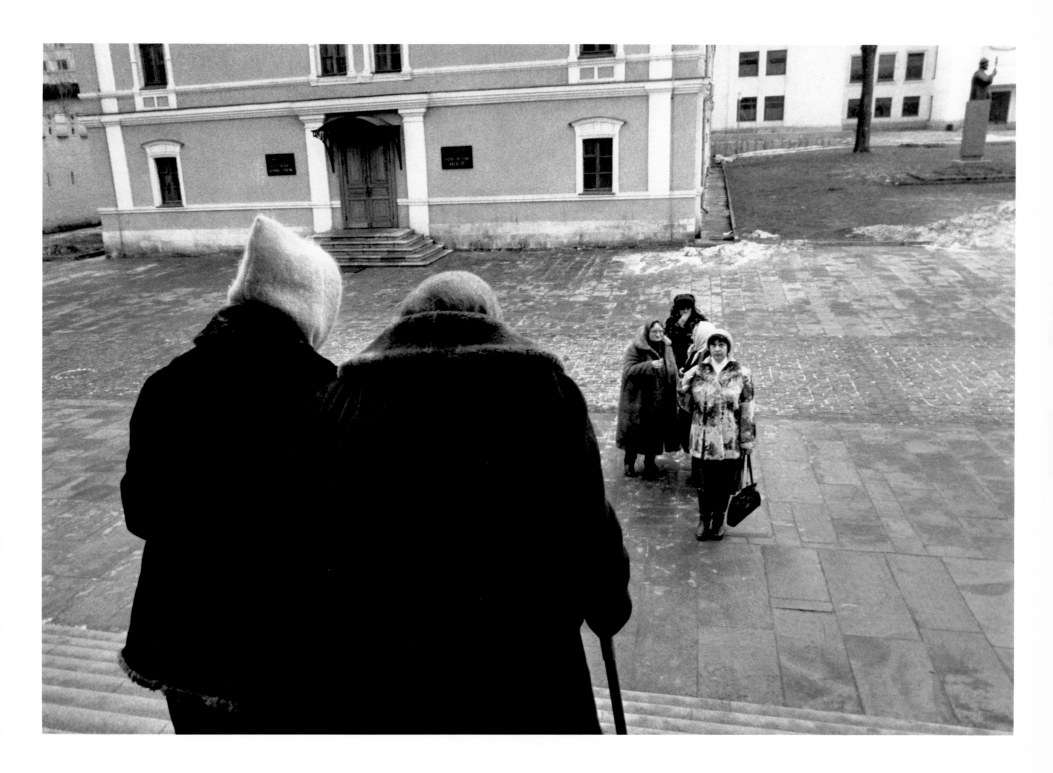

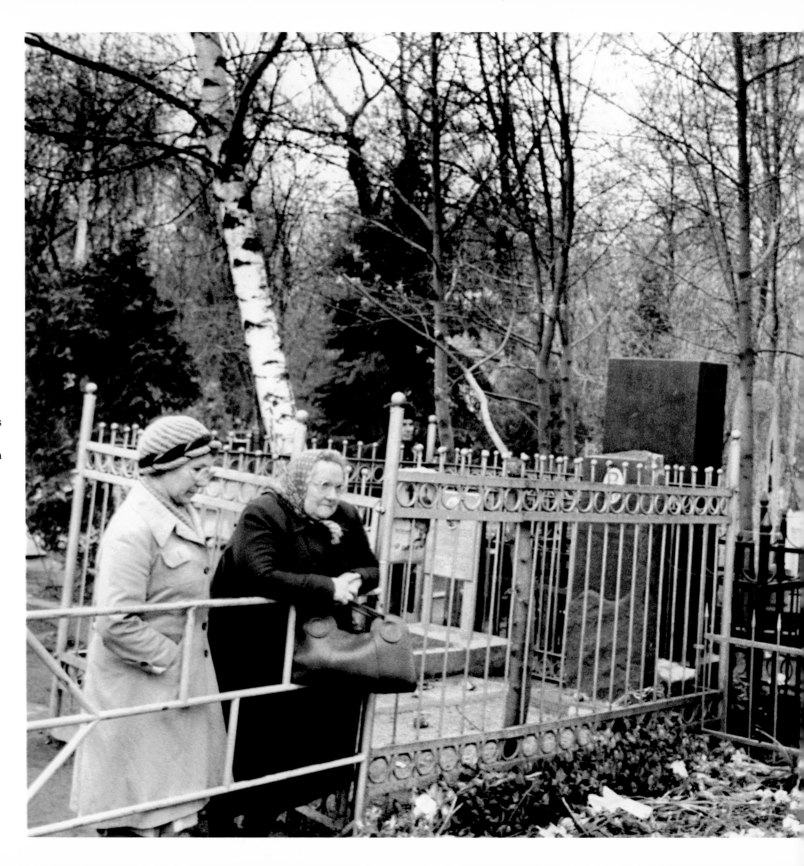

RIGHT: MOSCOW, 1988
Every day, visitors leave flowers at the tomb of Vladimir Visotsky, the poet and singer who challenged authority, died at a young age, and became a cult hero to Russians of all ages.

OPPOSITE: MOSCOW, 1967
The Novodevichy Cemetery is a pantheon in a setting of trees and flowers. A wall with urns contains the ashes of early revolutionaries.

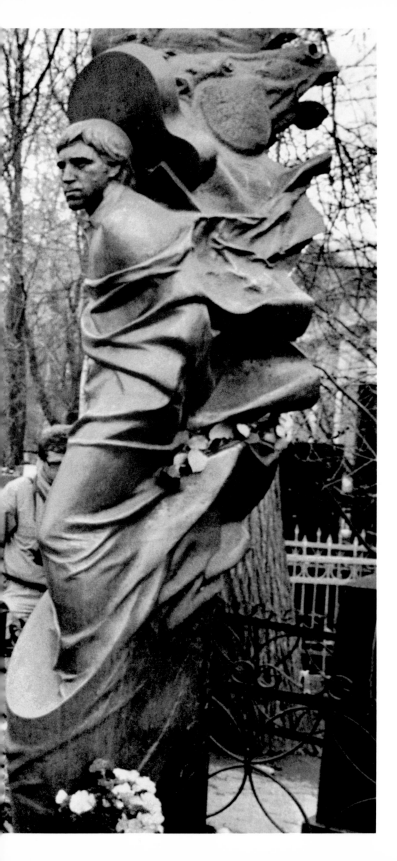

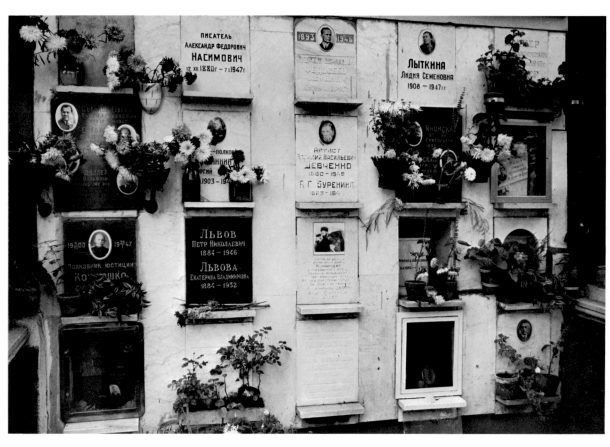

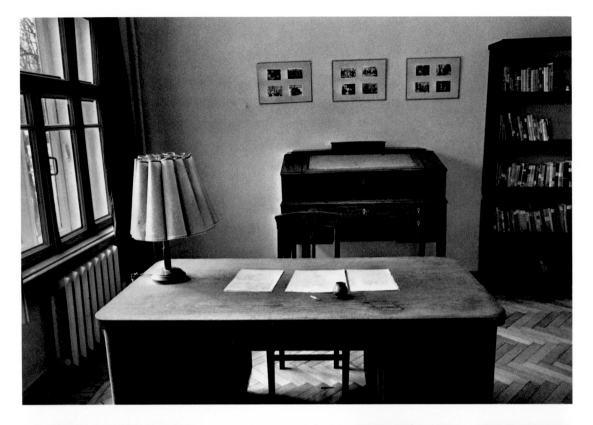

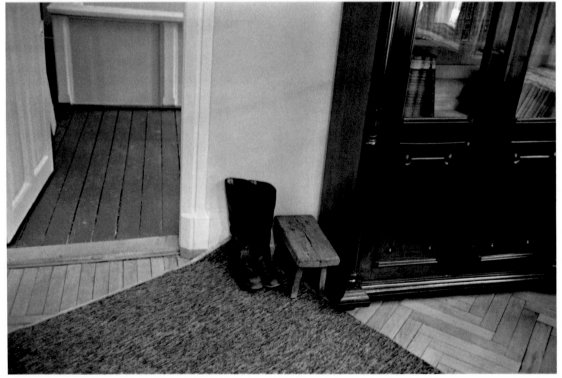

PEREDELKINO, 1967, 1990
This is a place of wooden
houses, gardens, and birch
groves outside Moscow. The
Writers' Union owns a large
number of dachas here and
allots them to writers for
their lifetimes.

The house of Boris
Pasternak, who had fallen
from official grace after the
publication of *Doctor Zhivago*
in the West, was preserved
after his death by family
members and literary figures
such as Andrei Voznesensky,
Yevgeny Yevtushenko, and
Lydia Chukovskaya. Visits
by admirers of the poet
were discouraged, but the
authorities could never stop
them from leaving gifts of
flowers, apples, and berries
on his tomb.

In 1990, on the hundredth
anniversary of the poet's birth,
the house was finally dedi-
cated as a museum, filled
again with the family's
furniture, the poet's beloved
piano, his writing desk;
even his coat and boots are
in place.

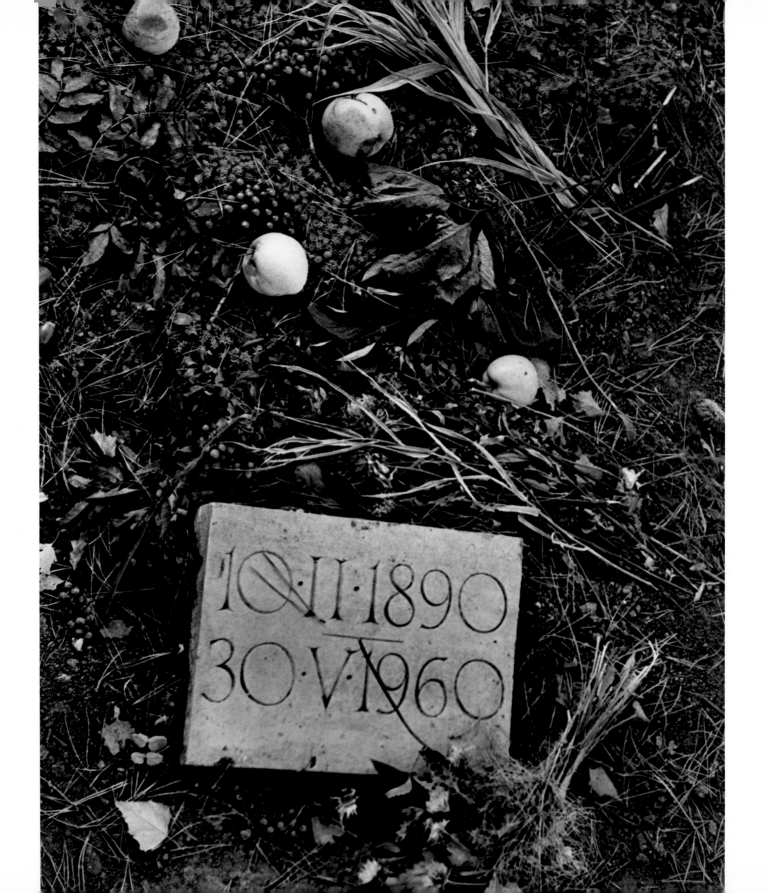

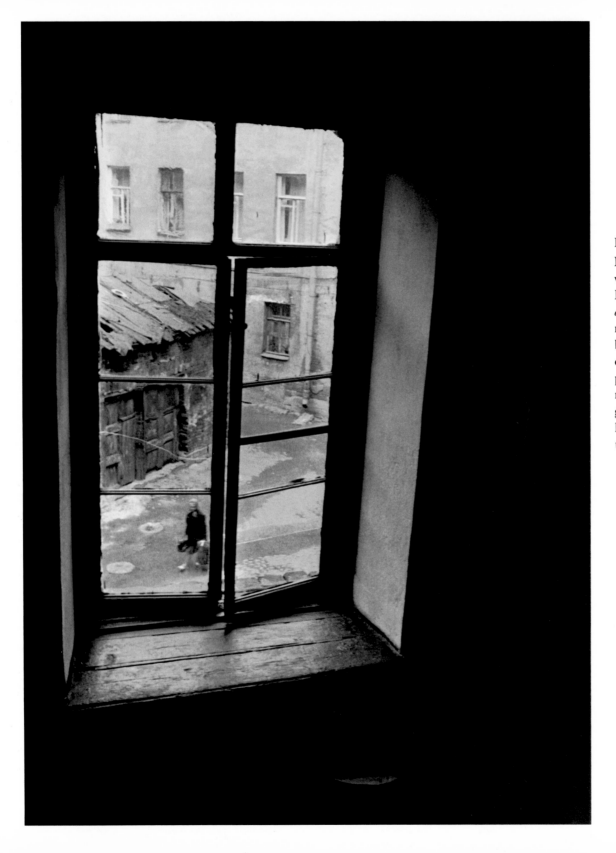

LENINGRAD, 1967

Number 7 Pergevalsky Street,
where both Dostoyevski and
Raskolnikov, the hero of *Crime
and Punishment*, lived. You can
reenact the section of the
book in which Raskolnikov
considers murdering the
pawnbroker Ivanova, and
measure the distance from the
gate to Ivanova's lodging
house: seven hundred and
thirty steps, exactly.

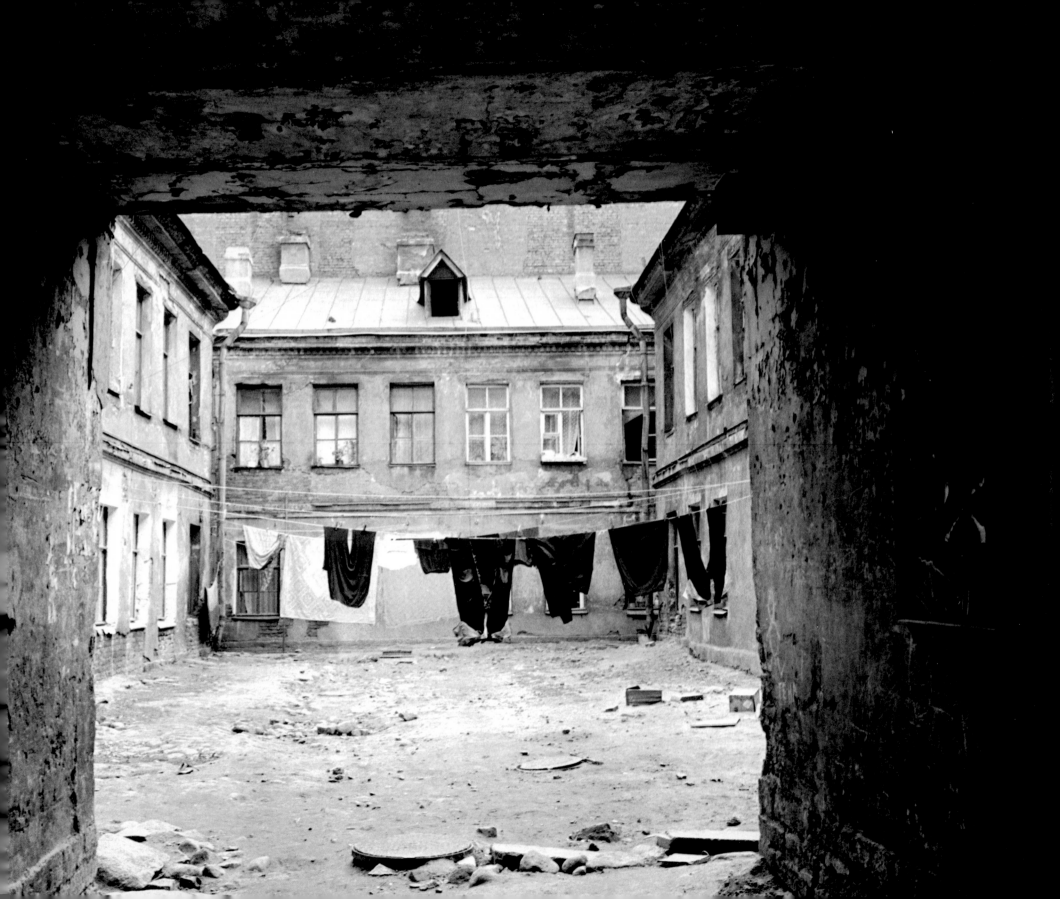

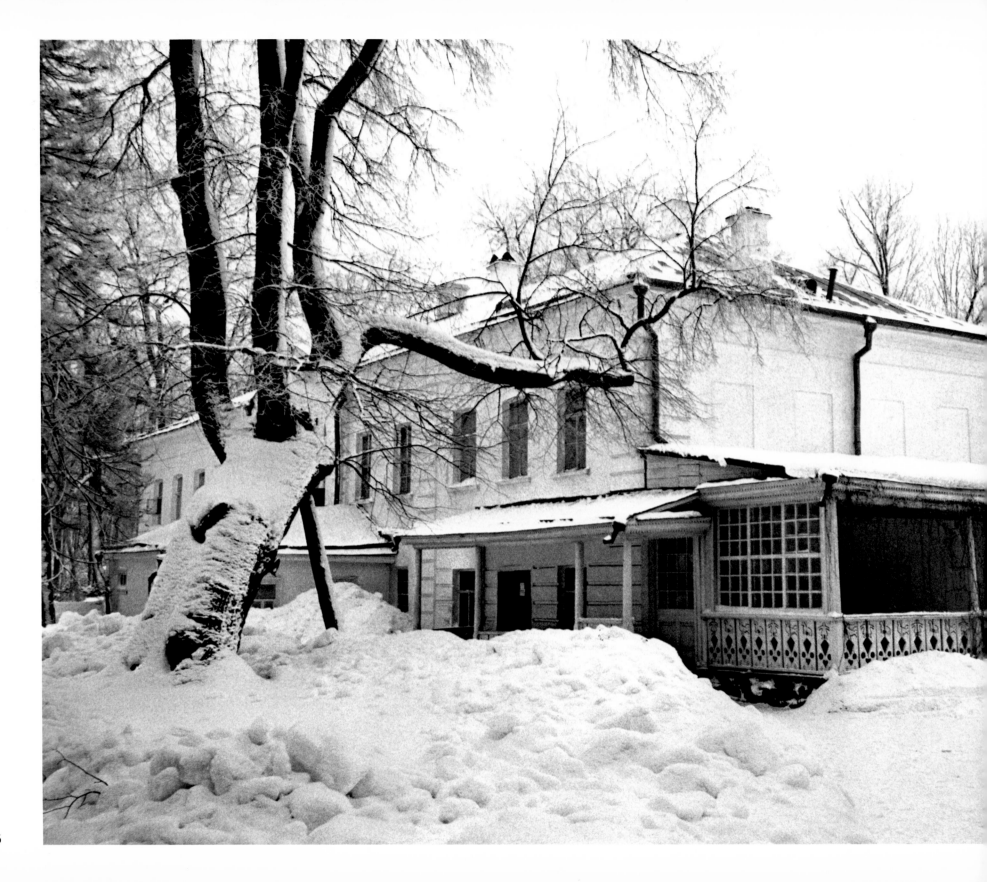

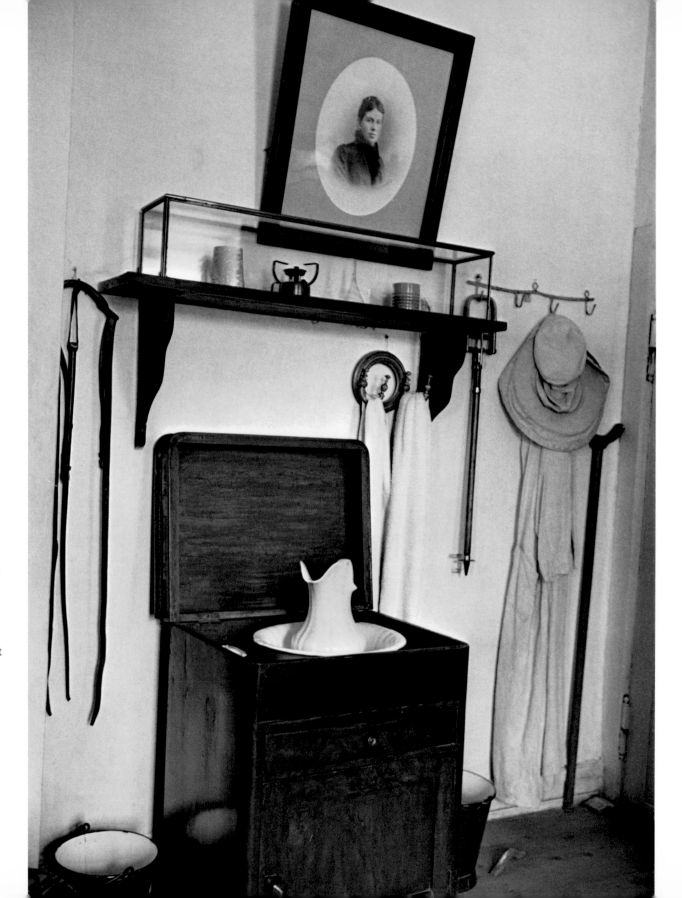

YASNAYA POLYANA, 1965
Deep in the countryside, 160
miles south of Moscow, lies
Yasnaya Polyana, Leo Tol-
stoy's estate. He inherited the
immense property from his
mother, Princess Volkonsky,
and lived here from 1862 to
1910. The absence of any
splendor speaks of a master at
work, seated on a sawed-off
chair to bring his eyes closer
to the paper. In his Spartan
bedroom, below the portrait
of his wife, Sophie Behrs,
hang his walking sticks and
the simple peasant clothes he
wore in his late years.

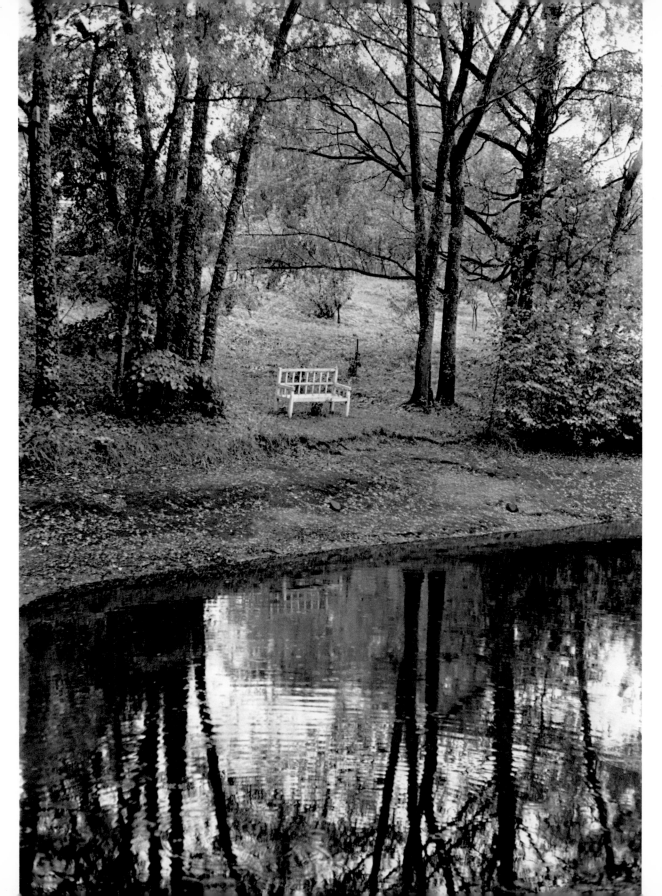

LEFT: MIKHAILOVSKOYE, 1967

Alexander Pushkin, Russia's greatest poet and a critic of the tsar, lived in exile on the estate given to his great-grandfather Hannibal by Peter the Great. Here, Pushkin wrote *Boris Godunov*, parts of *Eugene Onegin*, and *Graf Nulin*.

RIGHT: LENINGRAD, 1967

The poet's books and manuscripts are preserved in the library of his apartment on the Moika Canal, where he lived with his beautiful wife, Natalia Goncharova, until his death in a duel with Baron George Heckeren D'Anthes in 1837.

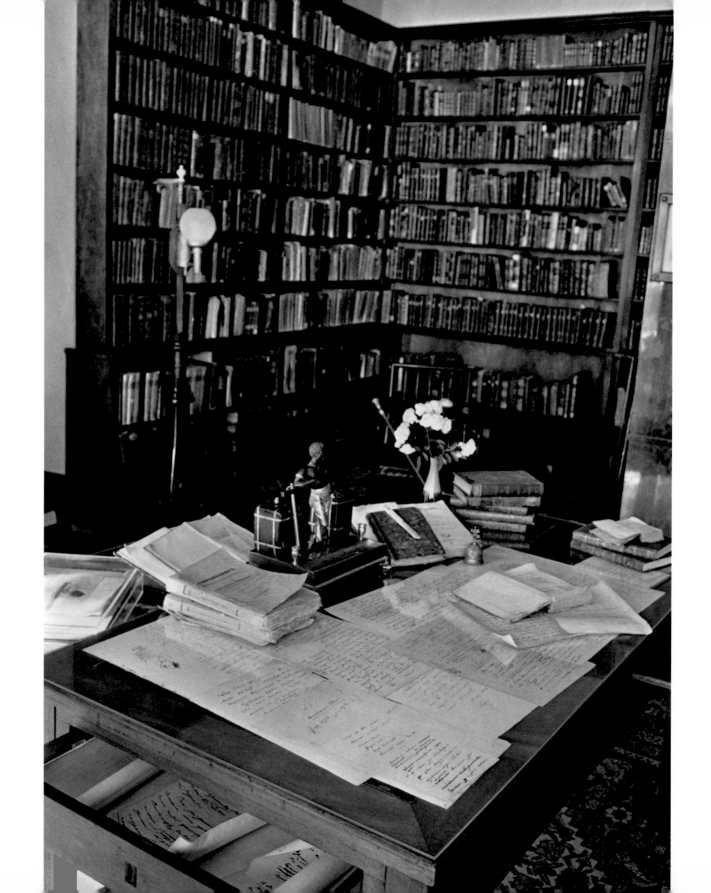

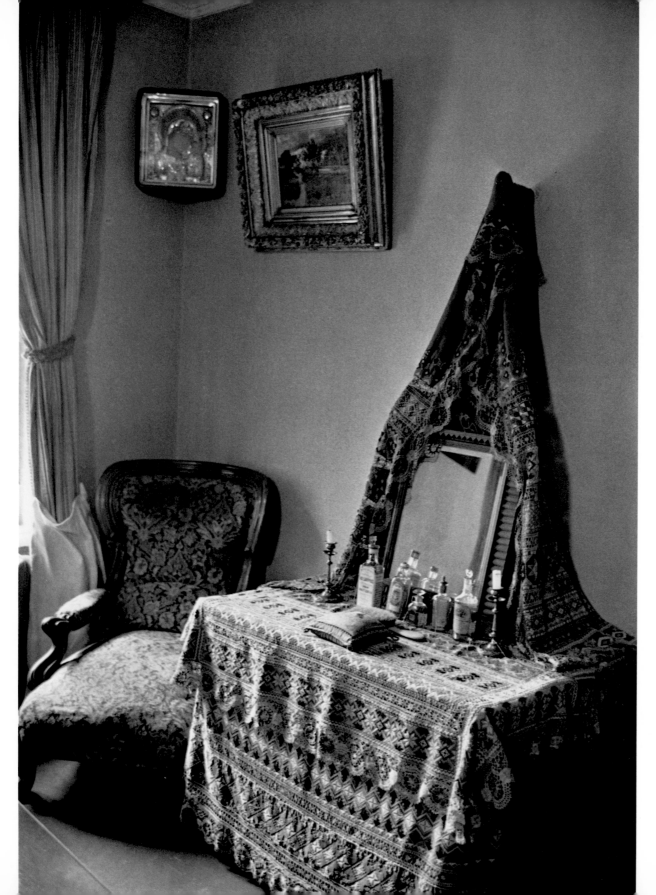

KLIN, 1967

Pyotr Ilich Tchaikovsky lived
in the small town of Klin,
between Moscow and Lenin-
grad, until his death in 1893.
The orientalized dressing
table with the mirror and all
the little bottles is a charming
surprise after the pristine
breakfast room.

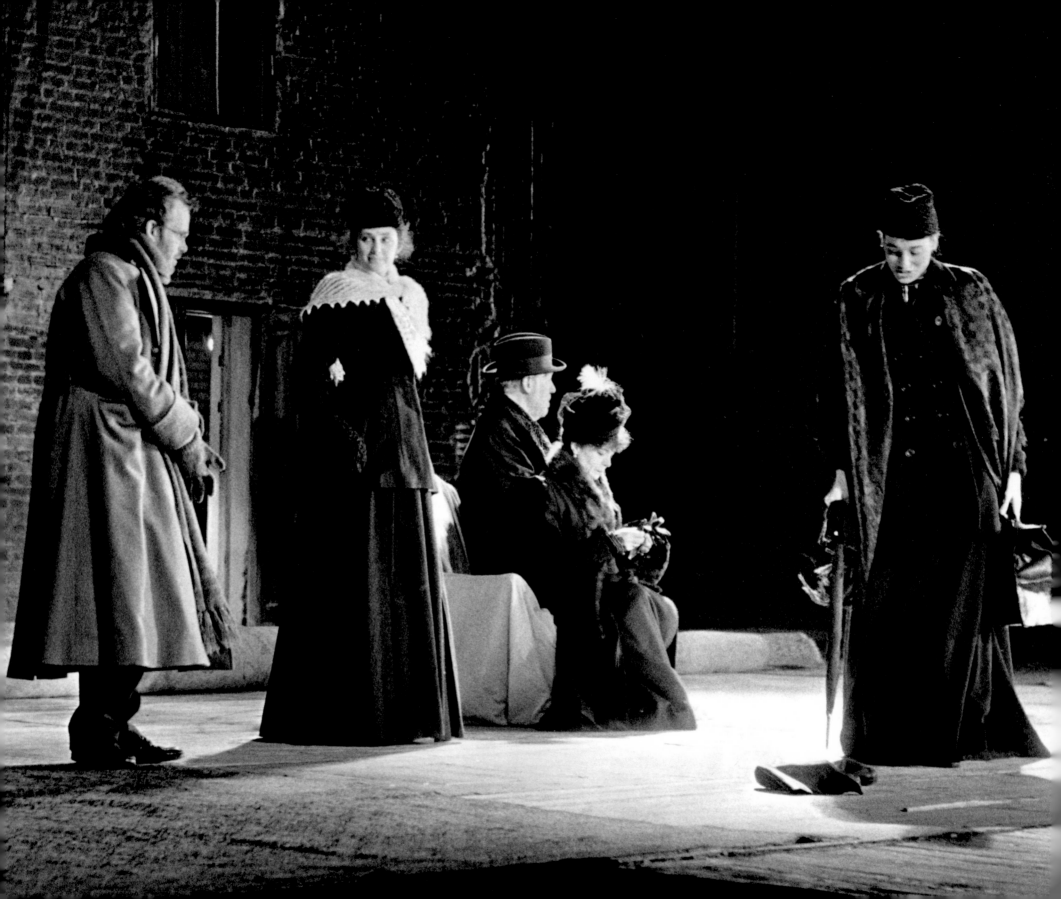

LEFT: MOSCOW, 1989
A scene from Peter Brook's production of *The Cherry Orchard* at the Taganka Theater.

RIGHT: YALTA, 1989
Anton Chekhov personally supervised the construction of his house at Yalta, where he lived with his family at the end of his life and where he wrote *The Cherry Orchard*, "Lady with a Dog," and *Three Sisters*. Already quite ill when he moved here, he continued to practice medicine.

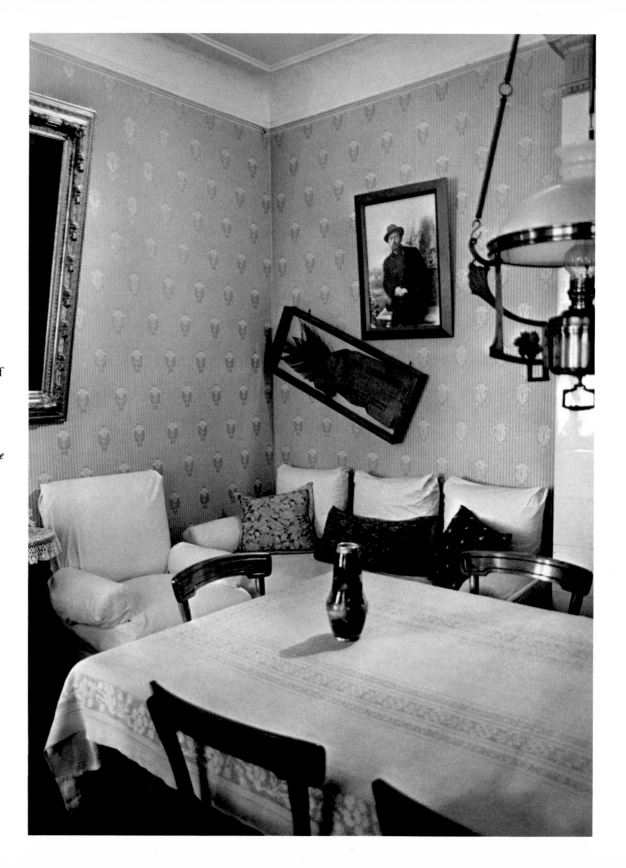

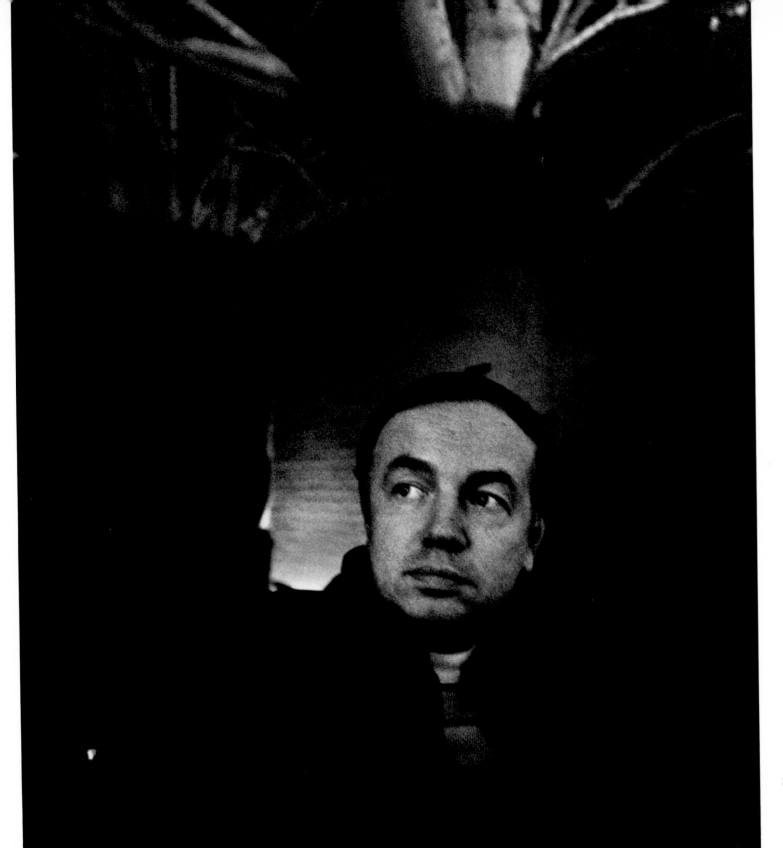

Salisbury, CT, 1977

# LETTERS TO INGE

from Andrei Voznesensky

Moscow, 1967

Dear, dear, dear Inge, Arthur and sexy Rebecca:

Thank you for your cables and letters, for your efforts—thank you all. Don't be afraid for me. My circumstances are not brilliant. But don't be afraid for me. I think I was a "happy man" too long. And it is so strange for me that it only happened just now and not before.

Strange people they are. They did not allow me to go to Lincoln, to London or to other places (even to Bulgaria!). But it is impossible for them not to allow me to write my poems, believe me!

But enough; fuck them!

What are your plans? Tomorrow I'll fly out of Moscow until mid-August. Write me your schedule and I'll fly to you or to Moscow or to any other place; I want to see you so much. Much love,

Andrei

Moscow, 1968

My dearest, dearest, my faraway Inge and Arthur:

So happy I was to receive your letter and lovely photos. As if I were once again in a different era—happy, un- chained, free—as if once again I was what I was.

How are things with you? Arthur's *Price* has been an enormous success here.

It makes me happy three weeks ago to see Arthur and me together on the pages of the *New York Times*, as we have been together in your New York apartment.

I have been in Latvia for a long time, wrote much but nobody knows when it is published. Today *Novi Mir* No. 7 published three of my poems. Believe me, I am so happy— after a year-long printed (meaning printless) interval; such a darkness. I do wish I could meet you—I miss you so much—but I have no hope. Love to you both, yours,

Andrei

Philadelphia, 1990

Inge, dear!

Inge, it was so unexpected to read these forgotten letters! It turns out that even a quarter century ago I had mastered four-letter words and knew where to aim them.

Now I am writing you another letter. Slip it into your book between pictures of churches and faces, the way my life since childhood was placed between these, leaving my imprint on them and theirs on me.

I don't know what will have happened to Russia by the time this book is published. Perhaps it will perish—God forbid!—and this country will no longer exist, and with it the world will have lost its poetic principle—terrible, ungainly, beautiful, ugly, ours is perhaps the last poetic country. Then your book will remain as a testimony to what the country was—as if you had taken photographs of Pompeii before its destruction.

But if—God willing—it survives and people have at last normal food, blood and freedom, then I would hope that it does not lose what you captured with your lens: its subtle poetry.

In either case, your book is a unique document.

Your camera is very intuitive. I am looking at a photograph taken in Tsarskoye Selo. You went to a remote place where tourists don't usually go. I look at the cast-iron branches over a small bridge and read the monogram "A.A." repeated in the reflection on the water. In Catherine the Great's bridge you instinctively captured a prediction about Anna Akhmatova. The landscape at Tsarskoye Selo is heralding the poet who would celebrate it a century later.

The eye is wiser than reason. The visual twenty-first century will read your photographs in place of words.

I see a photo that is not in the book. February, 1990. Arthur Miller in a red scarf standing on a snowy porch in Peredelkino at the inauguration of the Pasternak Museum. The Russian intelligentsia will not forget that you came to honor the hundredth anniversary of our martyr poet. You had flown in from West Berlin. Just think! Six months before, Germany was still divided. Arthur told the crowd below the porch that Hitler would have killed Pasternak twice: as a Russian intellectual and as a Jew.

At last today the intelligentsia of the world has a sense of itself as a nation: American, Italian, Georgian, Japanese, Lithuanian, Russian. Intelligentsia of the world, unite! Arthur's standing there was a symbol of the conscience of the world.

Poet versus power is the eternal Russian conflict. Pushkin and the Tsar, Stalin and Pasternak, Pasternak and Khrushchev. Every one of our poets has lived through his personally. When Khrushchev shouted at me, "Mister Voznesensky, get out of the country! You are slandering socialism and the party. You want a Hungarian revolution here! We need the harsh frost for people like you!"—he wasn't shouting just at me, he was trying to frighten the intelligentsia. It's not an accident that he became so nervous when poets began reading their works in stadiums. It wasn't only Khrushchev who was shouting, it was the system.

Without the support of the world spiritual energy field, our culture would not have survived.

And Khrushchev, when he was Tsar, persecuted Pasternak for sending his novel, *Doctor Zhivago*, to the West to be published. Yet when he became a writer himself, Khrushchev followed Pasternak's example and secretly sent his memoirs out, appealing to world public opinion for help.

Your book contains the onion domes of our churches and also the faces of our new saints: Andrei Sakharov, Nadezhda Mandelstam, Vladimir Visotsky, Venedict Erofeyev.

Remember the fate of your book *In Russia*, a loving description of our country? Your "spy" camera, Inge, revealed a terrible state secret—the number of wrinkles on the face of Minister of Culture Ekaterina Furtseva. The state took offense. In his foreword, Arthur mentioned how Furtseva had attempted suicide in her bath when she was fired as minister. You wanted to show the live woman inside the minister—and that was a crime. Entry to the country was closed for you. Miller's plays were taken out of repertory. The book was published in many countries but not in ours.

I hope that this new book will be published in Russia; I hope that the country depicted in it will continue to exist.

Before our eyes the most monstrous of centuries is coming to a close. And isn't it strange that the country that gave us the gulag also gave us the greatest upsurge in poetry. In the Soviet Union, books by serious poets are instantly sold out in printings of two or three hundred thousand copies. I have had the good fortune to be born in a country where people need poetry. Of course, poets here are often confused with the fire-alarm system.

Alas, we did not give the world an economic miracle or computers. Only poetic sense distinguishes us. Poetry readings were the only places where the texts were not censored beforehand. However, if you were too daring, your subsequent readings were banned. People went to poets for a breath of freedom. They also went as if to a religious sacrament. But most important, they went for the poetry, which in the days of totalitarianism and standardization was the sole vitamin for individualism. Your lens found this in us. But enough.

"It's better to see once than to hear ten times": that's a Russian proverb about your book. We are all its characters—people, and old nags, and dogs, and trees. And whichever of us looks out from the pages will always be looking at you, Inge. Much love,

Andrei

Translated by Antonina W. Bouis

Letters from 1967—1968 written in English

---

ANDREI VOZNESENSKY was born in Moscow in 1933. He studied architecture first, and he became famous as a poet with "I am Goya," published in 1959. A resolute modernist, Andrei Voznesensky is uncompromising, refusing to bend to authoritarian dictates. For his response to Khrushchev's famous condemnation of modern artists, he spent much time in the provinces.

Numerous collections of his poetry have been published, and his readings draw huge audiences. He is in love with Paris and New York, and also with Peredelkino, where he and his wife, Zoya Boguslavskaya, receive many distinguished visitors in their dacha. Voznesensky has been translated by many American poets, including Richard Wilbur, John Hollander, and Jean Valentine. *Arrow in the Wall* is his latest selection of poems published in America.

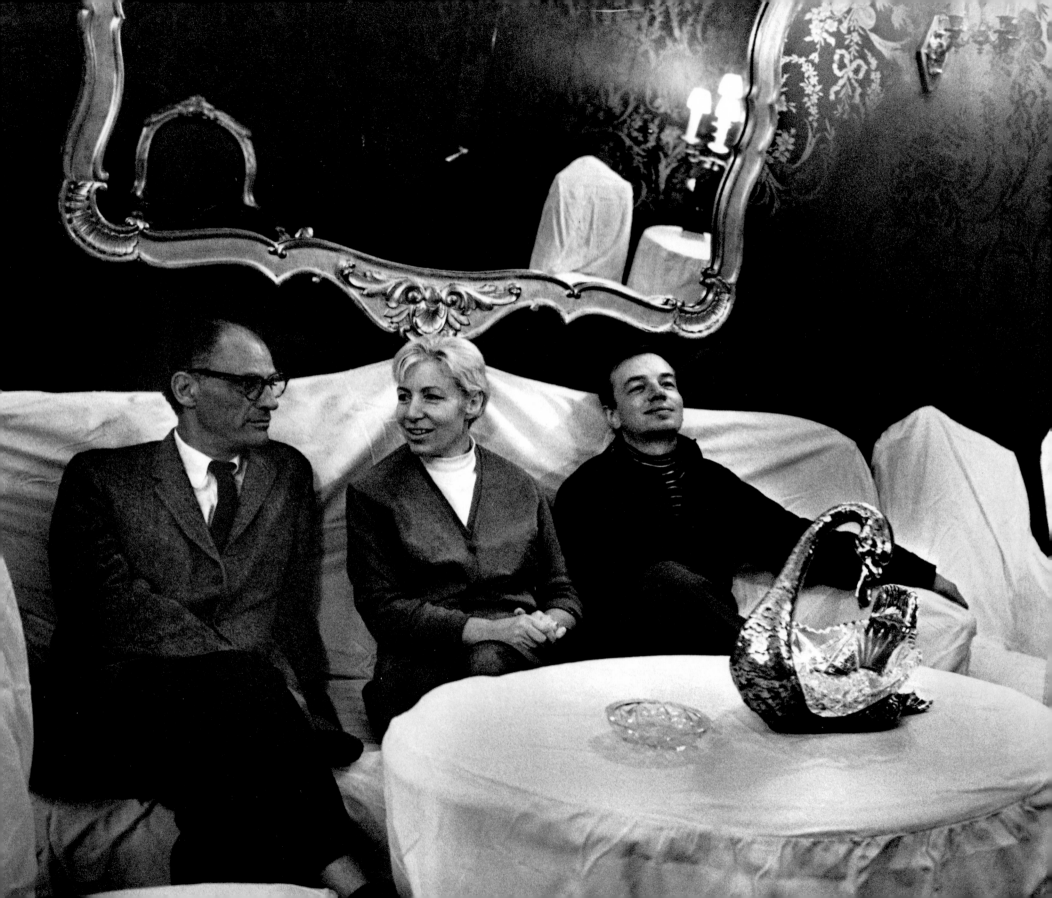

# THE INTELLIGENTSIA

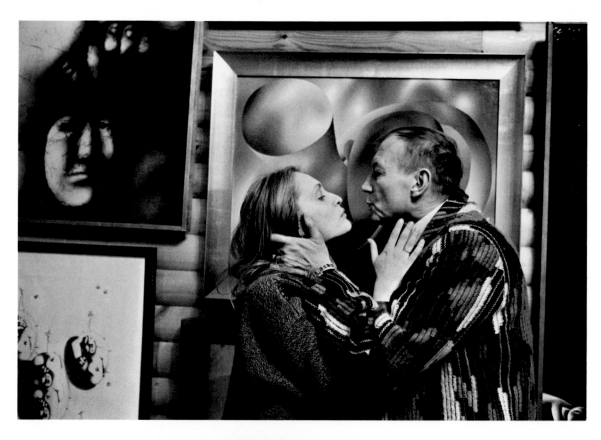

RUSSIANS CALL THEM the intelligentsia. They include writers, poets, critics, film-makers, painters, scientists, and readers of books—all those who act as the leaven of society, defying the icy hand of an all-powerful bureaucracy.

OPPOSITE: MOSCOW, 1967
Arthur Miller, in Moscow to see productions of his plays, joins Zoya Boguslavskaya and Andrei Voznesensky in a gilded salon backstage at the Bolshoi Theater, waiting to be received by Maya Plisetskaya.

ABOVE: MOSCOW, 1988
Masha and Yevgeny Yevtushenko at home in front of a painting by Oleg Tselkov, one of the persecuted artists supported by the poet.

RIGHT: LENINGRAD, 1967
Joseph Brodsky on a walk through Leningrad.

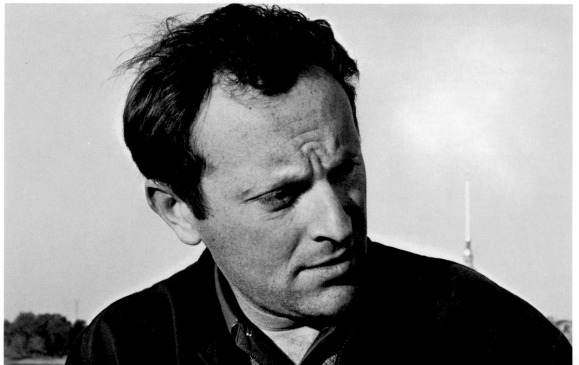

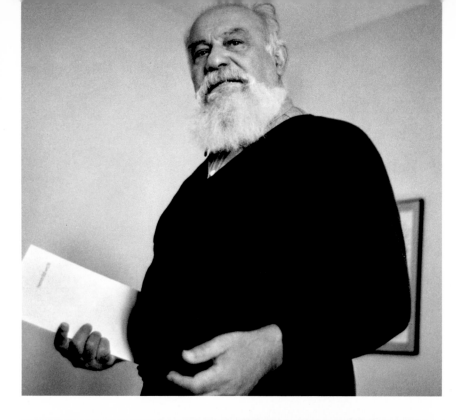

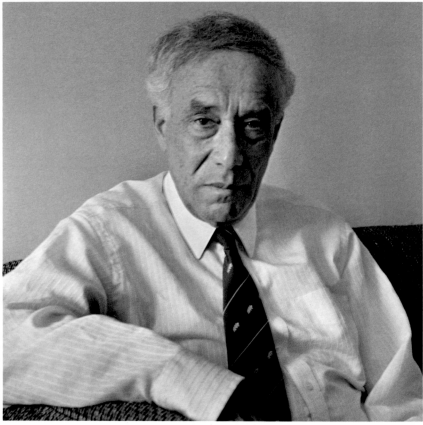

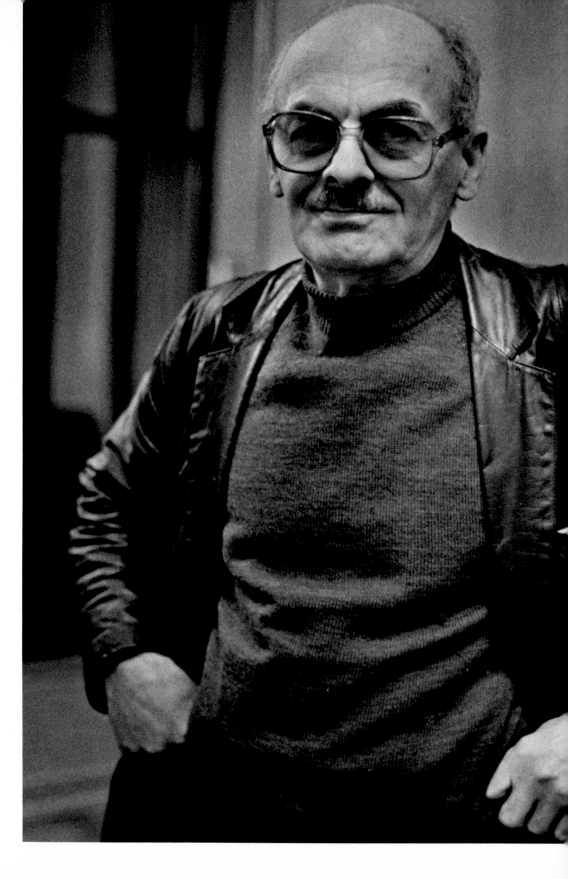

OPPOSITE, TOP:
NEW HAVEN, 1982
Lev Kopelev, a scholar, was a companion of Solzhenitsyn in detention. He served as the model for Rubin in *The First Circle*. He lives in exile in Cologne, Germany.

OPPOSITE, BELOW:
NEW YORK, 1990
Yevgeny Pasternak, the oldest son of Boris Pasternak, dedicates himself to the broadening of Pasternak scholarship.

LEFT: MOSCOW, 1987
The poet and balladeer Bulat Okudzhava is celebrated in the Soviet Union as one of the powerful voices in the struggle for artistic and individual freedom.

RIGHT: MOSCOW, 1990
Sasha Sokolov is the author of *School of Fools*, the cause of his leaving the Soviet Union for fourteen years, and *Astrophobia*, a biting satire about life at the Kremlin. He had just returned to Moscow and wanted his portrait taken inside the open doors of a cabinet. Hiding there, he still felt transient, vulnerable. What he wants most is to go back to the countryside where he first found his literary voice; he is hungry to hear his own language again. "Language to me is more important than life," he said.

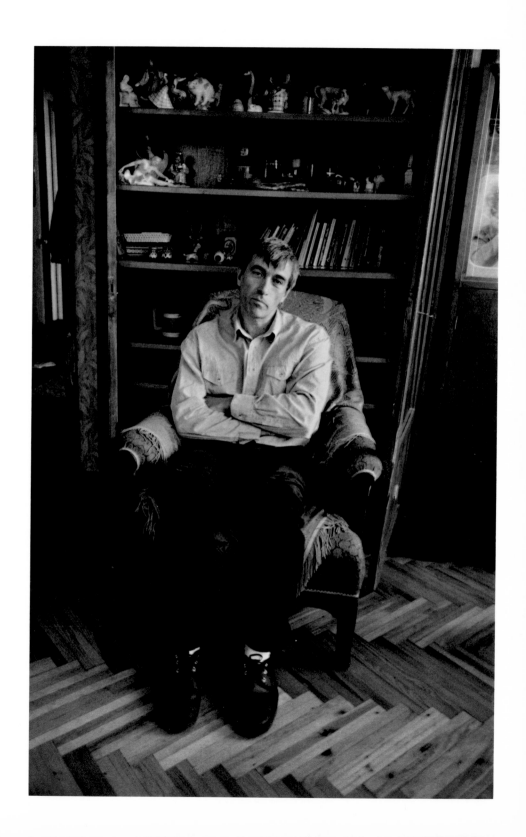

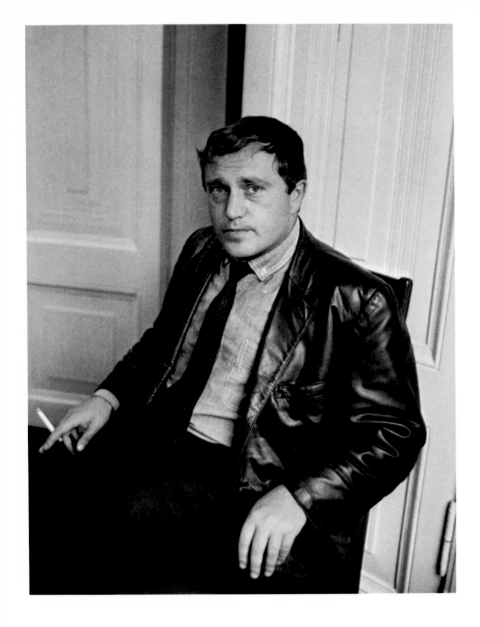

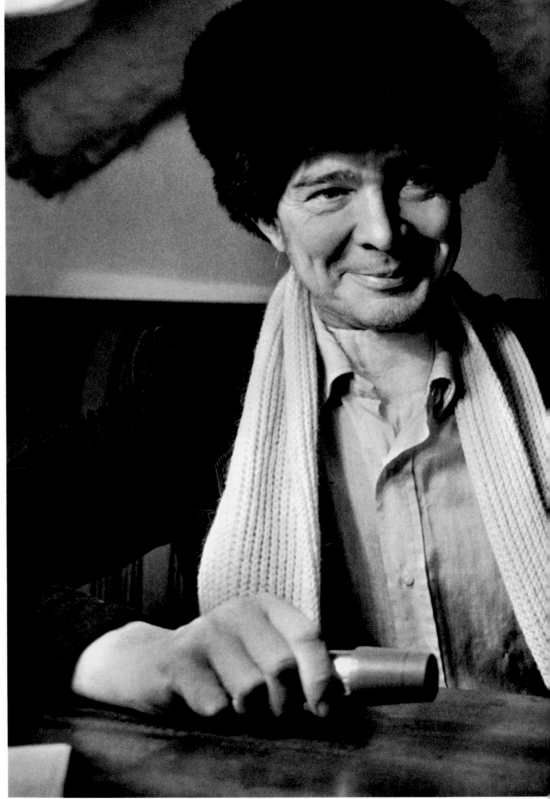

**OPPOSITE: MOSCOW, 1967**

Novelist Vasily Aksyonov achieved early recognition for his writings about Soviet youth. He is the son of Natalia Ginsberg, author of *Into the Whirlwind*, who survived years as a political prisoner. In the mid-seventies, Aksyonov was expulsed along with Solzhenitsyn, Vladimir Voinovich, and Valery Chalidze. The author of *The Burn*, he is now writer in residence at Goucher College in Baltimore.

**CENTER: MOSCOW 1988**

In his satirical novel *Moskva-Petushki*, which was banned but read by everyone in samizdat, Venedict Erofeyev tells the story of a drunkard's life in which he captures the humor and hopelessness of his motherland's current conditions.

**RIGHT: MOSCOW, 1965**

It is an old custom to sit a few minutes in silence before a departure. Oleg Efremov, actor, director of the Sovremennik and later the Moscow Art Theater, gives us a proper send-off on the Red Star Express to Leningrad.

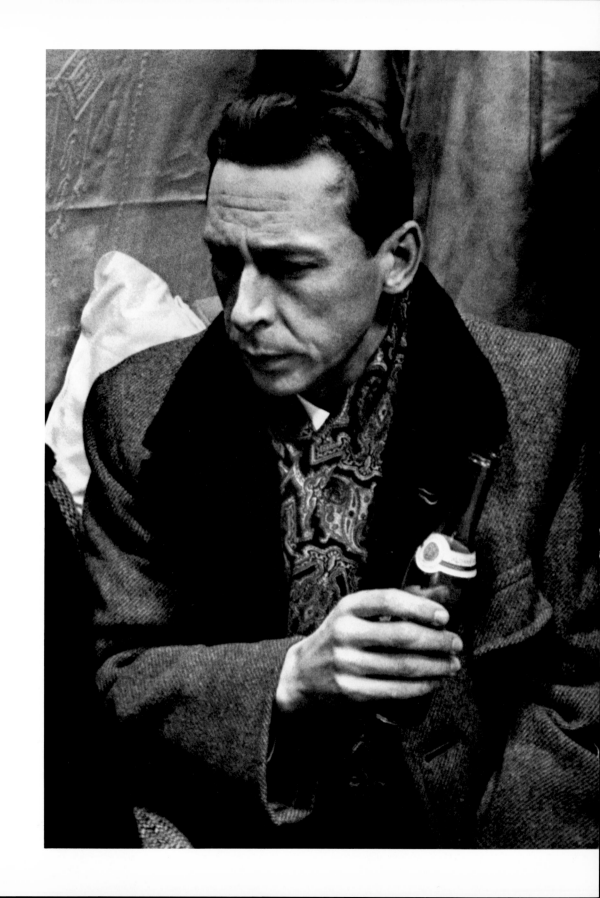

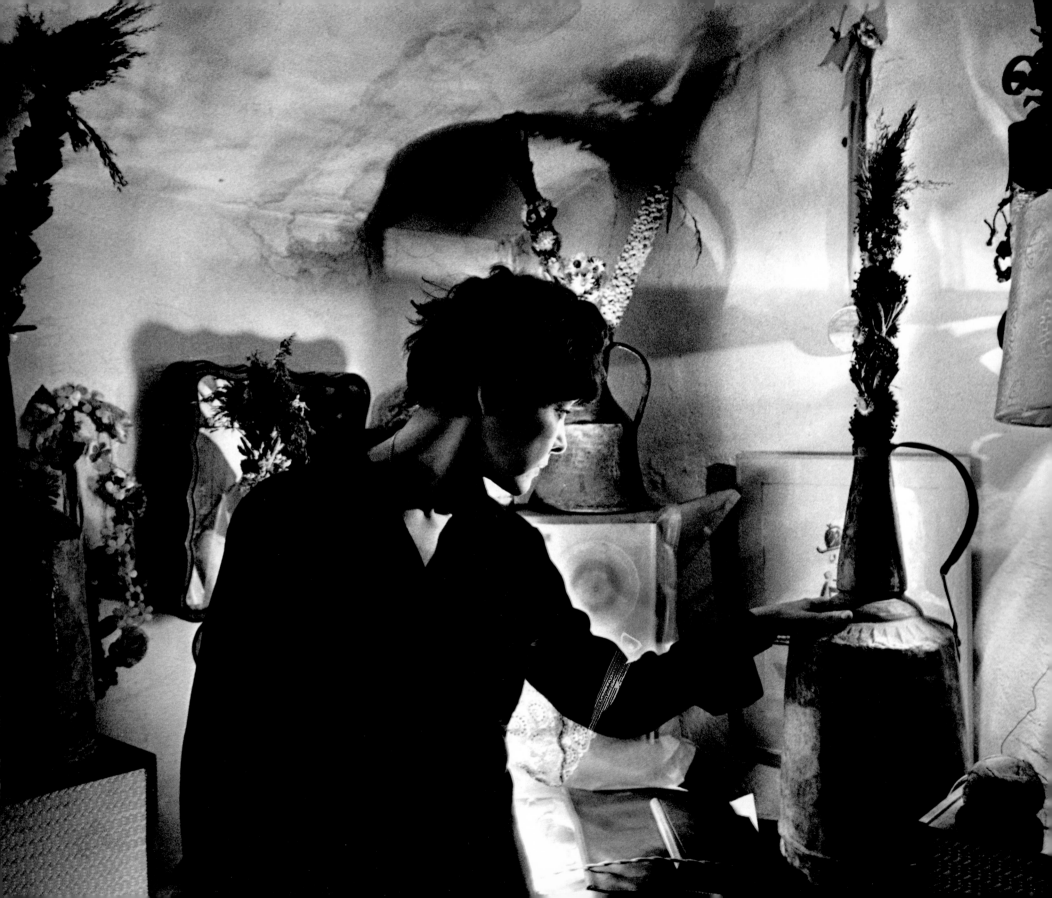

LEFT: MOSCOW, 1985
The poet Bella Akhmadulina
in a corner of her Moscow
studio, which is filled with
her special fetishes. Beautiful,
fragile, and courageous, she is
one of the most prominent
Russian poets today.

ABOVE: MOSCOW, 1989
Natalia Nesterova, a painter
of great independence whose
themes are modern man and
culture, in front of her huge
canvas *On the Beach*.

BELOW: MOSCOW, 1989
Azerbaijani painter Zhavad
Mirzhavadov with his wife,
Lyuba, wedged between his
canvases in a tiny room in the
National Hotel. After years
underground, when he was
sometimes labeled as
demented by the authorities,
glasnost brought him his first
big show in Moscow, to great
acclaim.

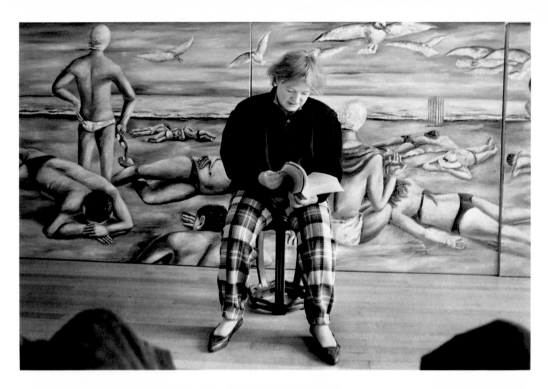

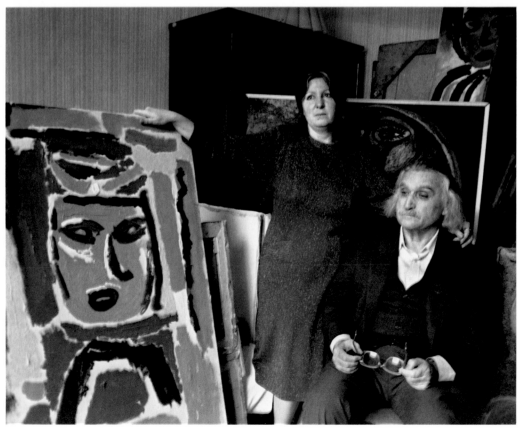

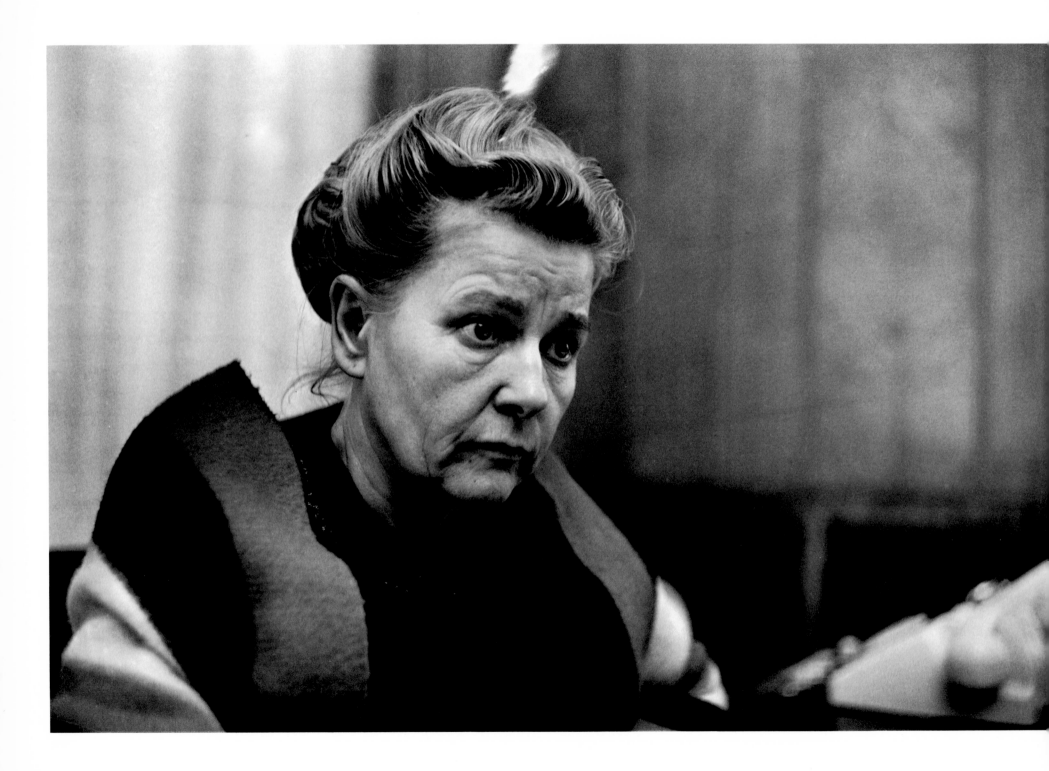

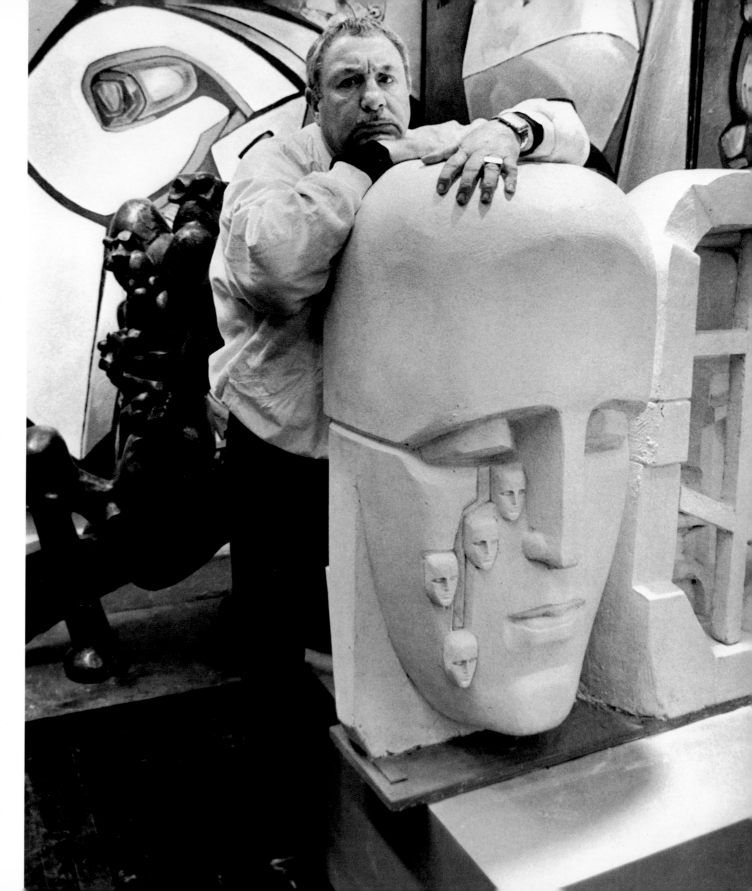

LEFT: MOSCOW, 1965
This is the photograph of Ekaterina Furtseva, the Soviet Minister of Culture, that caused her to ban our book, *In Russia*.

RIGHT: NEW YORK, 1990
Prominent Moscow sculptor Ernst Neizvestny became a target of Khrushchev's famous attack on modern artists in 1962. Ernst is quoted as telling his aggressor: "You may be premier and chairman, but not in front of my work. Here, I am premier, and we will speak as equals."

In 1976 Neizvestny went into exile. In 1989 he was commissioned by the Soviet government to create three memorials to victims of Stalinism. In this photograph, taken in his New York studio, he stands next to a model for one of them.

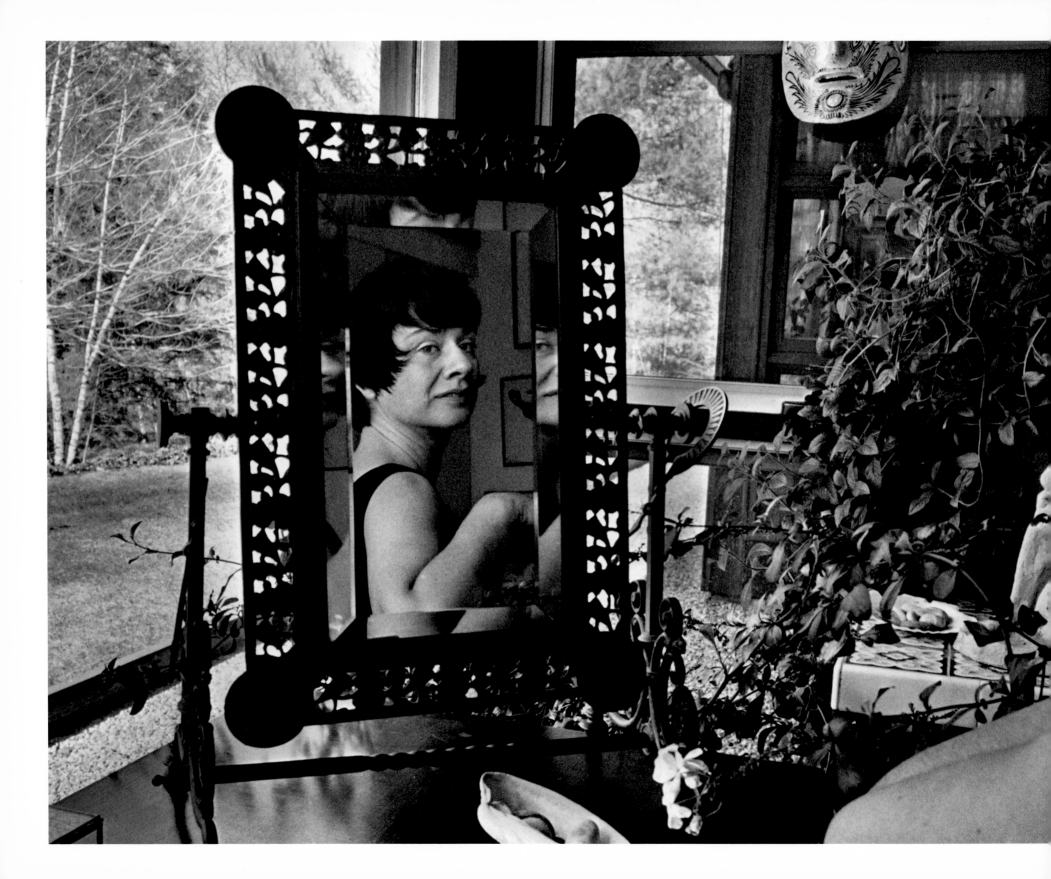

# INSTANTANEOUS
# FOREVER

by Olga Andreyev Carlisle

INGE MORATH, LIKE ALICE, has been able to step through the looking glass. A frequent visitor to the Soviet Union since 1965, she has entered worlds that are usually closed to outsiders. Now in *Russian Journal* she shares with us her lyrical vision of Russia.

Traveling with Inge in 1967 on one of her early trips to the Soviet Union, I was writing a monograph about her work for Bucher Verlag and was especially attentive to her technique—which turned out to be no technique at all but a perfect eye honed through decades of experience.

Speaking French or Russian to each other, more often than not we were taken for Estonians journeying at leisure through those parts of Russia and Georgia which at that time were open to tourists. The Soviet Union was secretive, visibly decaying, yet full of a beauty that Inge was determined to capture in her photographs. She had fallen in love with Russia. Following the artistic creed of her favorite Russian poet, Boris Pasternak, she sought to grasp the universal through the instant. Observing her at work I marveled at her hunter's instinct. I came to believe that it was Inge's camera that Pasternak had celebrated in his "Thunderstorm, Instantaneous Forever," nature and an individual's sensibility fused in one moment of artistic triumph:

Thunder, tipping its hat
Took a hundred snapshots
Blinding us with flashes . . .
Boundaries and hidden parts
Of reason, clear as daylight,
Would now be revealed.

In 1967 the Brezhnev repression was setting in—the political climate in the Soviet Union was becoming oppressive. Inge and I often had the feeling that we were being watched. Nonetheless, whenever a picture was at hand my friend's natural prudence and her exquisite Old World manners left her, giving way to an artist's steely determination. She became fearless. One afternoon, guided through Leningrad by the dissident poet Joseph Brodsky, she photographed the abandoned buildings of the infamous Third Department, the St. Petersburg police headquarters where Dostoyevski had been held after his arrest in 1849, a monument of the sinister past strictly off-limits to Western photographers. In these pages there is a photograph of Brodsky about to lead Inge on another perilous, forbidden expedition across the rooftops of the Peter and Paul Fortress overlooking the Neva River, where generation upon generation of Russian revolutionaries had been imprisoned. Re-

membering that afternoon adventure, during most of which I cowered behind a crenellation of the fortress, I see it now as a metaphor for the future literary and human exploits of the daring and brilliant young man who served as our guide for a day or two in Leningrad that year.

Throughout this photographic journal, Inge Morath seizes upon intimate instants that reflect Russian history: In Moscow in 1967, Nadezhda Mandelstam, widow of the great poet Osip Mandelstam, delights in a gift from the Khrushchev era—the comforts of her own apartment, her first since 1934. In Lithuania in 1989, a man tells his son of his life in the gulag. In Georgia a pilgrim makes his way along the walls of Alaverdi, a majestic eleventh-century basilica which in the nineteenth century the Russian tsars had whitewashed to conform to the Russian Orthodox preference for white stone churches. In Kirghizia in 1986, a local grandee, the writer Chingiz Aitmatov, affably greets newly arrived foreign dignitaries, an occasion that turned out to be the international debut of glasnost. And at the historic 1987 Moscow Forum, Andrei Sakharov, regarded now as a lay Russian saint, is surrounded by admirers after years of exile.

Wandering around Moscow, Inge Morath discovers that city's secrets. As she meets the steady gazes of the Moscow bird merchants she captures their faith that their ancestral trade will endure on Trubnaya Square as long as the city of Moscow herself stands on the banks of the Moskva River. At an open-air market she catches the undying flirtatiousness of a middle-aged woman as she chooses just the right mushroom. Everywhere we go, we partake of the lovely ceremonials of hospitality—in a painter's modest room on Gorky Street, in the luxurious living room of a successful writer in Moscow, at a banquet in Tbilisi.

Like Alice on her fantastic journey, Inge was able to meet some extraordinary personages. She portrays them for us, the people who helped save Russian culture from extinction during the long, icy years following Khrushchev's thaw. Many belong to Mikhail Gorbachev's generation: the conscience of the country. The poets are here, among them beautiful Bella Akhmadulina. Through her talent and her integrity she has helped uphold the grand tradition of women poets in Russian literature. Poet-balladeer Bulat Okudzhava is also the author of historical novels, profound meditations on the Russian past worthy of the great prose legacy of the twenties. Yevgeny Pasternak, the poet's eldest son, preserved his father's literary legacy, greedily coveted by Writers' Union officials, and now can devote his energies to the broadening of Pasternak scholarship in the Soviet Union and abroad. He willingly shares with those interested his vivid memories of his father.

Inge takes us on a pilgrimage to the holy places that have sustained these intellectuals' resolve: Pasternak's grave in Peredelkino; Mikhailovskoye, where Pushkin spent his most creative years in exile from St. Petersburg; Yasnaya Polyana, which speaks of Tolstoy's happiest years at work on

*War and Peace* and *Anna Karenina*, and, there is Chekhov's house in Yalta.

In Armenia, an outsize Lenin still keeps watch over Yerevan's main square, but surely someday he too, like Stalin, will be toppled. Already flags and slogans are disappearing; the Kremlin no longer rules the empire with an iron hand. The country is in flux, some of it is crumbling like the old monasteries that Inge Morath lovingly photographs, its very formlessness fascinating to Westerners.

RUSSIAN CULTURE, THE MYSTERIOUS FORCE that still holds together this multinational country, is made palpable in *Russian Journal*. It is an eclectic culture. There would have been no Russian icon painting without Byzantium, no Pushkin without Voltaire, no Pasternak without Rilke. This diversity has given Russian culture its complex identity, which Inge Morath captures through her photographic visions, as brief as the click of a shutter, instantaneous forever.

---

OLGA ANDREYEV CARLISLE was brought up in Paris and came to the United States in 1949 to attend Bard College. The granddaughter of renowned playwright Leonid Andreyev, Mrs. Carlisle, author and artist, has deep ties to the literary life of contemporary Russia. Her books include *Voices in the Snow, Poets on Street Corners, An Island in Time,* and *Solzhenitsyn and the Secret Circle.* In 1990 she was invited to teach a course on Russian-émigré literature at the Gorky Literary Institute. She collaborated with Inge Morath on *Pasternak: My Sister, Life* in 1975.

# THE NEW REALITIES

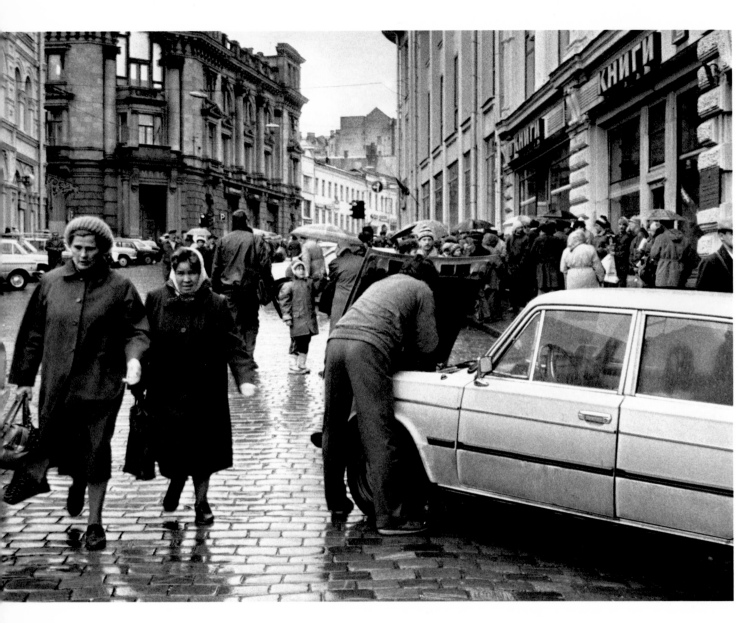

LEFT: MOSCOW, 1989
A busy thoroughfare shows at
one glance some of today's
problems: Women return
after hours of queuing up for
"whatever they can catch" in
their shopping bags. A man
repairs a car that he cannot
replace. Muscovites line up at
a bookstore; there are never
enough books in print for a
nation of passionate readers.

RIGHT: ISSYK-KUL, 1986
One of the first signs of
openness in Gorbachev's
administration was the Issyk-
Kul Forum, held in Kirghizia.
Free of party guidance,
candid talk was invited from
writers, scientists, and artists
from around the world.
    The host was novelist
Chingiz Aitmatov, standing in
the center with Peter Ustinov,
Claude Simon, Arthur Miller,
and Russian futurist Rustem
Khairov.

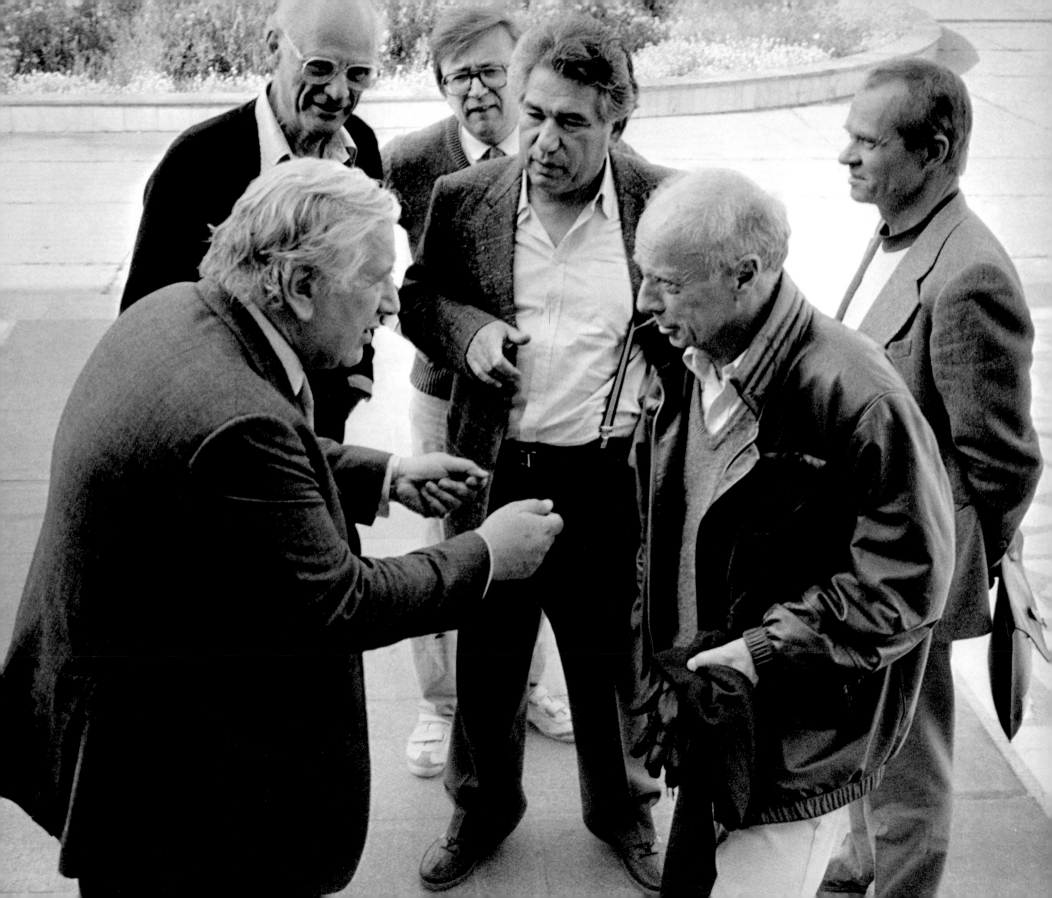

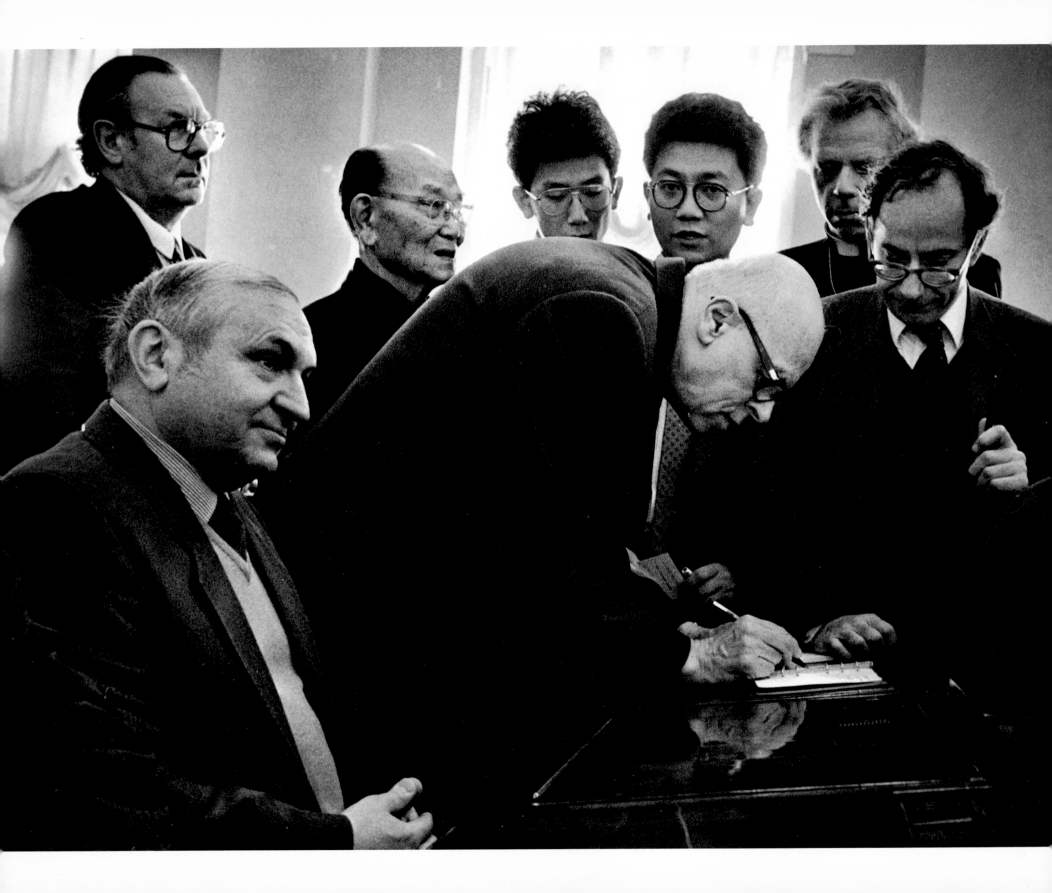

LEFT: MOSCOW, 1987

In February 1987, the second year of perestroika and glasnost, an international group of scientists, writers, artists, and filmmakers was invited by the Gorbachev government to participate in the Moscow Forum for Peace in the Nuclear-Free World. Mikhail Gorbachev had just released Andrei Sakharov from exile in Gorky; his participation in the meetings had an enormous effect—a great moral force had returned to public life. Sakharov died on December 14, 1989, after writing a speech renewing his call to abolish the Communist Party's monopoly on power.

RIGHT: MOSCOW, 1989

"The tree where perestroika began" is the pride of its Moscow neighborhood, the first to publicly protest a government measure: the land had been sold, the tree would be cut down. But the citizens kept a vigil around it. One of them told me, "This tree has been here since the Napoleonic wars, and our poet Marina Tsvetayeva saw it from her windows." The city council gave in, bought back the land, put up a protective fence, and gave the tree a plaque.

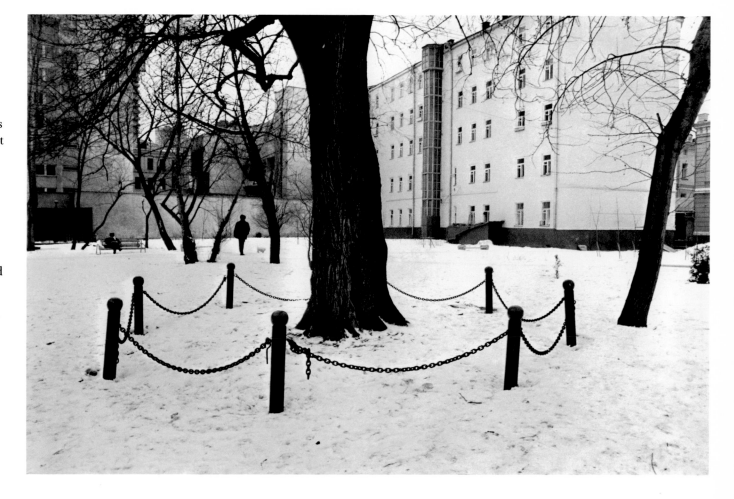

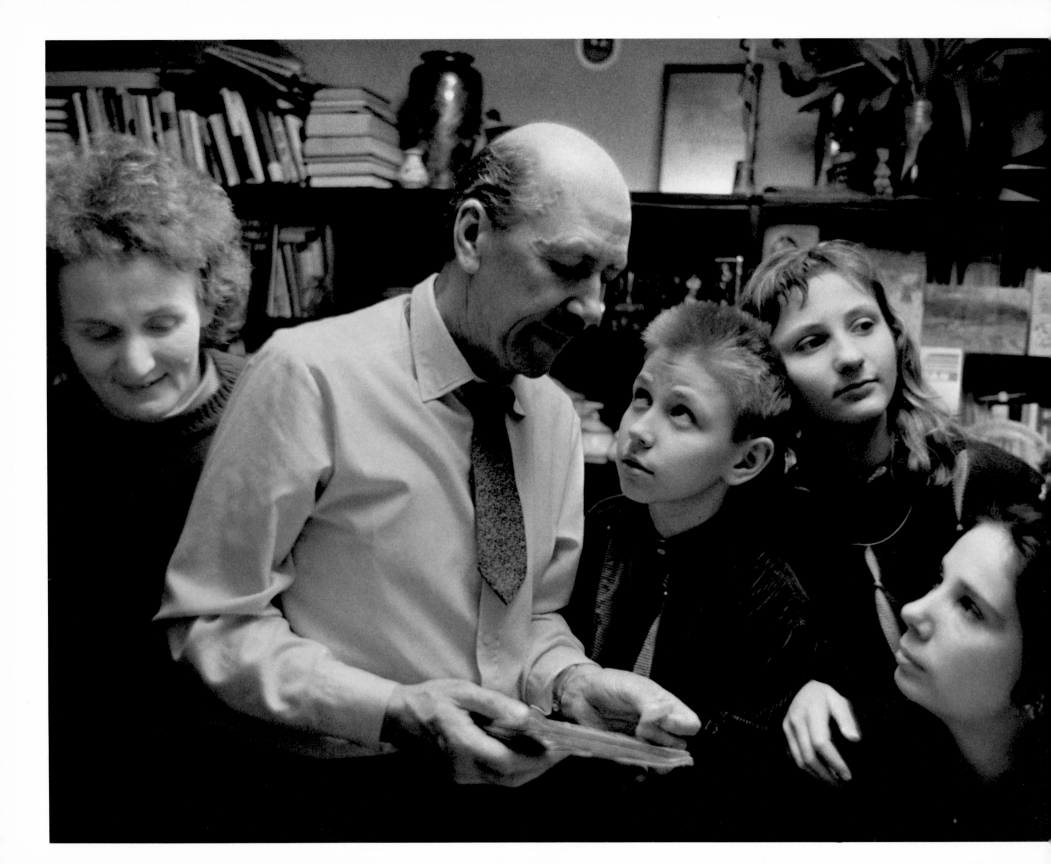

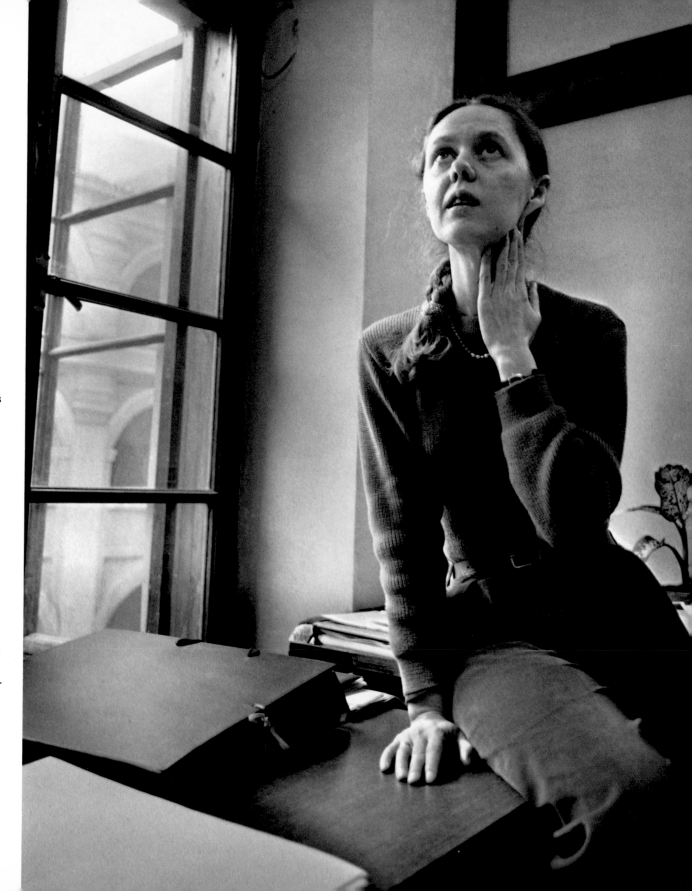

LEFT: VILNIUS, 1989
As a youth, Alvis Genusias spent years in a labor camp for his "antigovernment activities." At dinner in his house, he pours out the story of his life in detention to his family. Before, such revelations would have cost him his job. Now he is openly active in collecting poems and letters from labor-camp inmates for publication in Lithuania.

RIGHT: VILNIUS, 1989
Laima Skeiviene, art critic and vice president of the National Association of Lithuanian Photographers, is building an archive of photographs collected in secret for fear of their being confiscated as anti-Soviet. It is a collection of powerful images of life in a state fighting for independence.

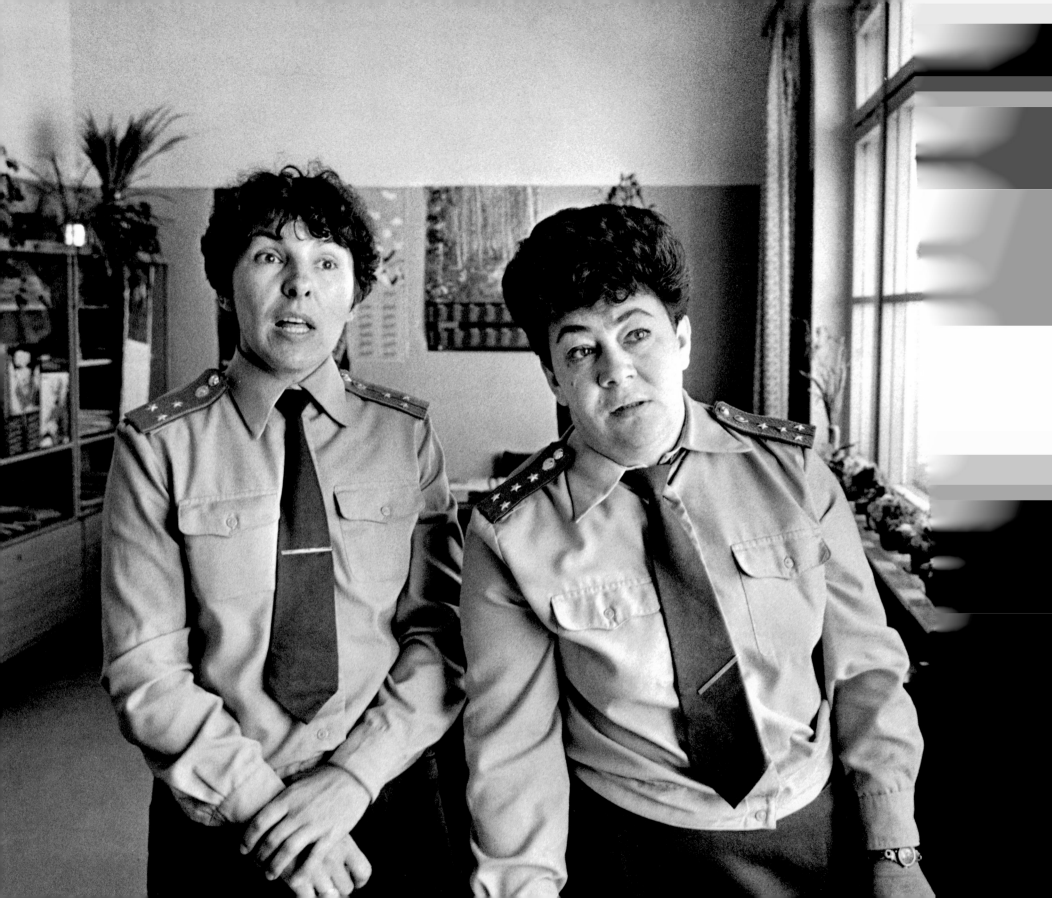

MOSCOW, 1989

The new openness has permitted a glimpse into formerly taboo territories, including juvenile delinquency. The writer Natalia Darialova, who took me to this "colony," eloquently evokes the plight of these children: "Transports of convicts, many underage, arrive continuously. The colonies are hidden far away from the center of Moscow and serve for offenders as well as for abandoned children. They bring in the little ones abandoned by parents being treated for alcoholism or serving time in prison. Here they deliver the young prostitutes who go from man to man, roaming the countryside like tumbleweed, without aim and without future."

LEFT, AND RIGHT:
Supervisors and inmates in a facility for juvenile delinquents.

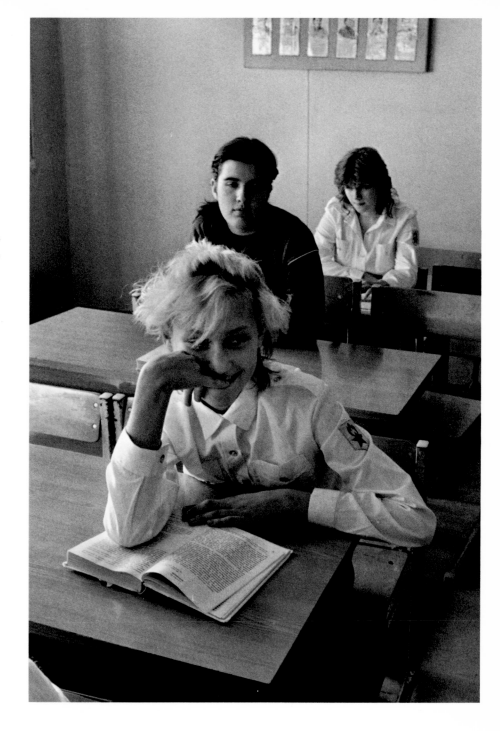

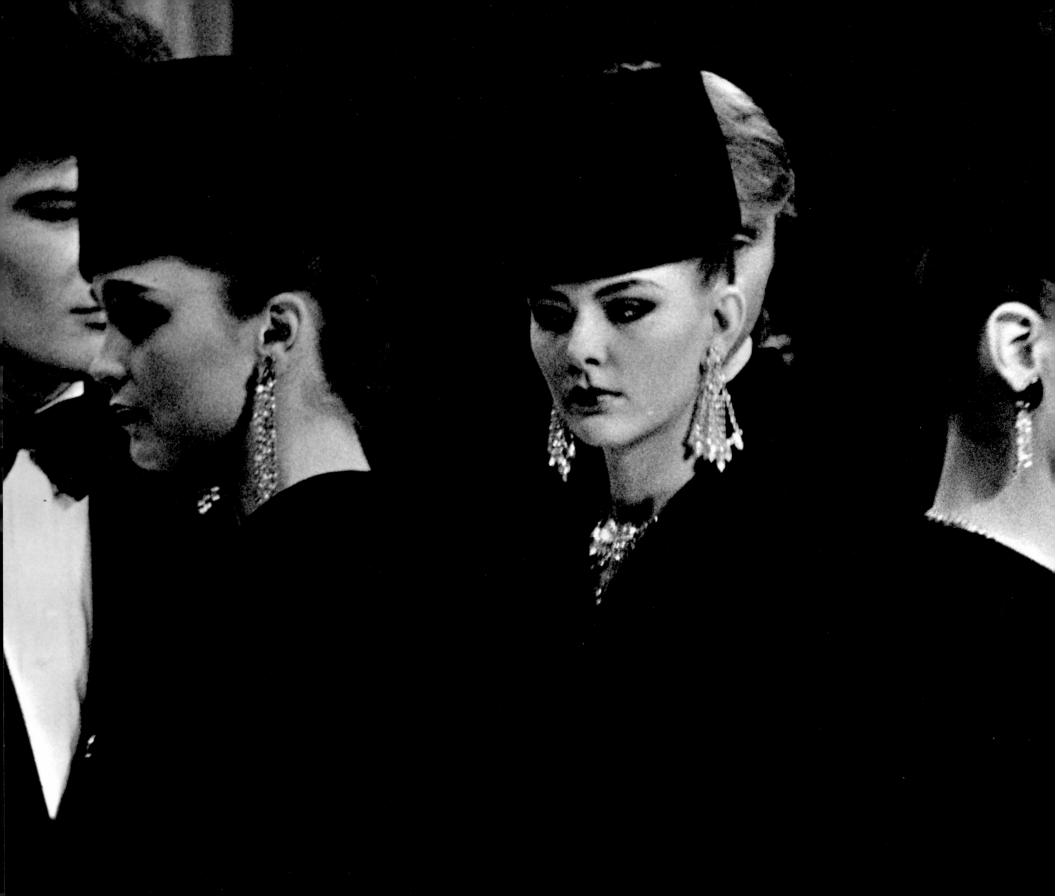

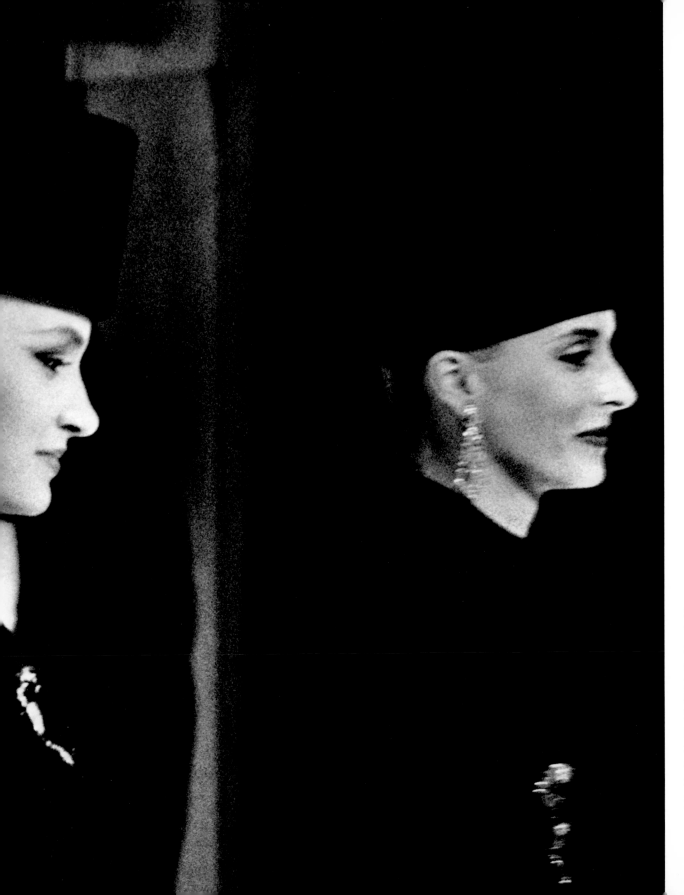

MOSCOW, 1988
The look of Soviet women is
changing. Premier couturier
and artist Slava Zaitsev
produces "fashion-theater"
shows in which he exhorts the
ladies to be brave and follow
the lead of his handsome
male and female models; his
exquisitely cut clothes are a
mélange of Parisian and
tsarist elegance.

# ACKNOWLEDGMENTS

I WOULD LIKE TO THANK MY RUSSIAN FRIENDS who helped me find what I was looking for in their country, among them Frieda Lurie, the interpreter on my first trip, and Svetlana Makurenkova, who guided me through the eighties. I would also like to thank all the organizations that sponsored my trips:

> The Writers' Union
> The Union of Journalists of the USSR, Center of Press
>     Photography
> The Artists' Union
> The Issyk-Kul Forum
> The Soviet Peace Committee
> Progress Publishers

Needless to say, there was always someone in every place who helped.
-I.M.